ABOVE HALLOWED GROUND

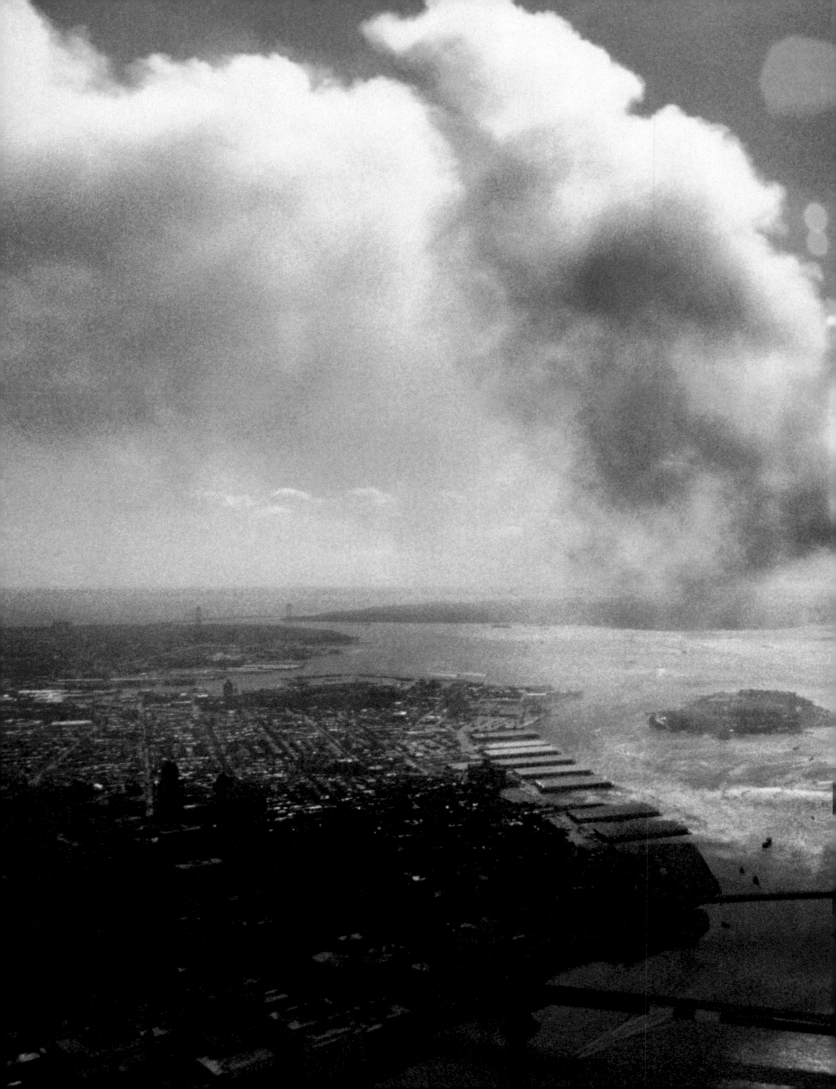

ABOVE HALLOWED GROUND

A PHOTOGRAPHIC RECORD OF SEPTEMBER 11, 2001
BY PHOTOGRAPHERS OF THE NEW YORK CITY
POLICE DEPARTMENT

Edited by Christopher Sweet

VIKING STUDIO

VIKING STUDIO
Published by the Penguin Group
Penguin Putnam Inc., 375 Hudson Street,
New York, New York 10014, U.S.A.
Penguin Books Ltd, 80 Strand,
London WC2R 0RL, England
Penguin Books Australia Ltd, 250 Camberwell Road, Camberwell,
Victoria 3124, Australia
Penguin Books Canada Ltd, 10 Alcorn Avenue,
Toronto, Ontario, Canada M4V 3B2
Penguin Books India (P) Ltd, 11 Community Centre, Panchsheel Park,
New Delhi – 110 017, India
Penguin Books (N.Z.) Ltd, Cnr Rosedale and Airborne Roads, Albany,
Auckland, New Zealand
Penguin Books (South Africa) (Pty) Ltd, 24 Sturdee Avenue,
Rosebank, Johannesburg 2196, South Africa

Penguin Books Ltd, Registered Offices:
Harmondsworth, Middlesex, England

First published in 2002 by Viking Studio,
a member of Penguin Putnam Inc.

1 2 3 4 5 6 7 8 9 10

CIP data available

ISBN 0–670–03171–2

This book is printed on acid-free paper. ∞

Printed in the U.S.A.
Set in Franklin Gothic
Designed by BTDNYC

THIS BOOK IS DEDICATED TO THE TWENTY-THREE MEMBERS OF
THE NEW YORK POLICE DEPARTMENT WHO SACRIFICED THEIR LIVES
ON SEPTEMBER 11, 2001, SO THAT OTHERS MIGHT LIVE;
AND TO THEIR FAMILIES WHO MUST BEAR THEIR LOSS.

Sergeant John G. Coughlin

Sergeant Michael S. Curtin

Police Officer John D'Allara

Police Officer Vincent G. Danz

Police Officer Jerome M. Dominguez

Police Officer Stephen P. Driscoll

Police Officer Mark J. Ellis

Police Officer Robert Fazio

Sergeant Rodney C. Gillis

Police Officer Ronald P. Kloepfer

Police Officer Thomas M. Langone

Police Officer James P. Leahy

Police Officer Brian G. McDonnell

Police Officer John W. Perry

Police Officer Glen K. Pettit

Detective Claude D. Richards

Sergeant Timothy A. Roy

Police Officer Moira A. Smith

Police Officer Ramon Suarez

Police Officer Paul Talty

Police Officer Santos Valentin

Detective Joseph V. Vigiano

Police Officer Walter E. Weaver

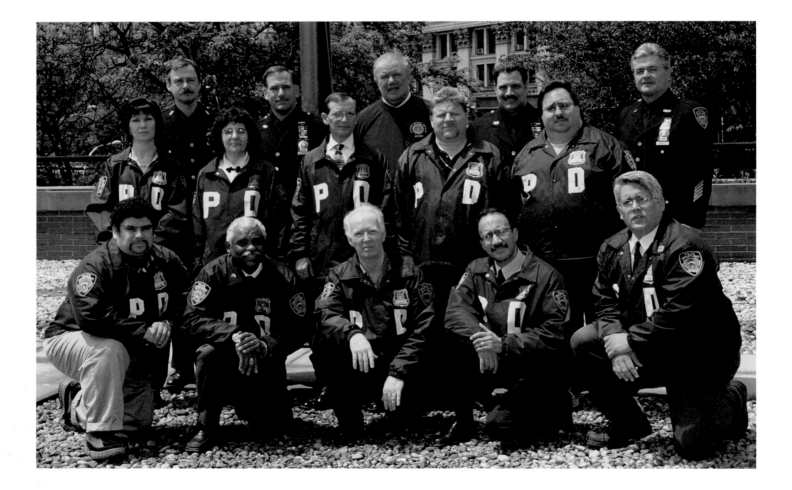

THE PHOTOGRAPHERS

BACK ROW (*left to right*): Detective Michael O'Brien, Detective David Fitzpatrick, Lieutenant Anthony Garvey, Detective Charles Parone, Detective William McNulty. **MIDDLE ROW** (*left to right*): Senior Photographer Valerie Hodgson, Photographer Janice L. Sugarman, Photographer H. Keith Manis, Photographer Charles Wisniewski, Senior Photographer Lance F. Karp. **FRONT ROW** (*left to right*): Photographer James Mercado, Administrative Manager Walter Taylor, Senior Photographer Douglas A. Campbell, Photographer Raymond Aponte, Photographer Wilhelm Figueroa.

ACKNOWLEDGMENTS

This book could not have become a reality if not for the courage and dedication of the thousands of NYPD members who responded on September 11th and in the days and weeks afterward. Many people contributed their time and talents so that this book could be published.

THE NEW YORK POLICE DEPARTMENT WOULD LIKE TO THANK:

Michael R. Bloomberg, Mayor of the City of New York

Raymond W. Kelly, New York City Police Commissioner

George A. Grasso, First Deputy Commissioner, NYPD

Joseph J. Esposito, Chief of Department, NYPD

Pamela D. Delaney, President of the New York City Police Foundation, and Jeffrey L. Laytin, counsel to the New York City Police Foundation

Stephen L. Hammerman, Deputy Commissioner of Legal Matters, and Deborah L. Zoland, Assistant Deputy Commissioner of Legal Matters

Detective Dave Fitzpatrick and all the photographers of the New York Police Department

The staff at Penguin Putnam, specifically:
Susan Petersen Kennedy, Dick Heffernan, Clare Ferraro, Adrian Zackheim, Patrick Adams, Ellen Schiller, Alessandra Lusardi, Beth Tondreau, Michael Carlisle, and Christopher Sweet

Cynthia Brown, editor of *American Police Beat*

WITHOUT THEIR DILIGENT EFFORTS, THIS BOOK WOULD NOT HAVE BEEN POSSIBLE.

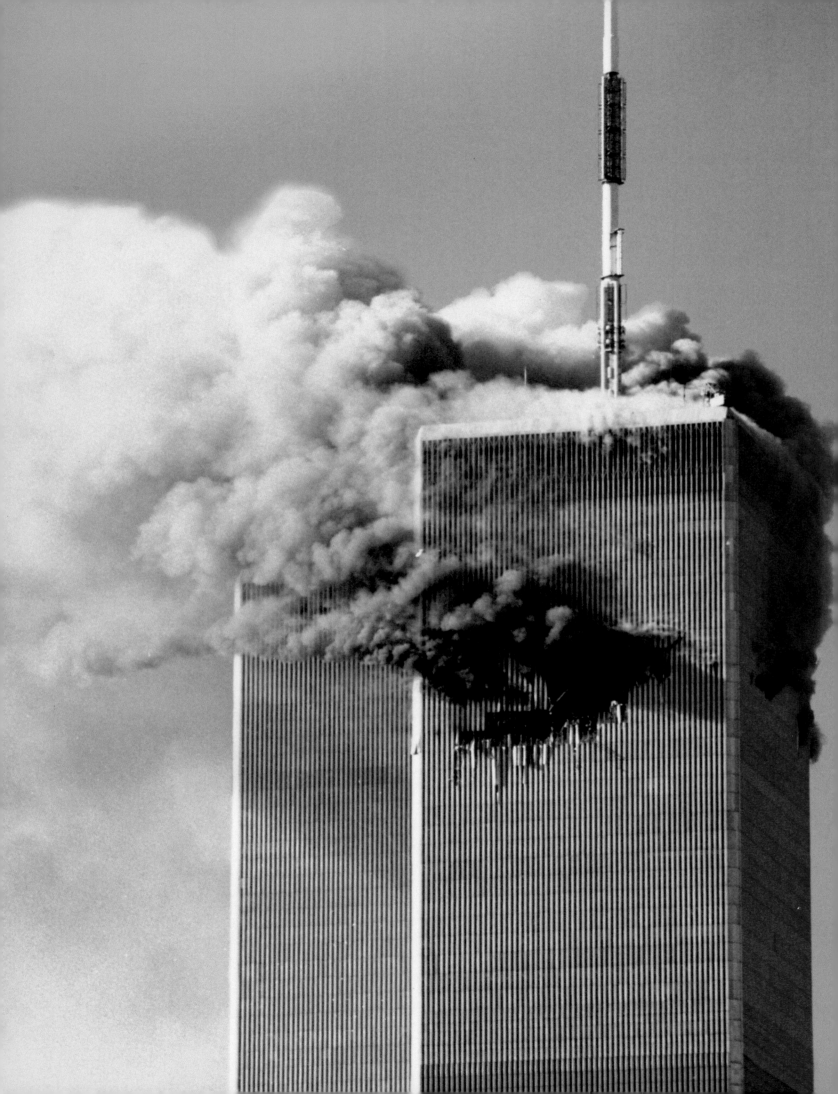

No one ever imagined this kind of attack. No one ever witnessed this kind of devastation. And no one ever captured the kind of images you're about to see.

THE MOST HORRIFYING TWO HOURS IN AMERICAN HISTORY occurred on the morning of September 11, 2001. As people went to work, as children started school, as a beautiful late-summer day began, somewhere high above the Hudson River a hijacked airliner was descending on New York City. Unknown to the eight million people going about their business that morning, an insidious attack was unfolding unlike any other in history. At 8:47 A.M., terrorists crashed the plane into the north tower of the World Trade Center and sent the city, the nation, and the world reeling in disbelief.

Instantly, New York City firefighters, police officers, EMS and other rescue workers, as well as countless civilian volunteers, rushed to the scene. Emergency plans were coordinated, rescue operations were launched. But just fifteen minutes after the disaster began, a second airliner slammed into the south tower, horrifying witnesses and shocking television viewers across the nation. Two more plane crashes in Washington, D.C., and Pennsylvania soon confirmed that this was no accident but the monstrous work of terrorists. In New York, however, the uniformed and civilian rescuers kept focused on one thing—saving lives.

Inside the burning towers, they scurried to evacuate an estimated tens of thousands of people. Outside, those fleeing the area watched with horror as human bodies rained down from the 110-story towers—victims jumping to their deaths rather than being burned alive. As flames consumed the towers and as smoke poured into the sky, panic and horror spread through all of downtown Manhattan.

At 9:50 A.M., the nightmare grew much worse: The south tower collapsed. The downward rush of steel, glass, and human life shook the bedrock of the island. A black cloud of dust engulfed the area, blinding rescuers and shrouding the devastation from news cameras. Finally, less than two hours after the attack began, its destruction was complete: The north tower, buckling in plain view, tumbled to the ground.

The intensity, the adrenaline, the horror of those first two hours was followed by agonizing days and weeks of searching and sifting the wreckage for human life. Seven other buildings also collapsed. Early estimates of the overall death count were too ghastly to comprehend. At one point, tens of thousands of people were thought to be missing. The number dropped as lists were checked and double-checked. But though the search continued for weeks, no survivors were found after the initial rescue effort. To date, the official death count is 2,823, which includes the passengers and crew of the two planes. It was the single worst attack on U.S. soil in the nation's history.

PHOTOS AND VIDEO IMAGES OF THE ATTACK filled newspapers and televisions for months after September 11th. Many of them were repeated endlessly, cropped to suit different stories, edited to highlight different details. The finite number of clear, presentable images led to a saturation of them in the media. The photos in this book, however, have never been published before. These pictures chronicle the attacks from a

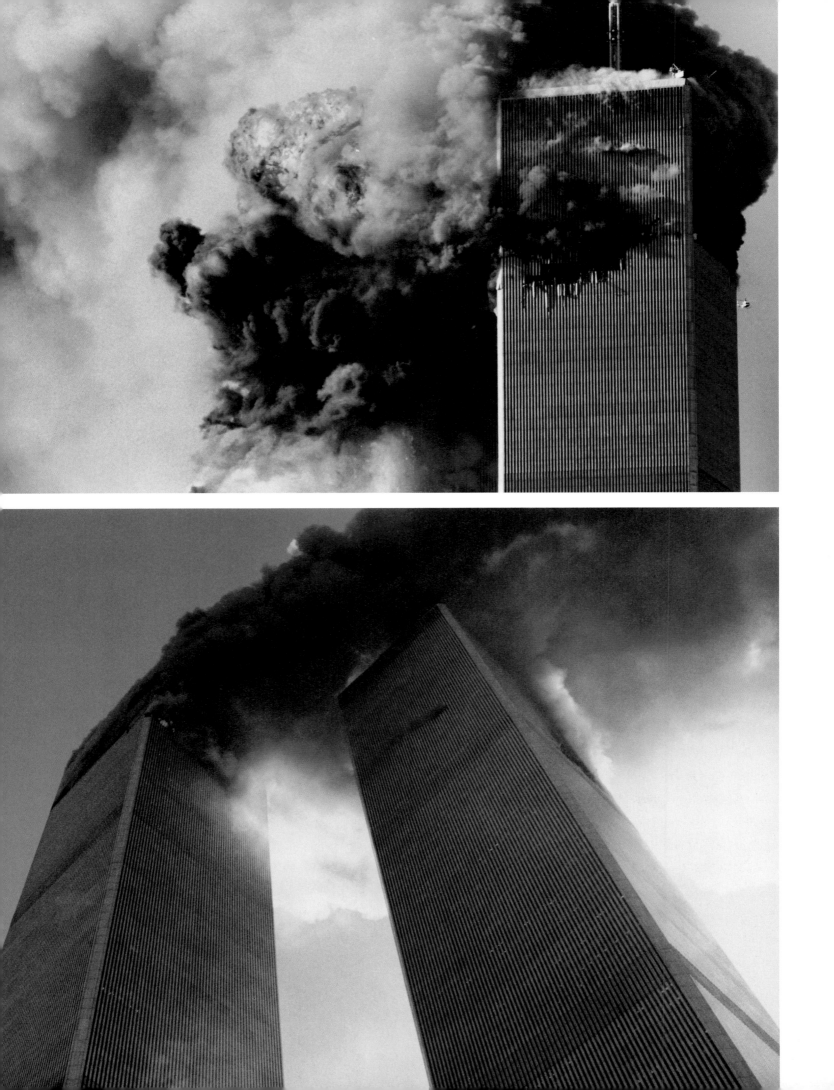

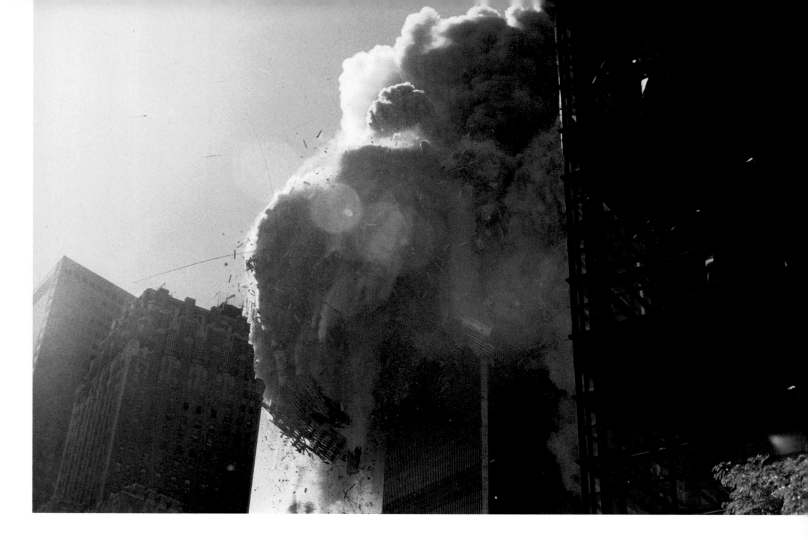

vantage point no ordinary photographer could obtain: They were taken by members of the New York City Police Department, uniformed and civilian, who were on the scene moments after the first plane hit and who were behind the scenes during the entire rescue and recovery effort.

Many officers took pictures during the course of their duties. Some were inside the lobbies of the World Trade Center before they collapsed. Some were in helicopters hovering near the burning towers. Some were trapped in the dust cloud after the buildings fell. They took pictures of the pandemonium around them, the fear, the effort, the exasperation. This collection portrays the courage of those who rushed in to the danger so that others could escape it.

One of the featured photographers, Detective Dave Fitzpatrick, was off duty when he heard a report of the attack over his radio. Immediately he went to an NYPD airfield, joined a crew boarding a police helicopter, and flew to the World Trade Center. They arrived right after the second plane hit and were instructed to observe the scene and watch for any other incom-

ing aircraft. Over the course of three flights that day, Fitzpatrick shot thousands of photographs that became the only aerial views of the devastation and early rescue efforts downtown. He also covered all Ground Zero operations for the next two months. His best photos, along with those of numerous other members of the NYPD, have been collected in this book.

ON THE MORNING OF SEPTEMBER 11TH, a new kind of horror entered the world. But at the same time a new generation of heroes rose up to fight it. Not all of them survived. In fact, 343 FDNY firefighters, 37 Port Authority police officers, and 23 NYPD police officers died in the line of duty. And no record can tell the number of civilian heroes who died that day helping others get out of harm's way. These men and women sacrificed everything they had to save thousands of lives. They formed the first line of defense against the worst attack in American history. The images collected here pay tribute to their valiant efforts, and it is to them and their families that this book is dedicated.

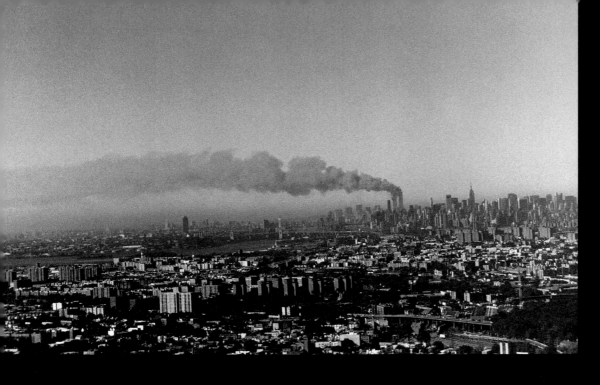
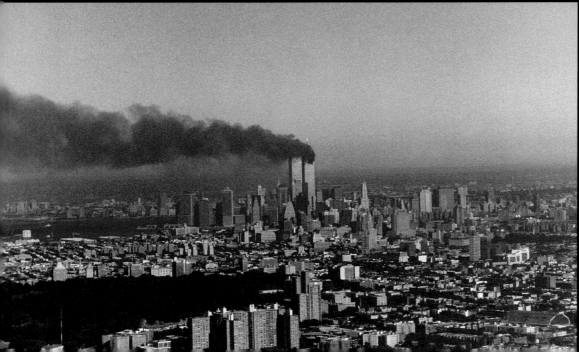
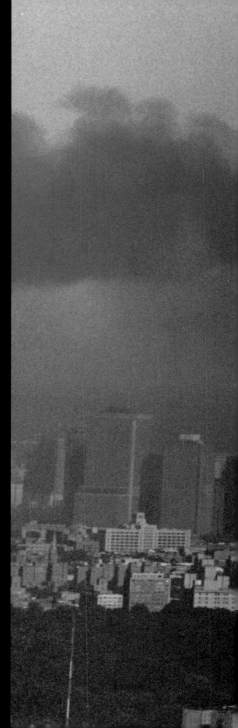

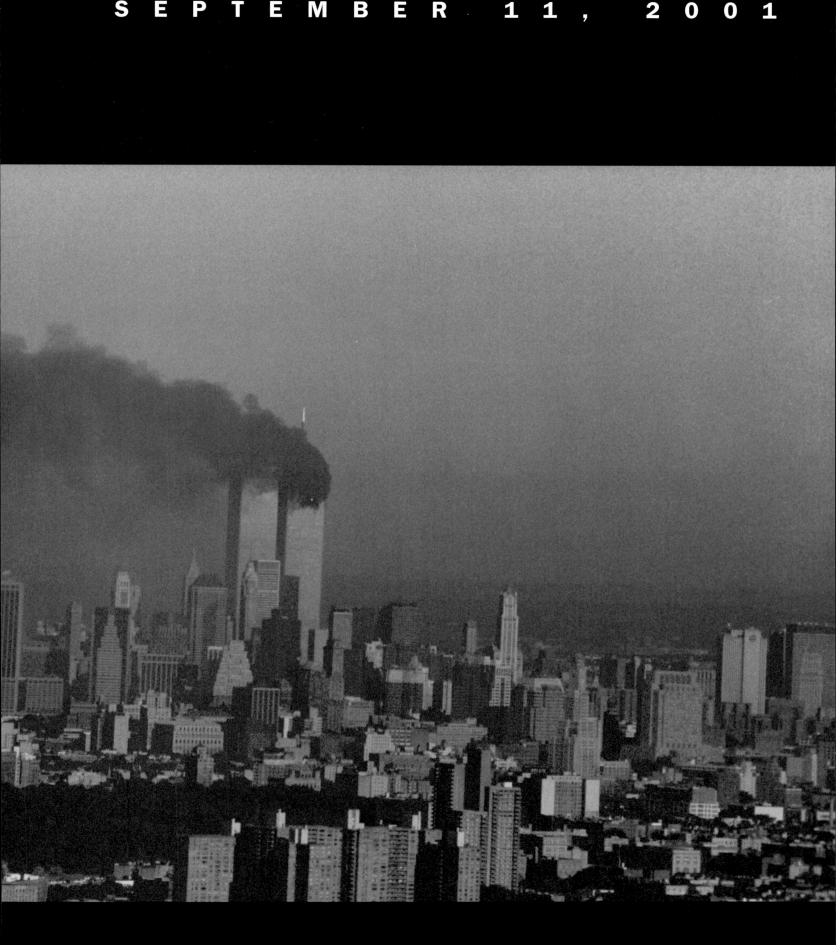

Heading west to lower Manhattan, over Brooklyn.

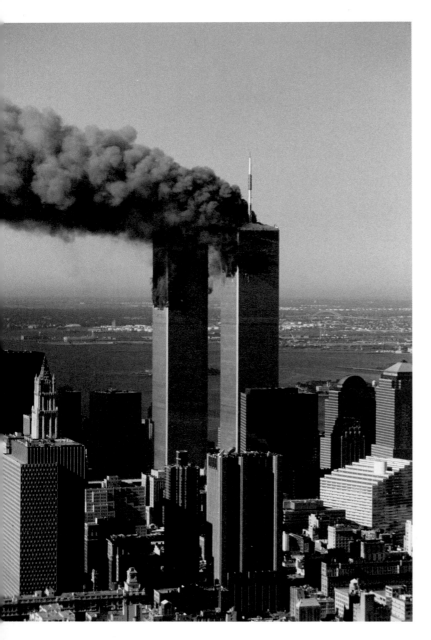

The two burning towers from the north.

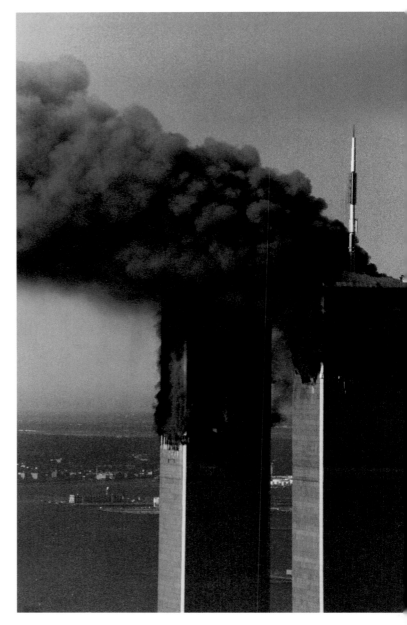

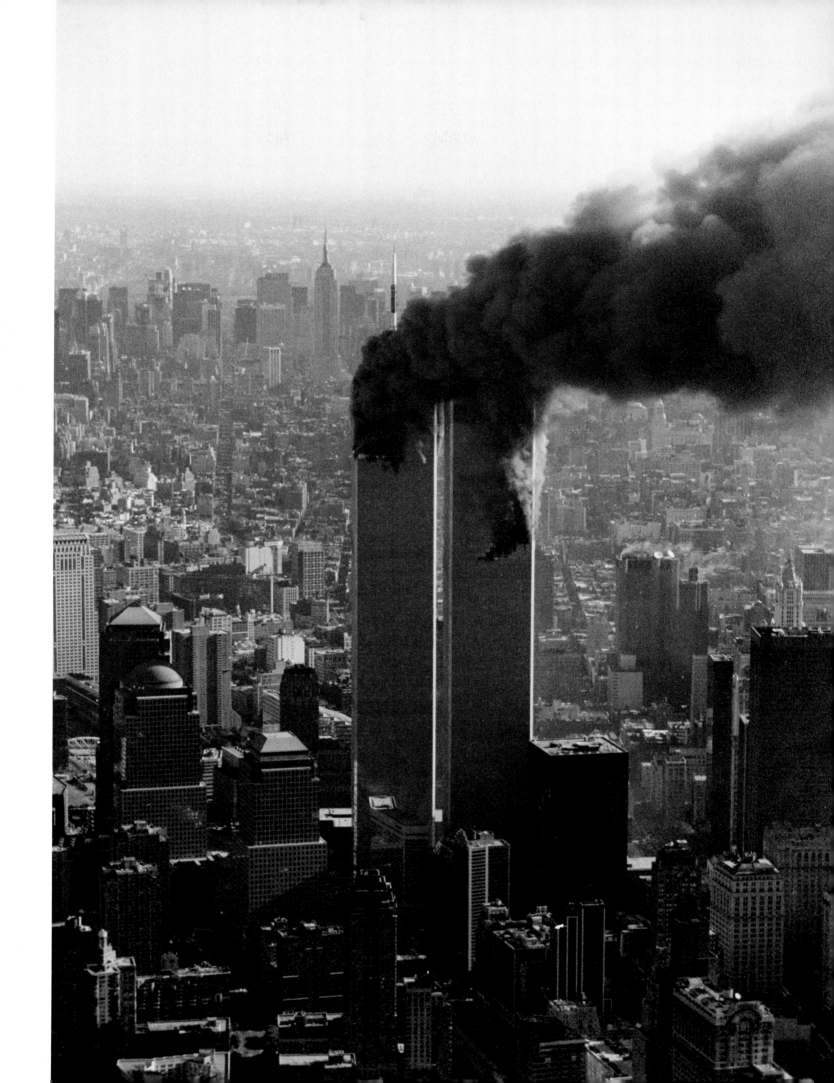

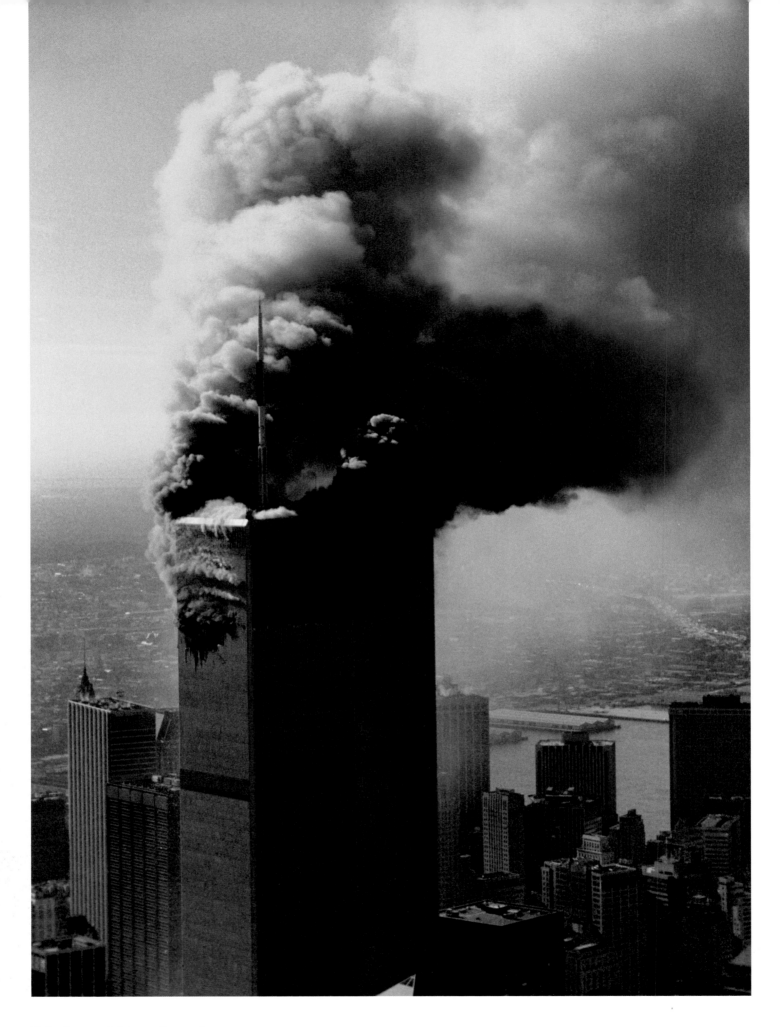

Nobody was visible on the roofs.

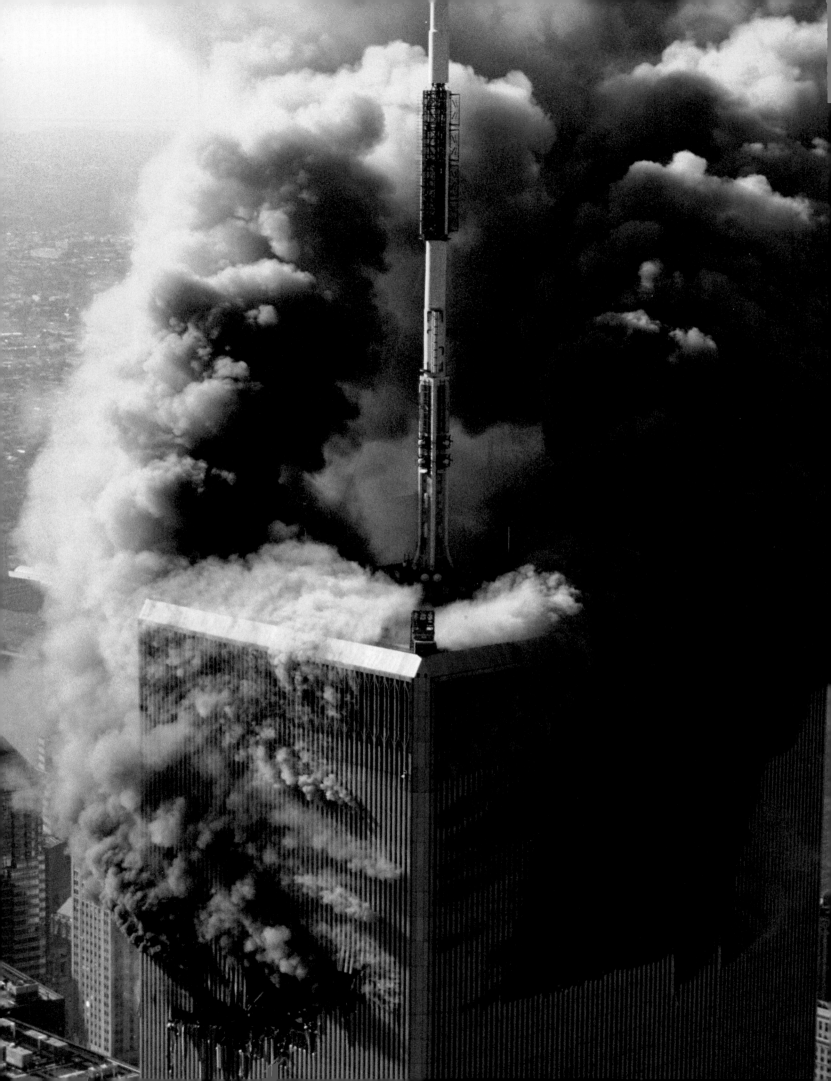

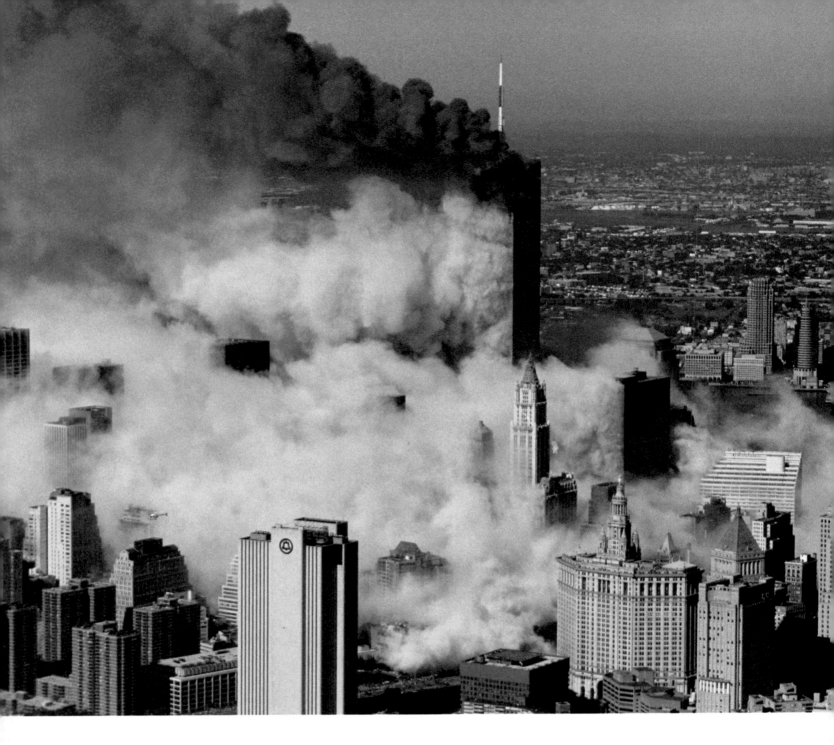

Flying in a wide circle over midtown looking for incoming rogue aircraft when the south tower fell at 9:50.

OPPOSITE: The Staten Island ferry making its way toward Manhattan.

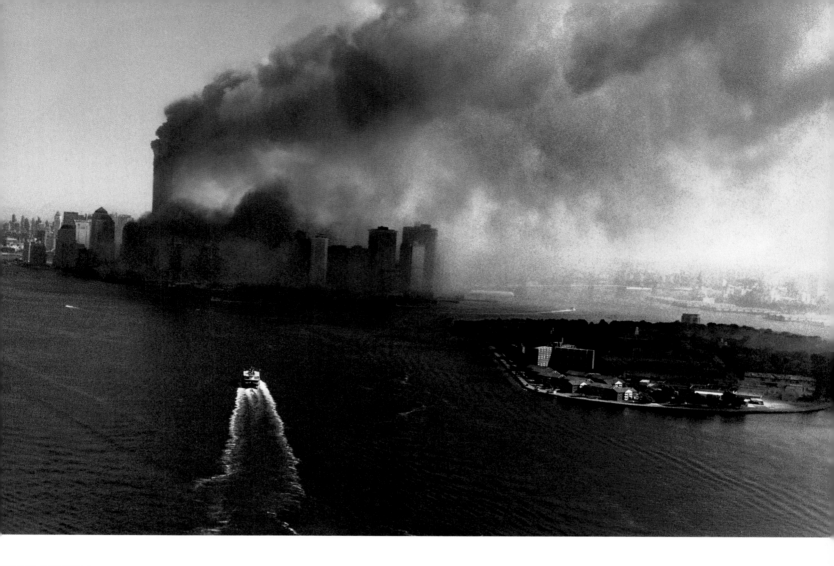

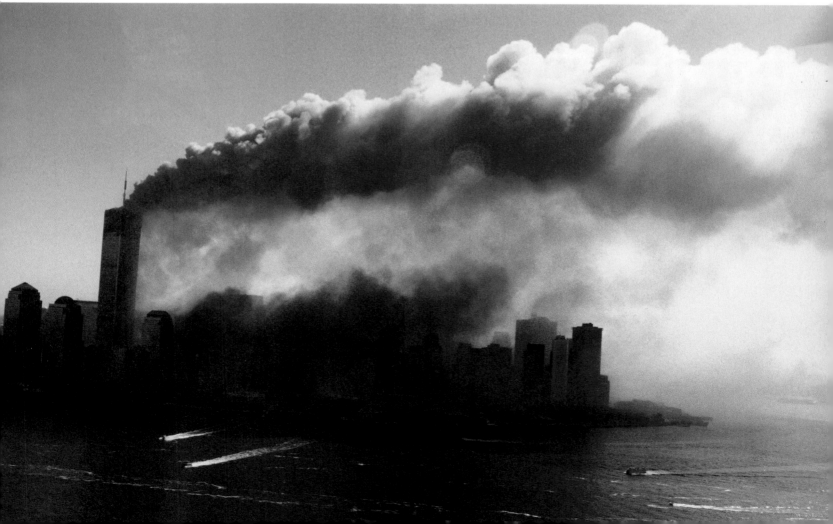

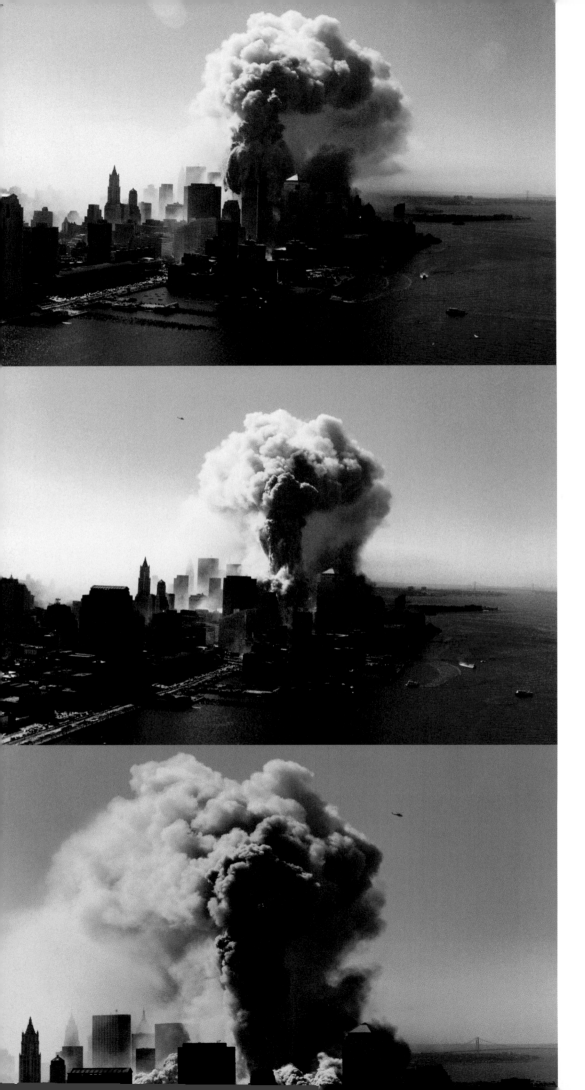

At 10:28 the north tower
started to come down.

OPPOSITE: Banking to the
right to head back downtown,
the helicopter blade came
into the frame.

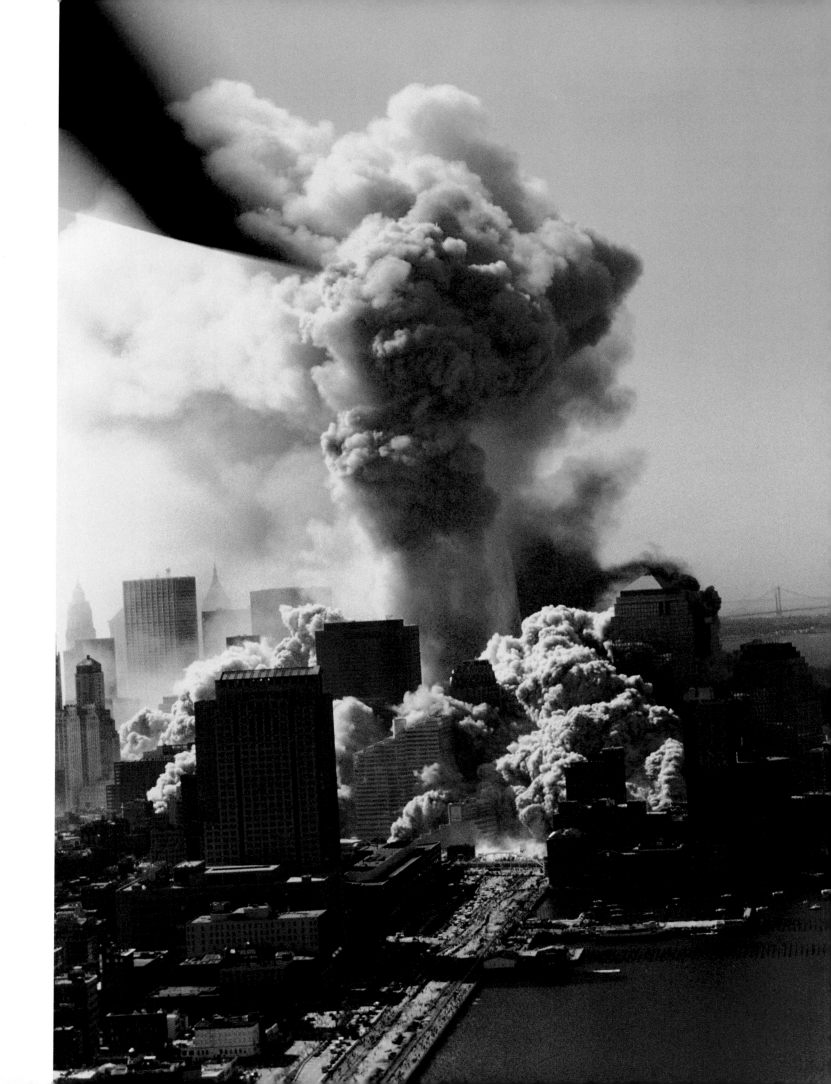

A vast cloud of smoke, dust, and debris engulfed the financial district. Buildings disappeared, boats fled the scene. There was silence. In the helicopter—the collapse, the cloud made no sound, and no one spoke.

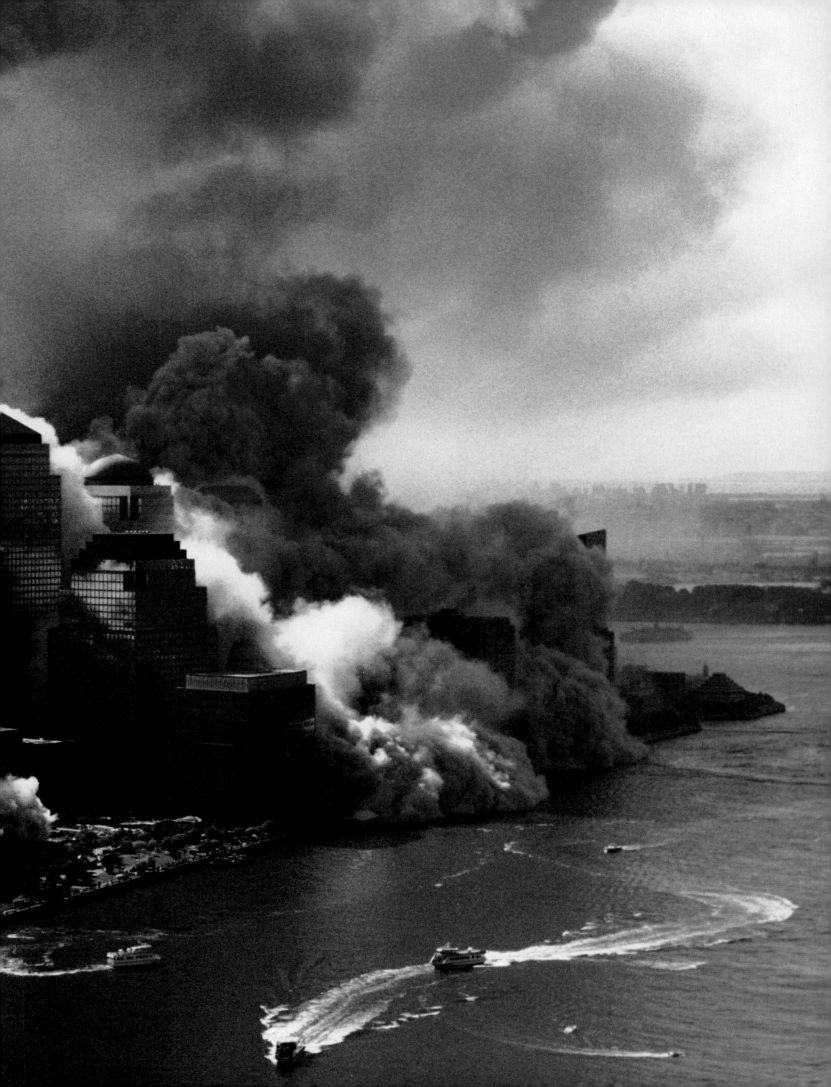

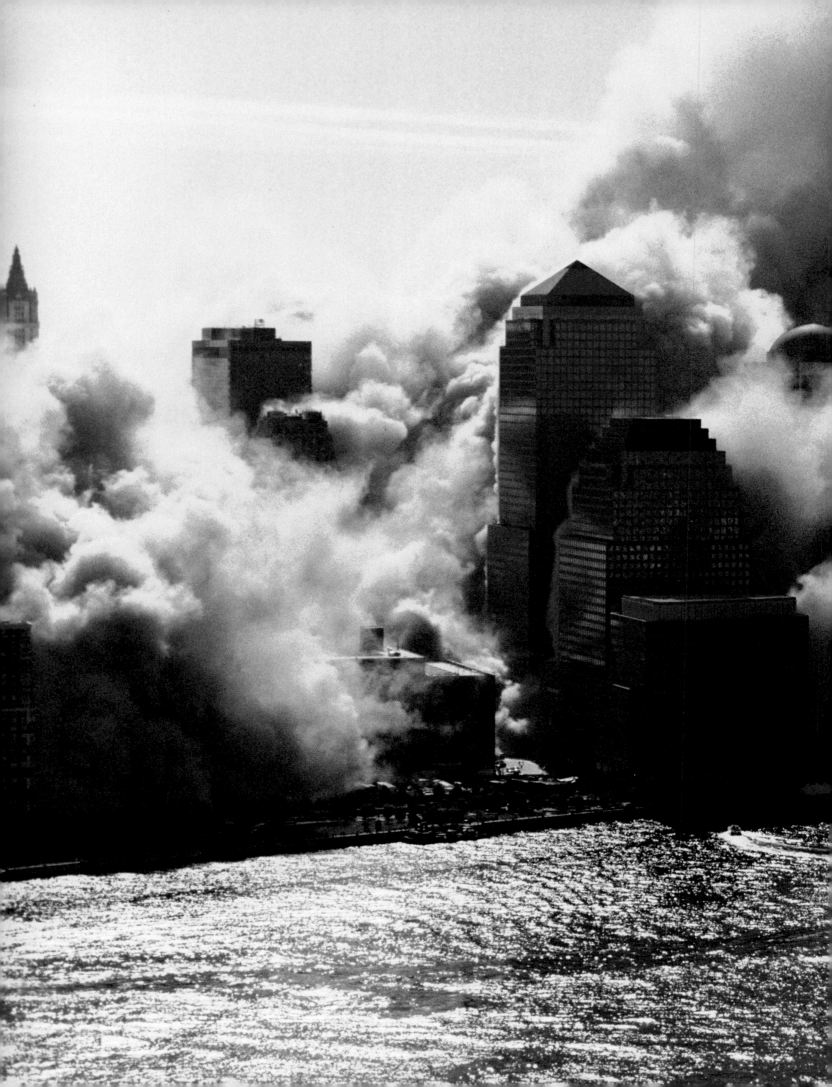

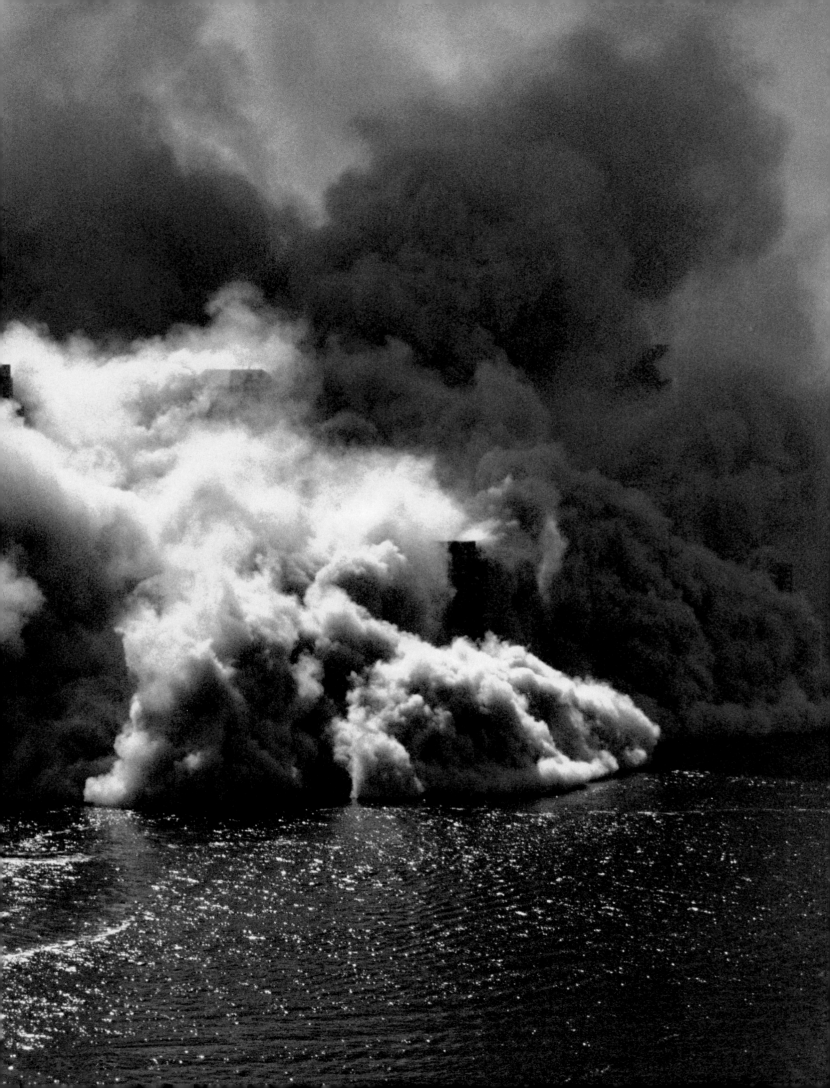

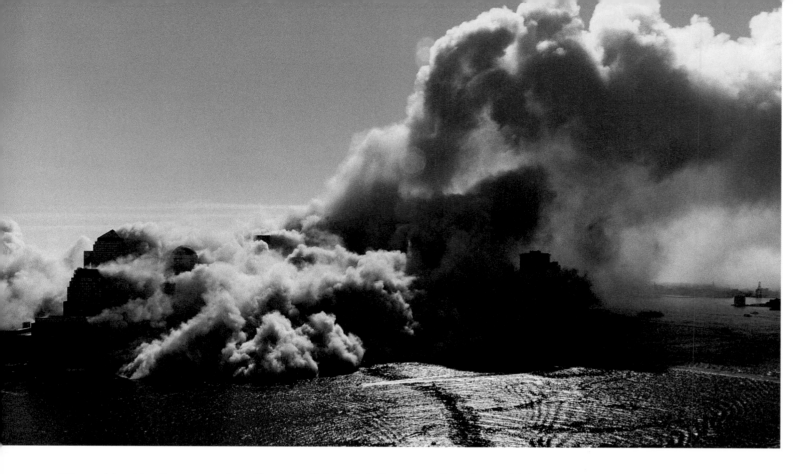

Life would not be the same again. The potential death toll was too sickening to think about.

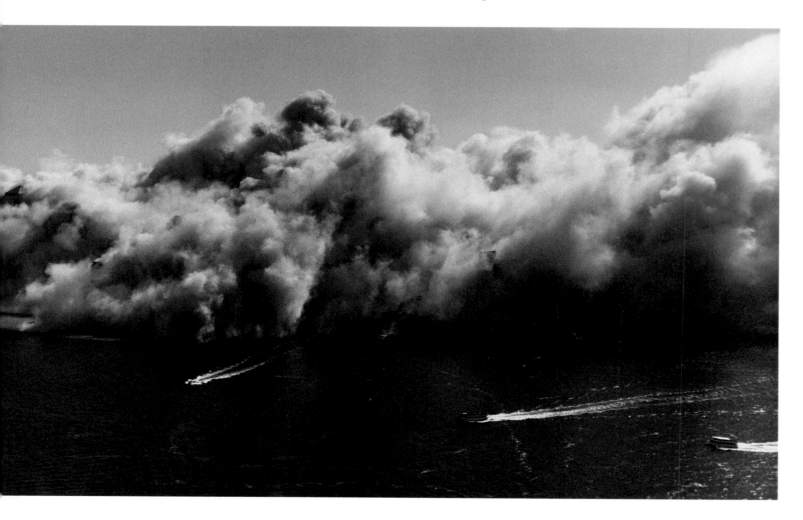

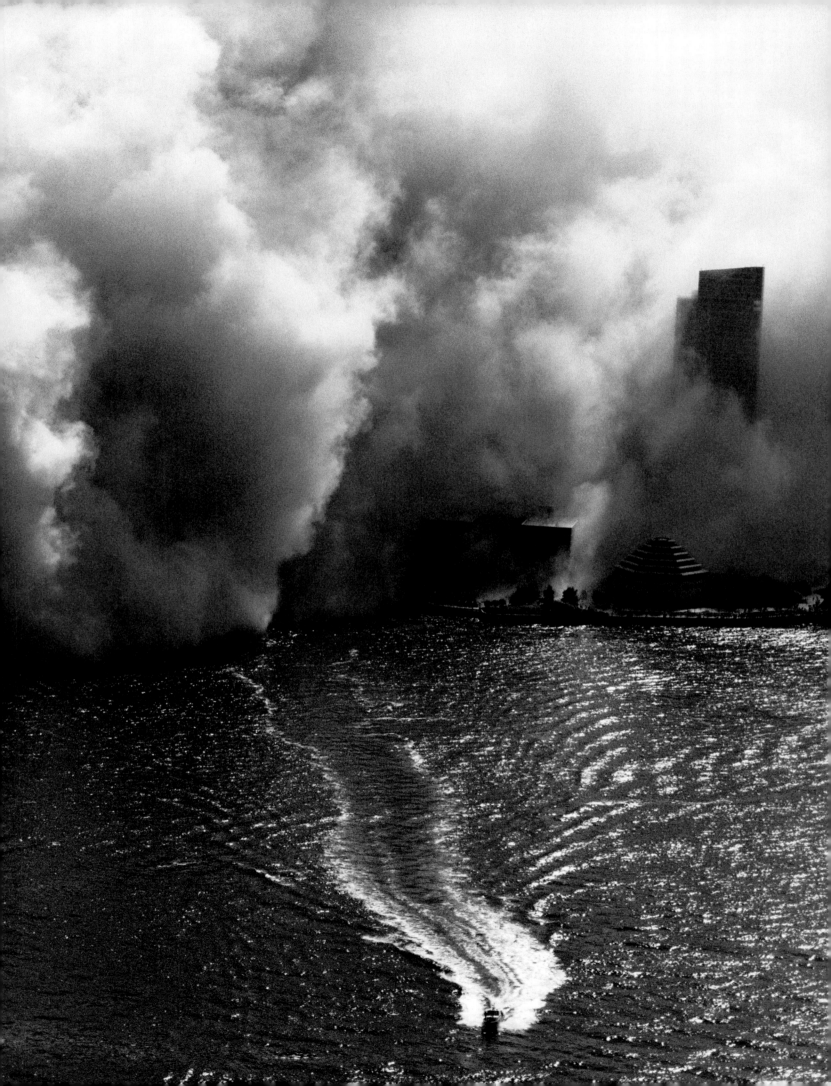

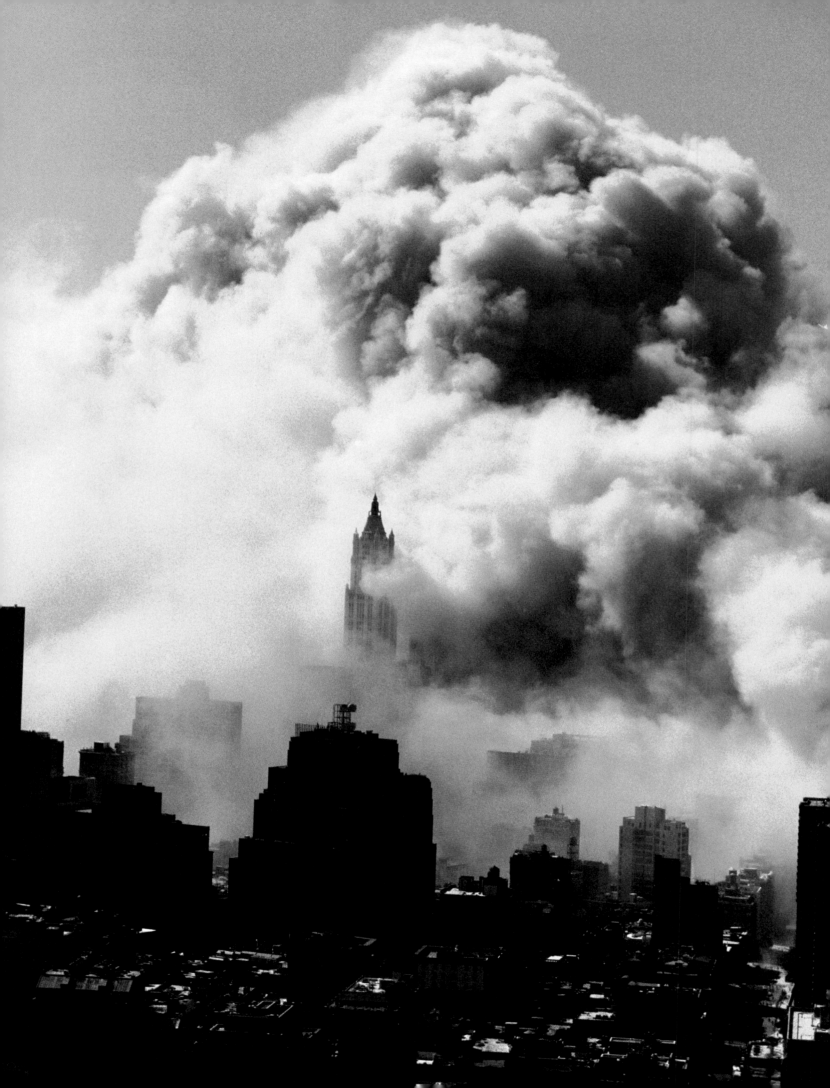

Looking down the West Side Highway to the footbridge between Manhattan Community College and Stuyvesant High School.

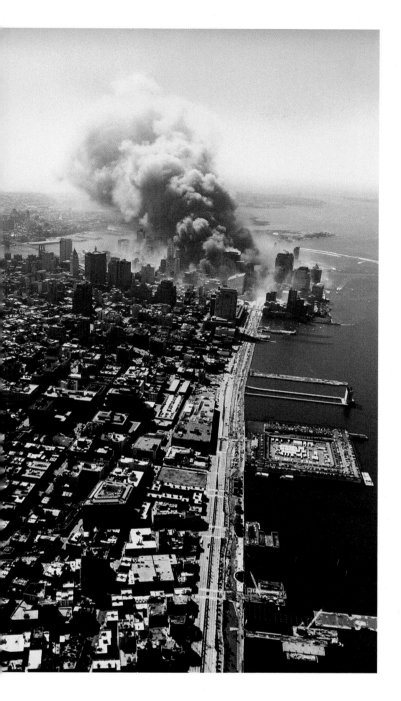

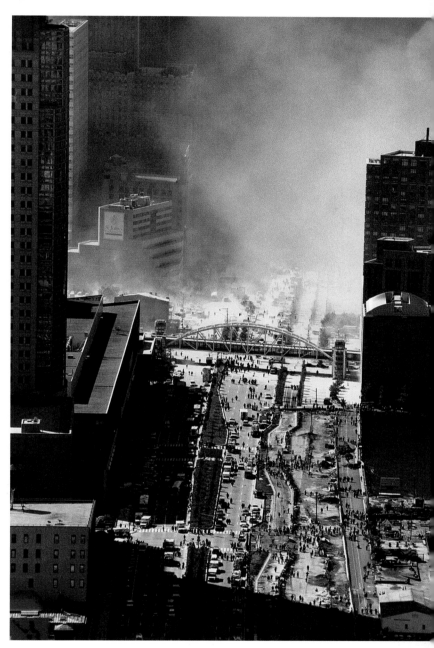

OPPOSITE: The Woolworth Building against the cloud of dust and smoke. The dust and smoke seemed to be moving in slow motion.

OVERLEAF: The World Financial Center and Battery Park City emerge from the smoke as the wind pushes the cloud eastward. New York's Museum of Jewish Heritage is visible on the far right.

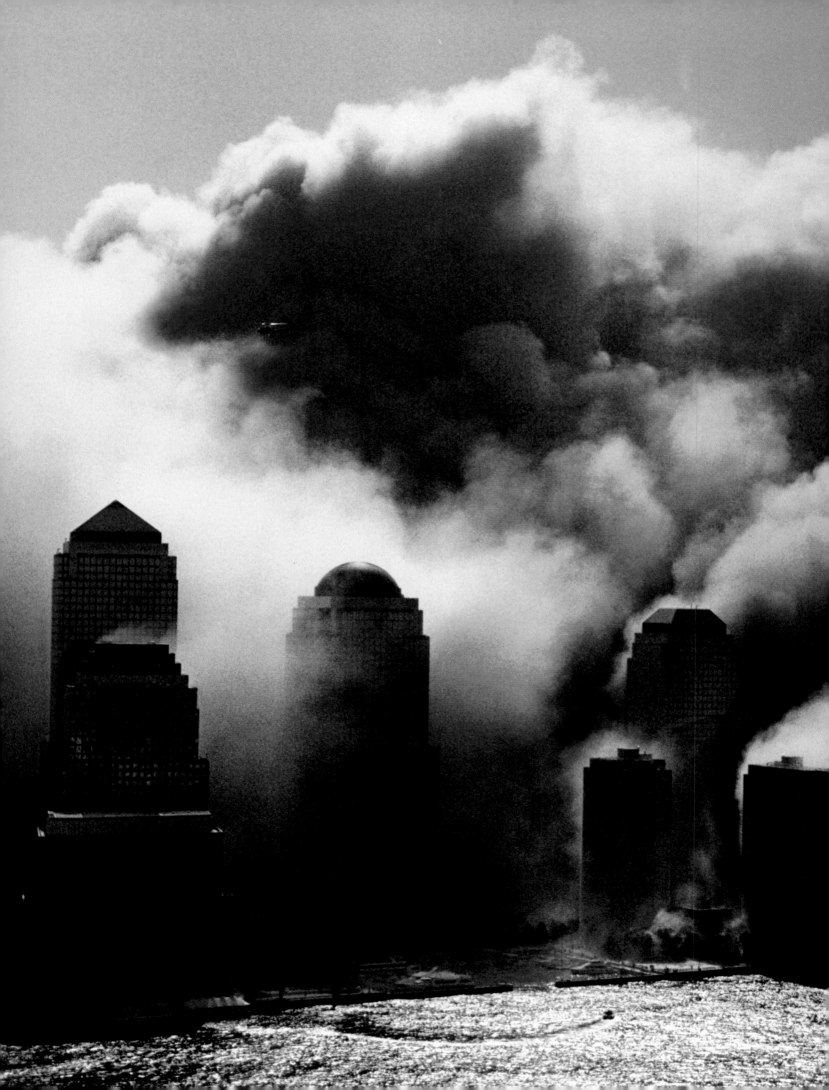

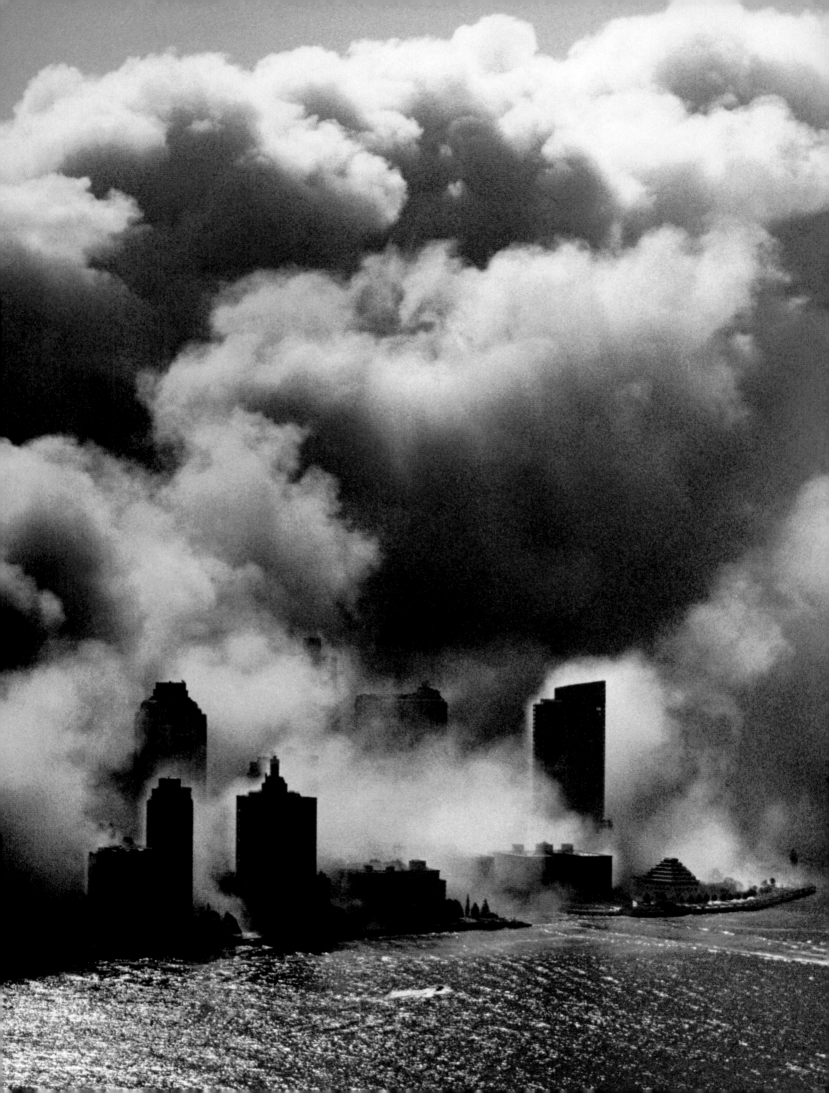

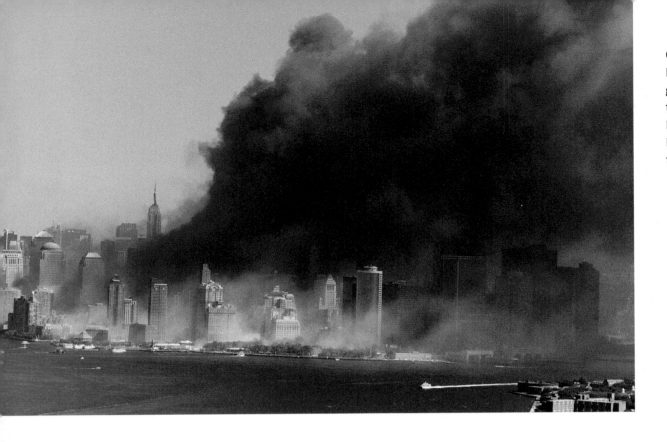

Over Governor's Island. As the fires grew, the smoke turned black. The Empire State Building looms in the distance.

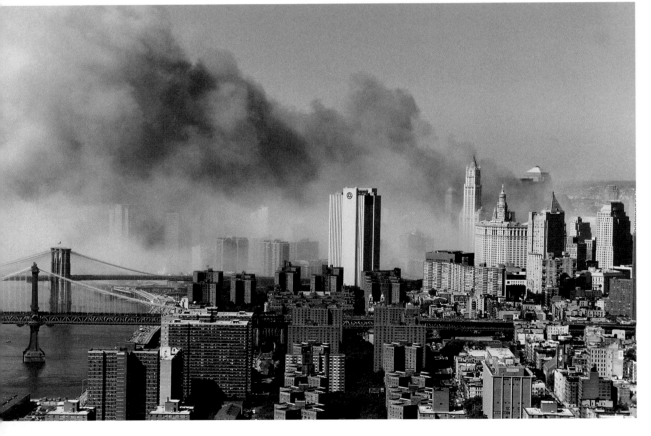

Along the East River, looking south over the Lower East Side.

OPPOSITE: People walking home can be seen on the ramp to the Brooklyn Bridge. In between the Municipal Building (*in the foreground to the left*) and the Woolworth Building is City Hall.

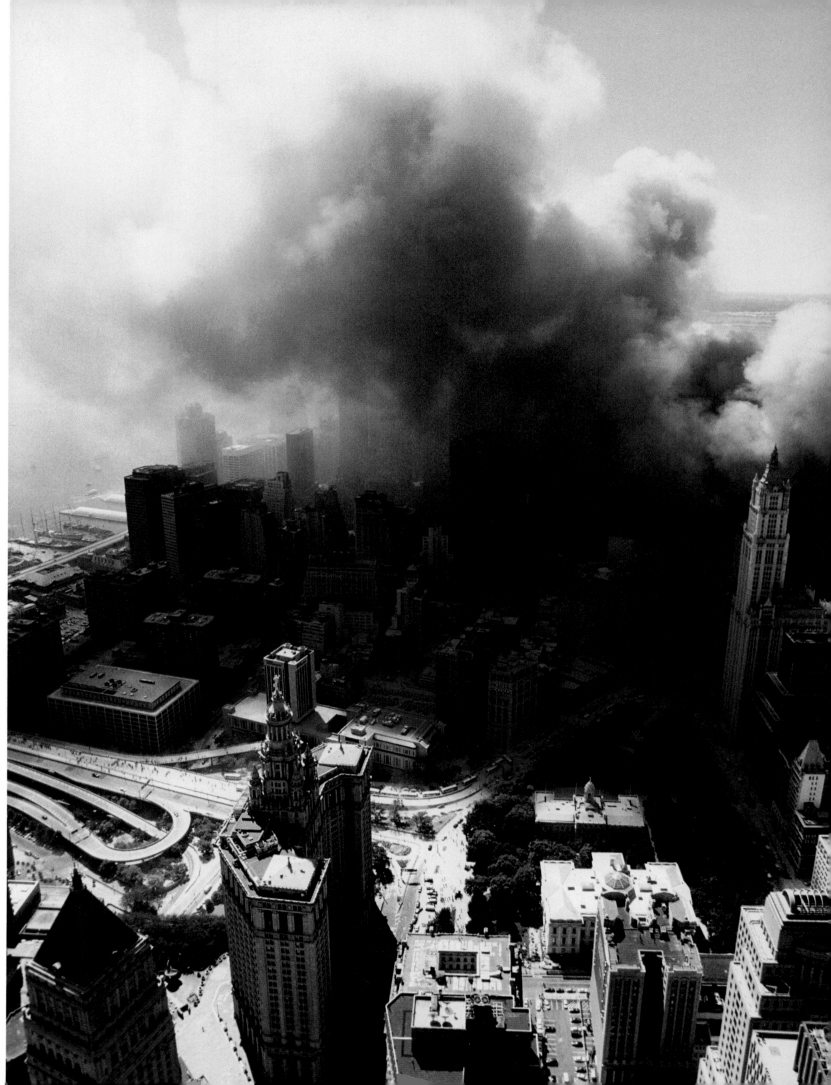

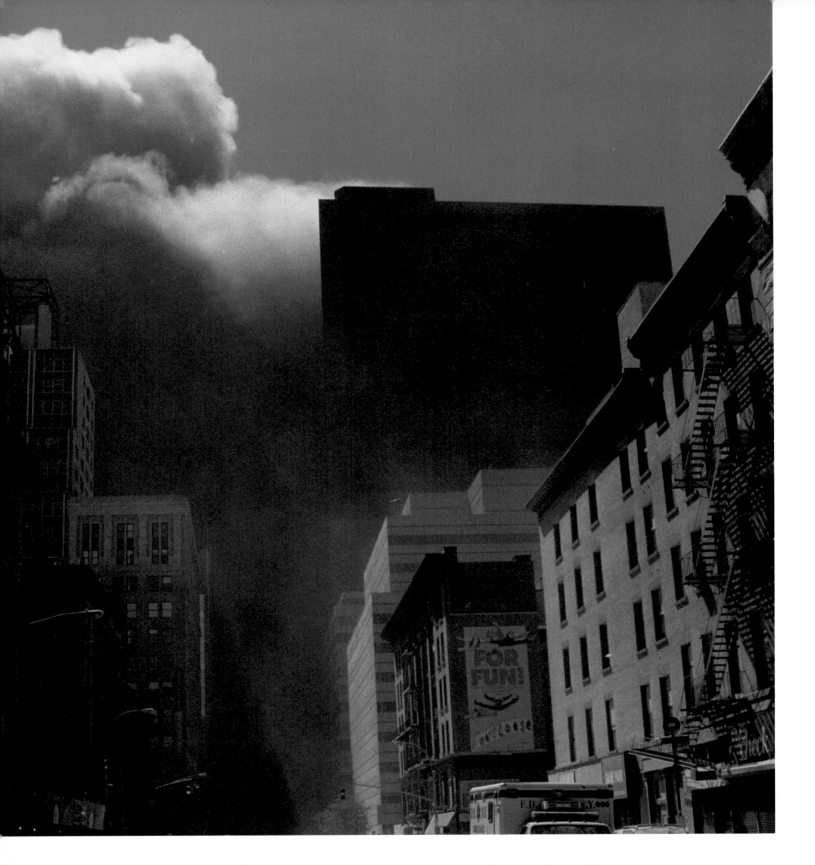

Looking down West Broadway toward Ground Zero. Building 7 looms up against the smoke and sky.

OPPOSITE: To the right, Building 7 of the World Trade Center. The fires that would bring it down later in the day are visible on one of the lower floors. Over the hours, the flames crept across the length of the building.

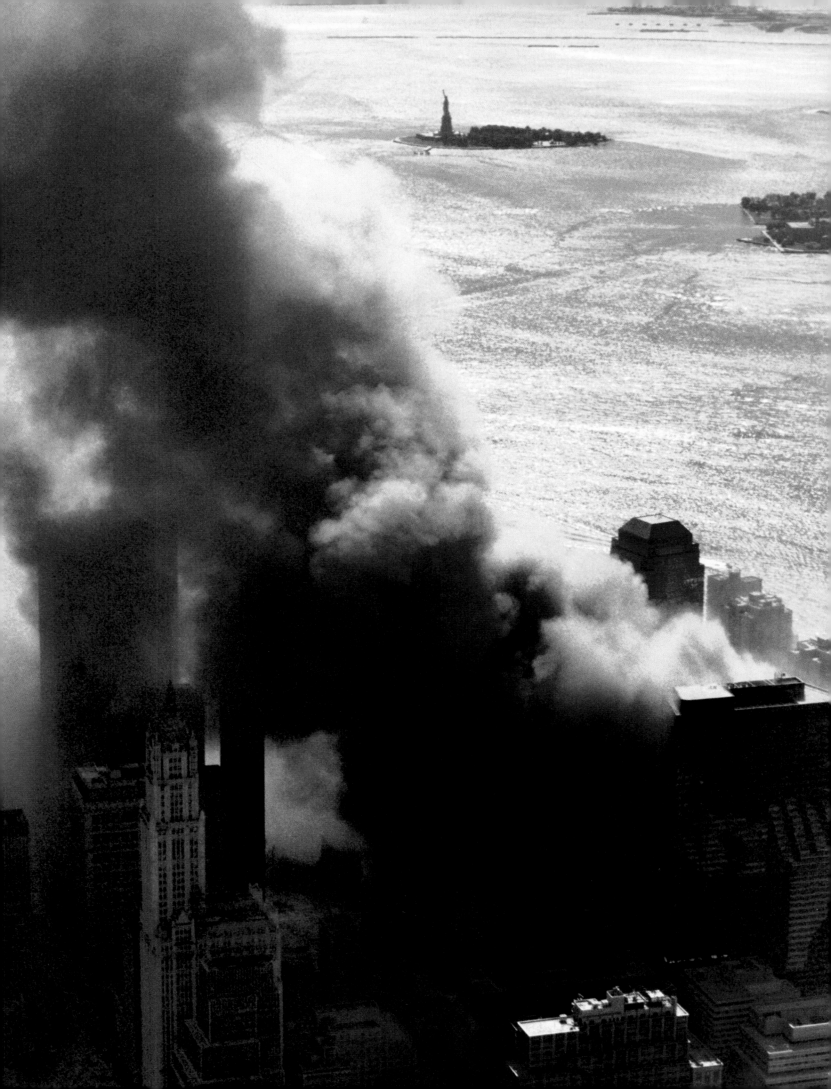

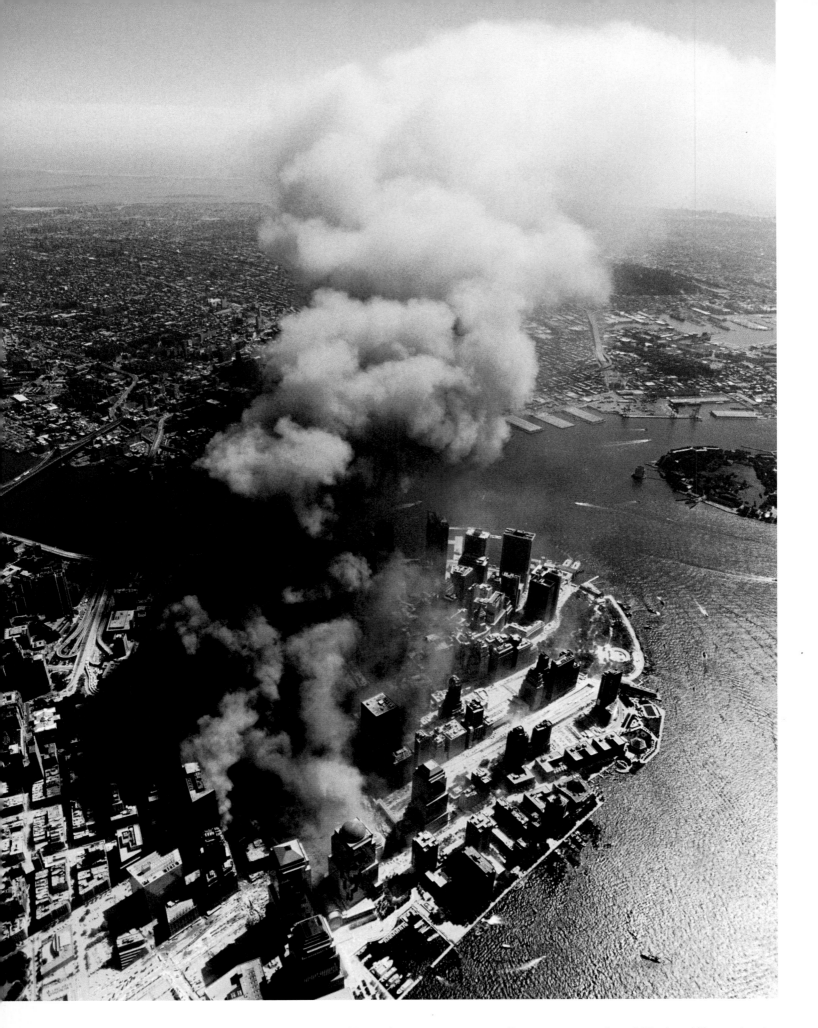

Lower Manhattan blanketed with dust and choked with smoke.　　OPPOSITE: Rescuers regrouping at West and Vesey streets.

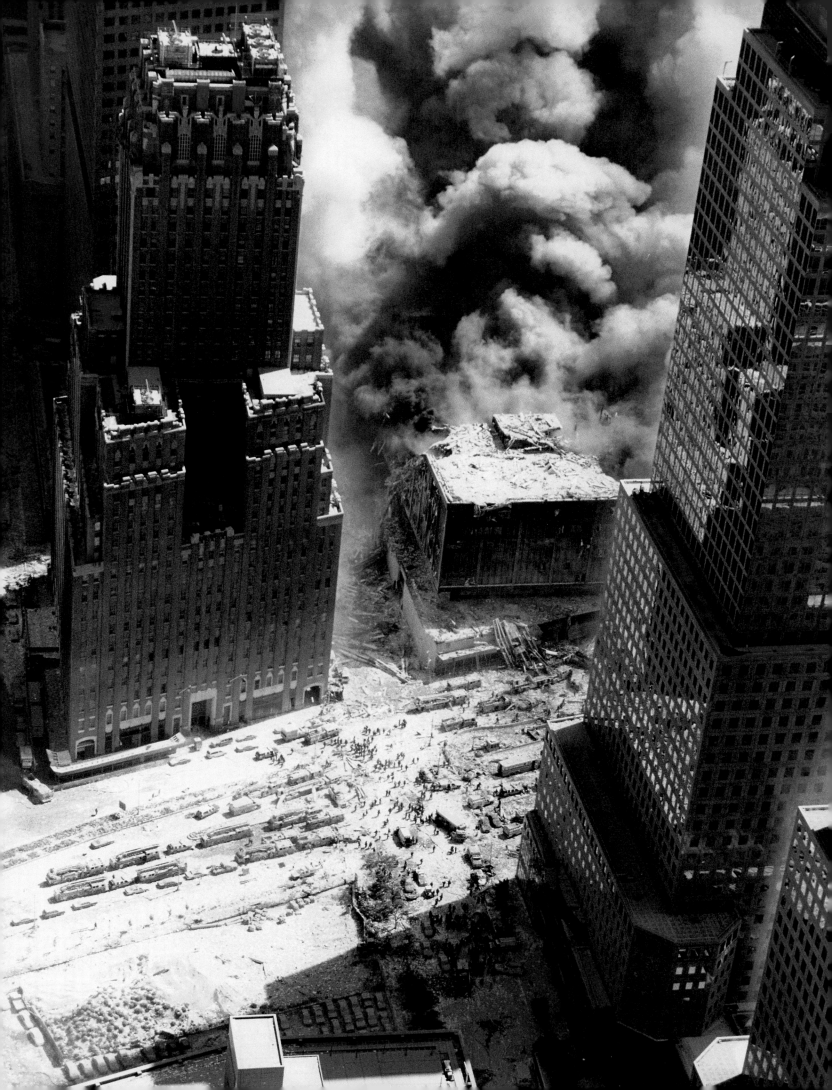

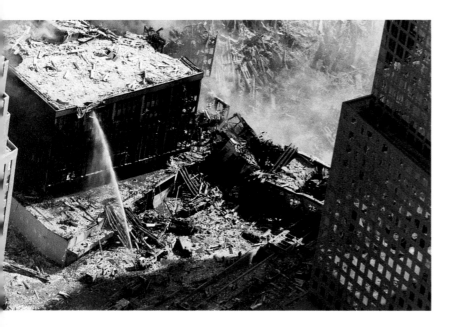

Building 6 of the World Trade Center on fire and the ruins of the North Bridge. Firefighters and rescue workers make their way into Ground Zero over the collapsed façade.

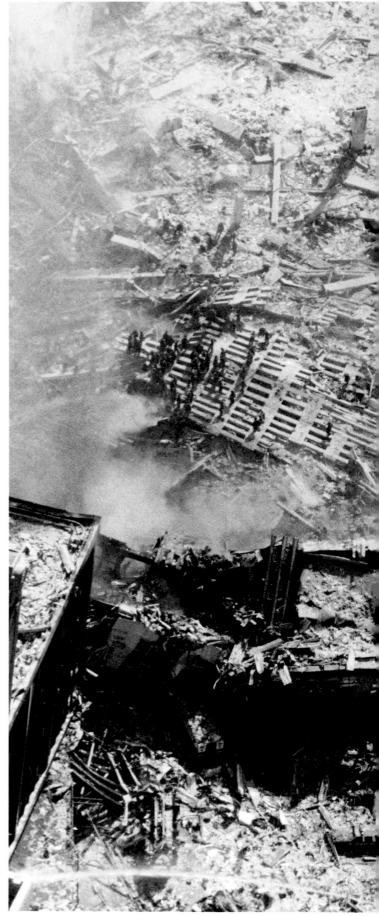

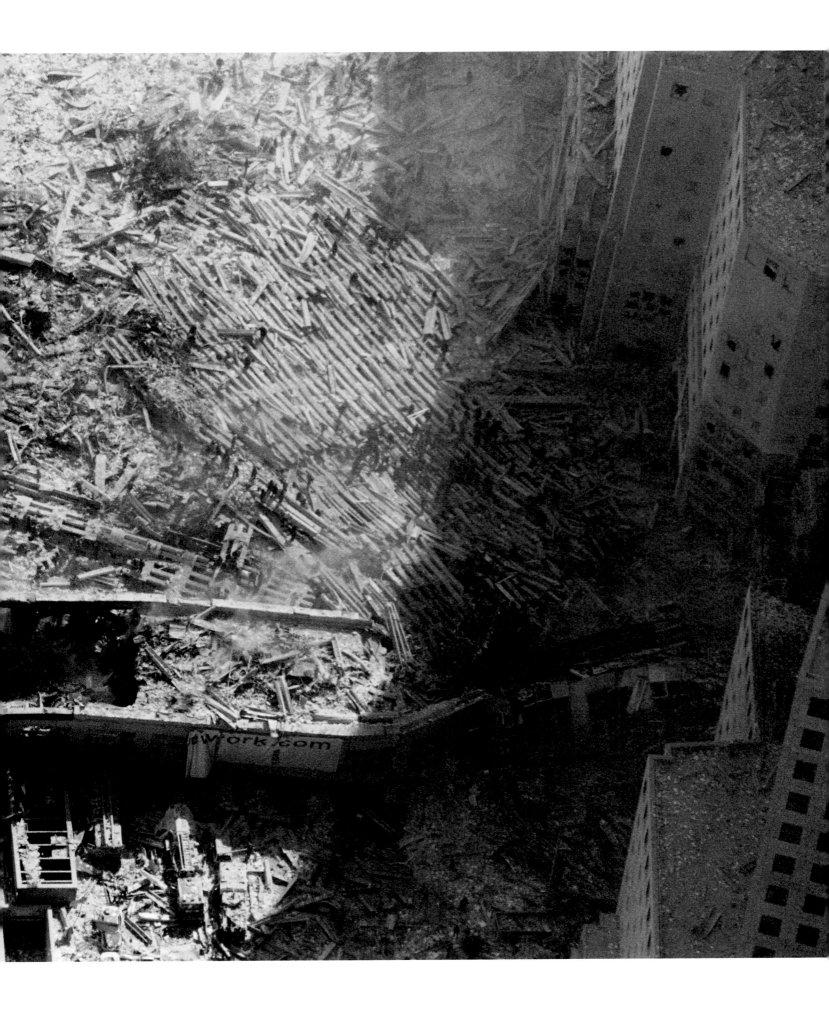

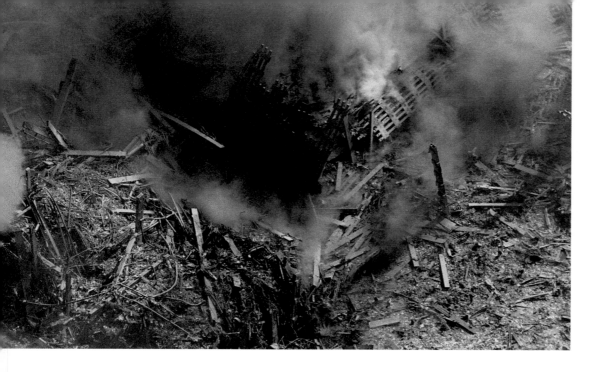

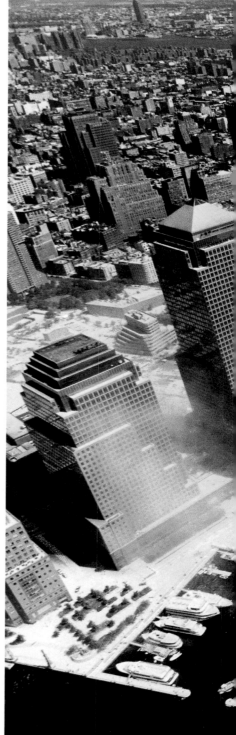

Ground Zero from the air. Bits of the façade that remained upright jut through the smoke.

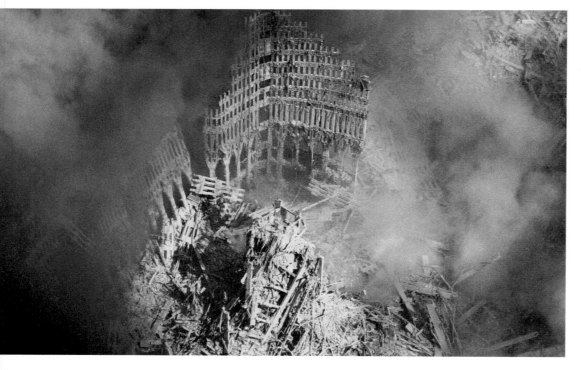

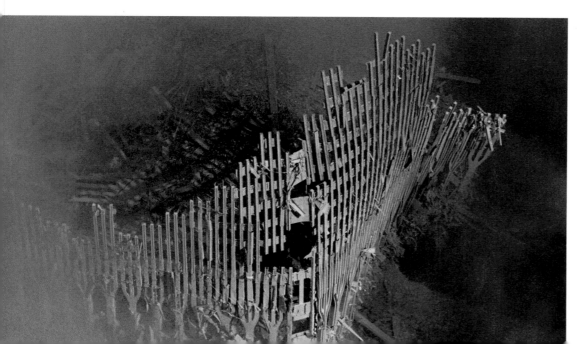

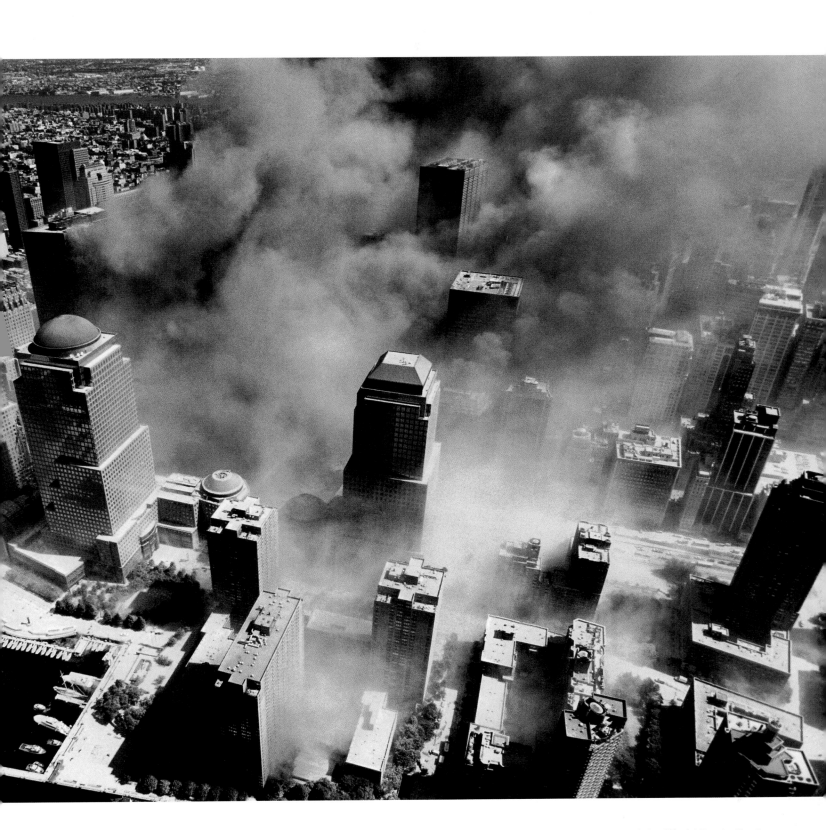

The World Financial Center along the western side of the ruins of the World Trade Center.

OVERLEAF: Over New York Harbor, still looking for incoming planes.

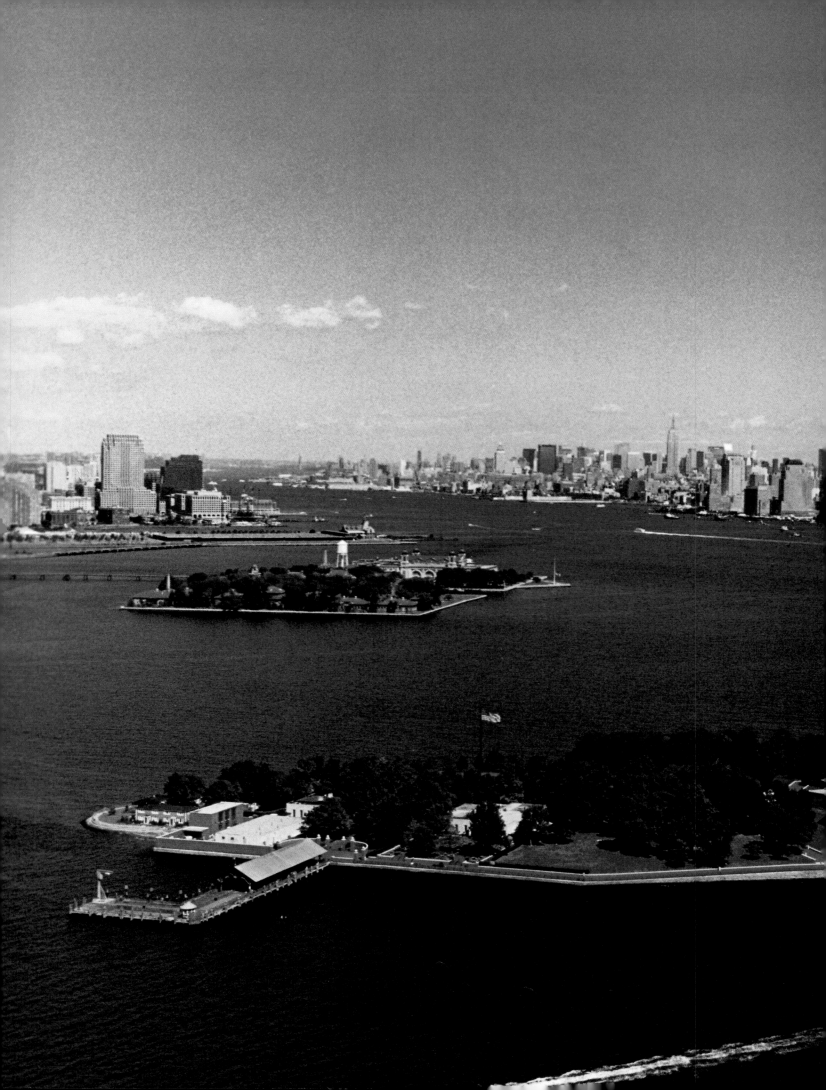

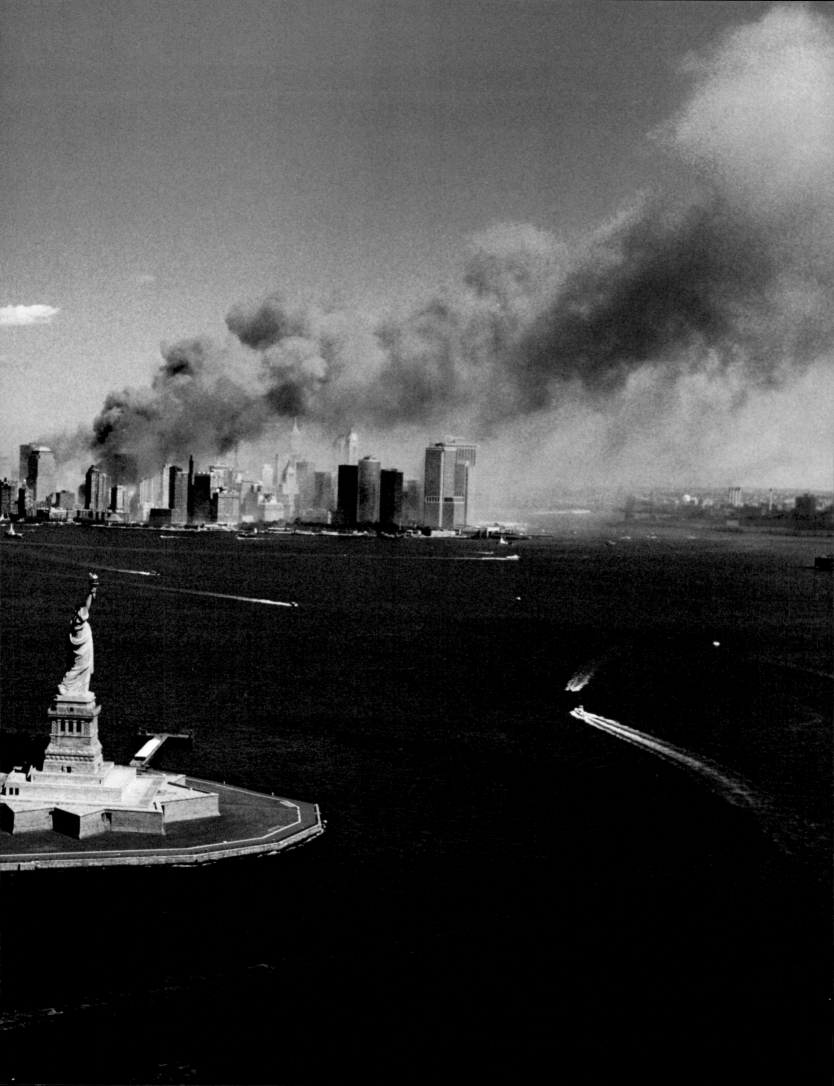

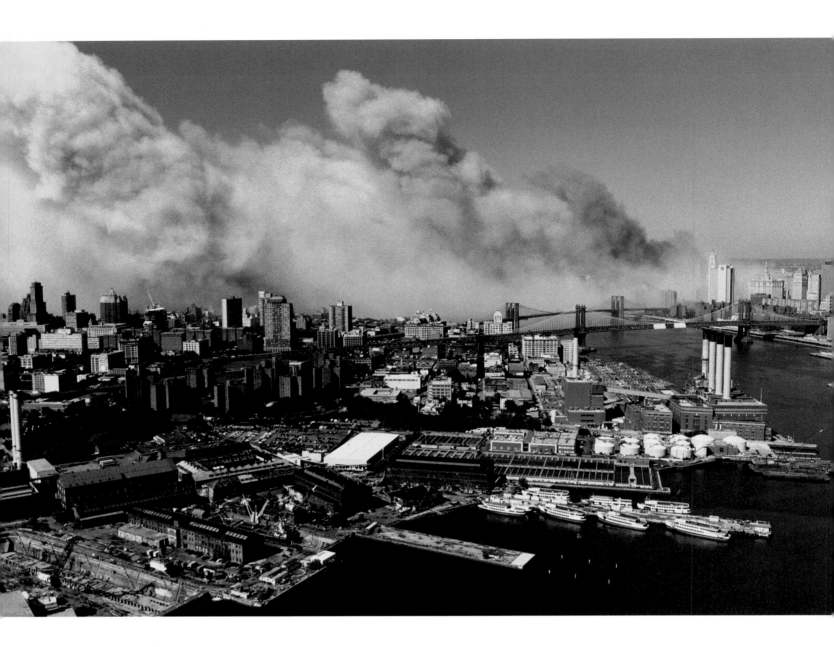

Circling all the way around the vast cloud of smoke spreading over Brooklyn.
Office paper floated in the air outside the windows of the helicopter.
The Brooklyn Navy Yard is in the foreground.

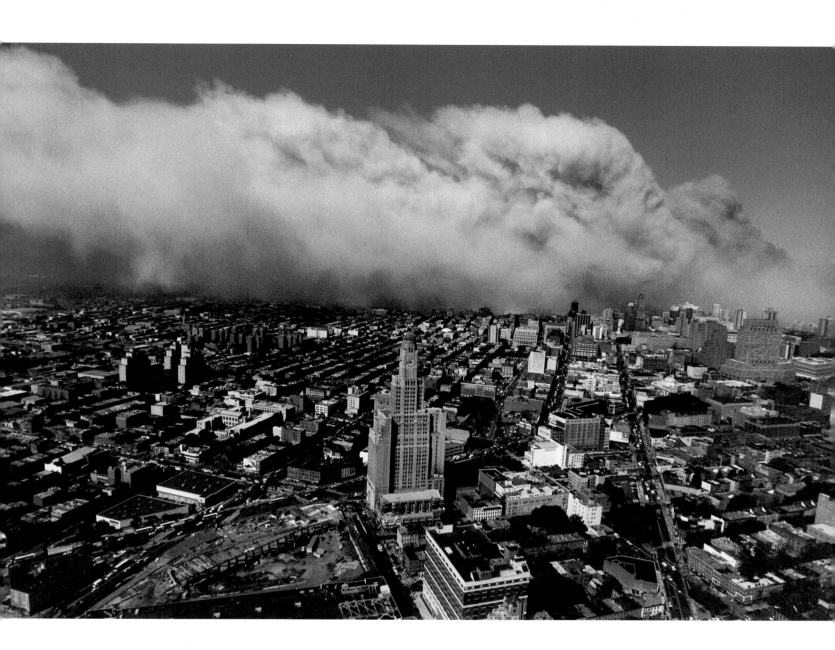

Farther out over Brooklyn. The Williamsburg Bank Building is in the foreground.

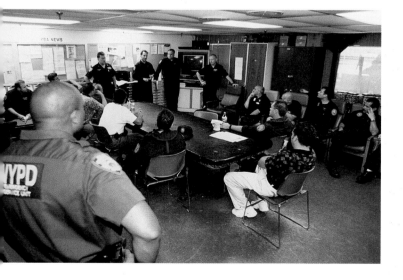

Between flights. A briefing to coordinate aviation units from Nassau and Suffolk counties and New York State troopers, led by Captain Joseph Gallucci.

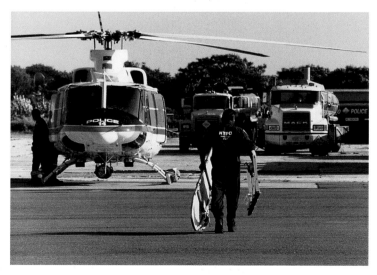

One of the pilots is getting ready for a medevac situation with an air-sea rescue ship.

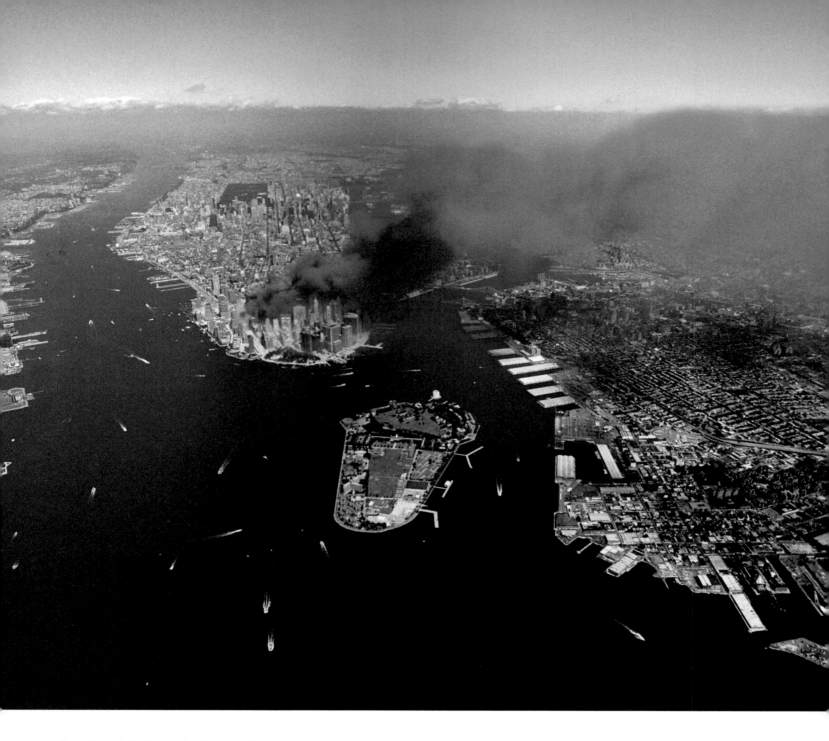

Over New York Harbor looking north, as high as the smoke, about 6,500 feet.

OPPOSITE: The bridges and tunnels were closed, so ferries carried people across the river to New Jersey.

OVERLEAF: Looking down from above lower Manhattan: the financial district, Tribeca, Soho, Chinatown, Little Italy, and the Lower East Side. The patch of green in the foreground by the Hudson River was a medevac site. An NYPD helicopter is there on the ground.

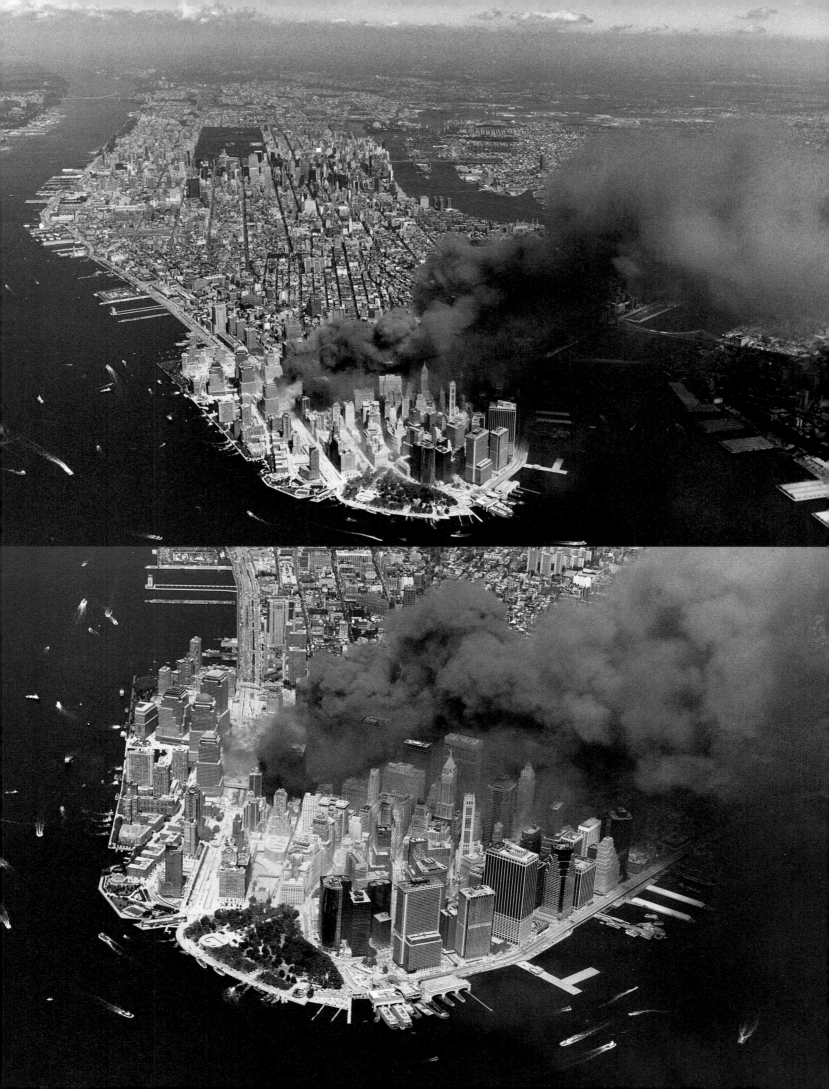

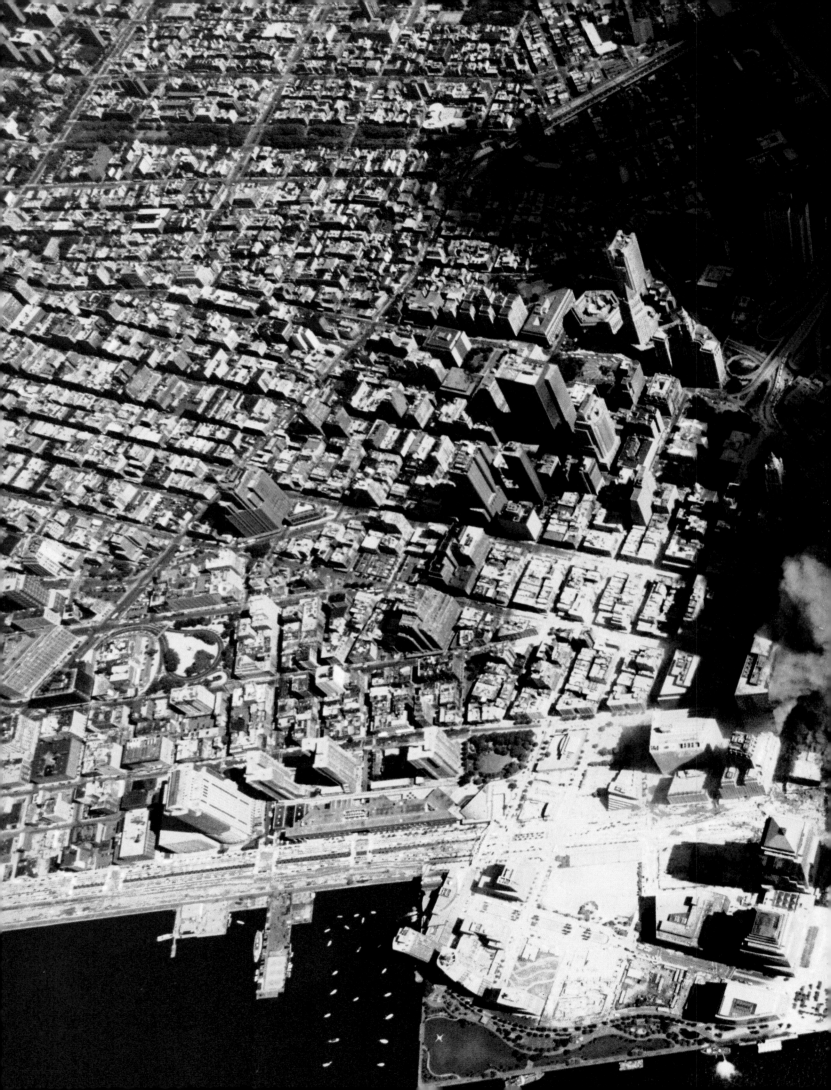

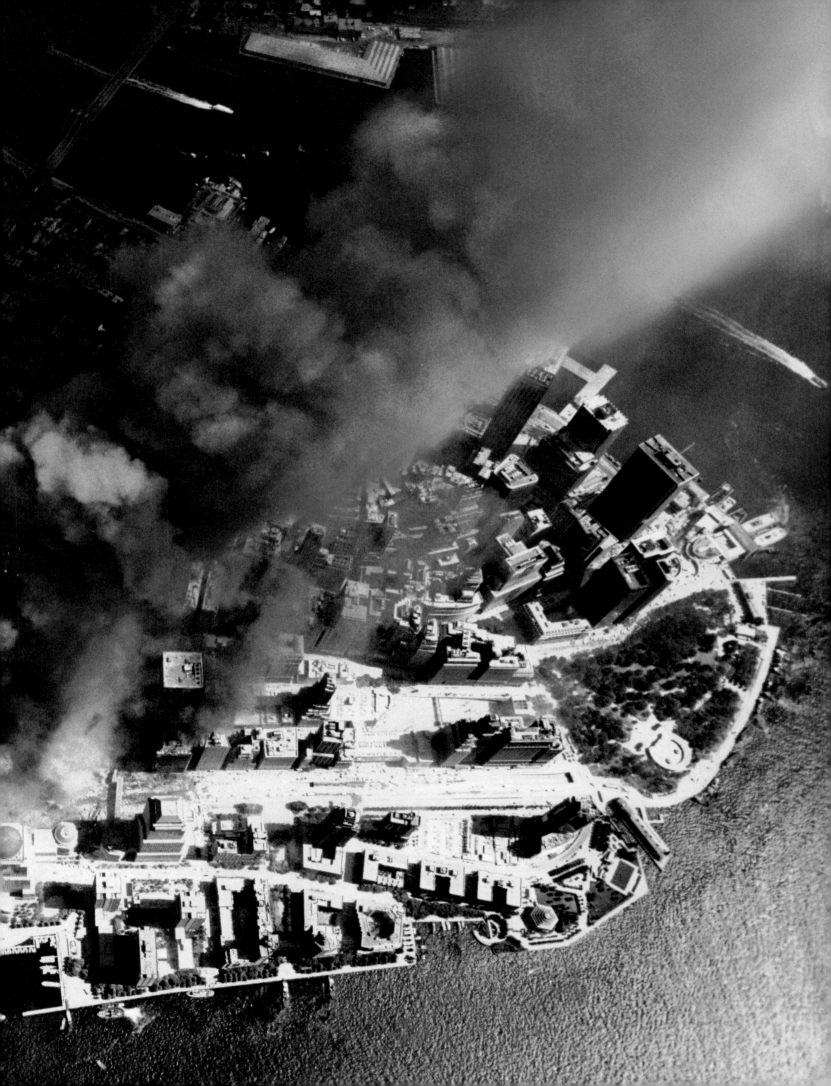

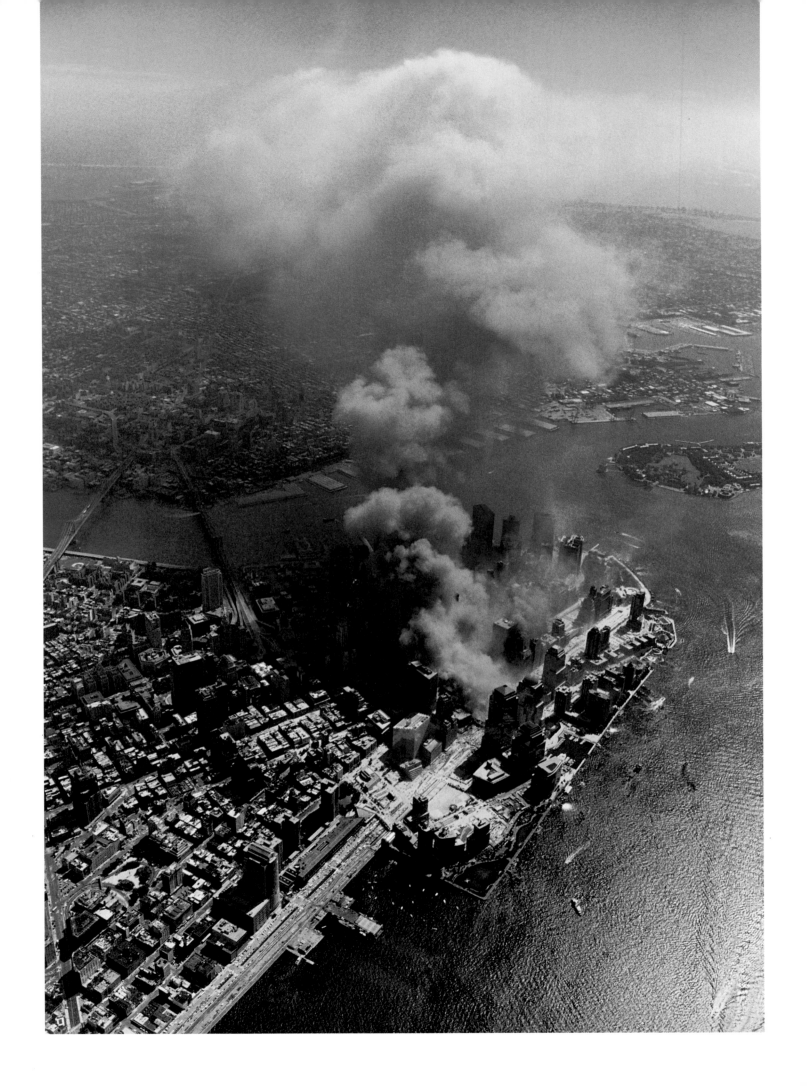

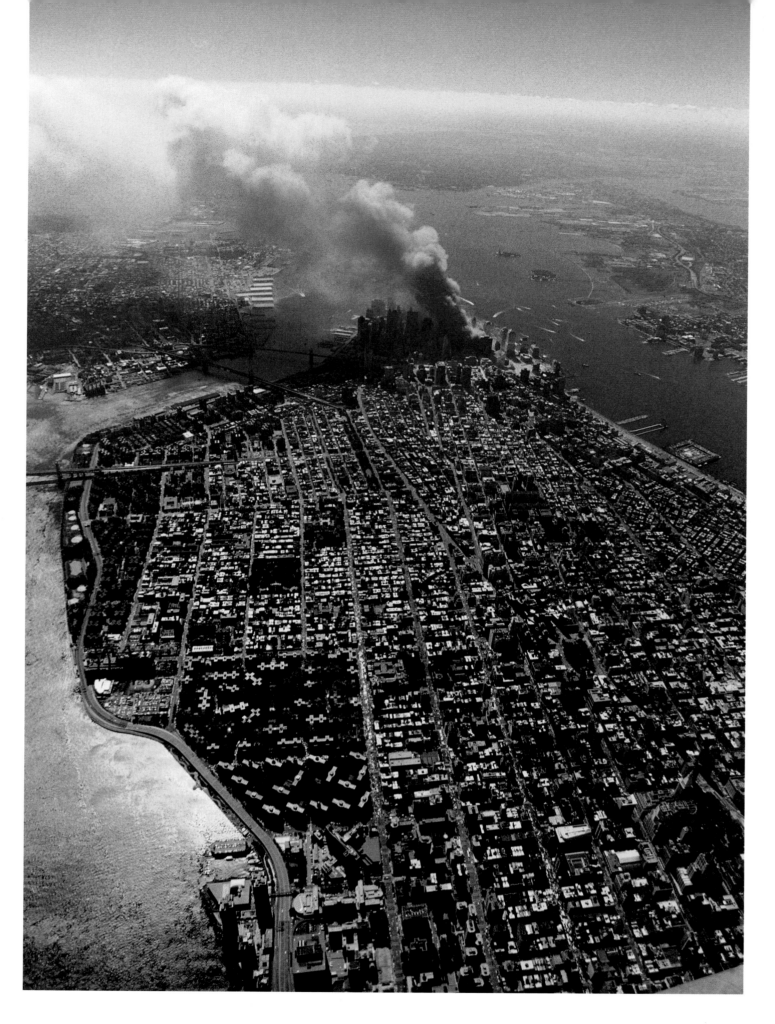

The view from above the East Twenties.

On the lookout for two remaining planes that were unaccounted for just before an F-15 roared past.

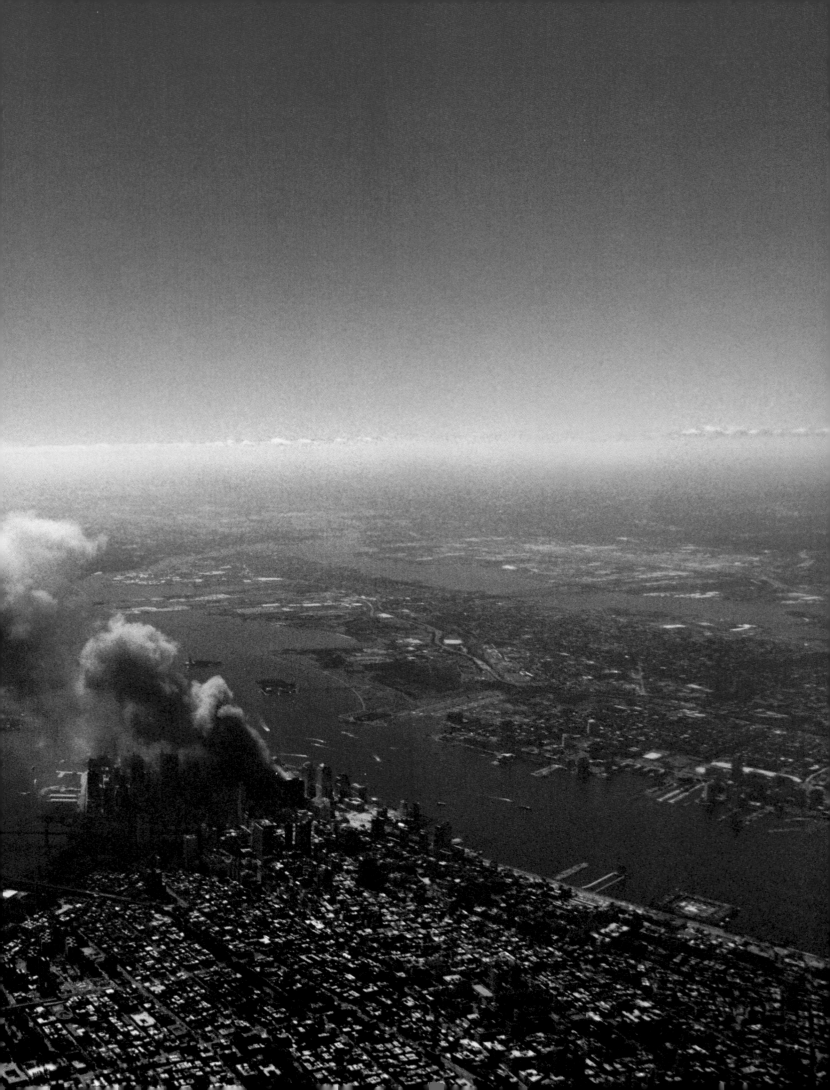

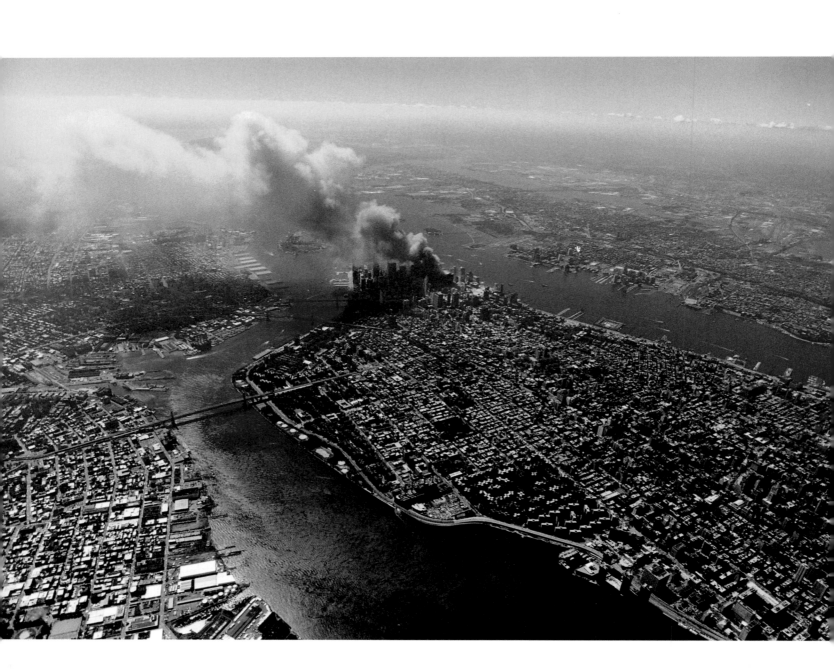

Lower Manhattan from over Brooklyn near the border to Queens.

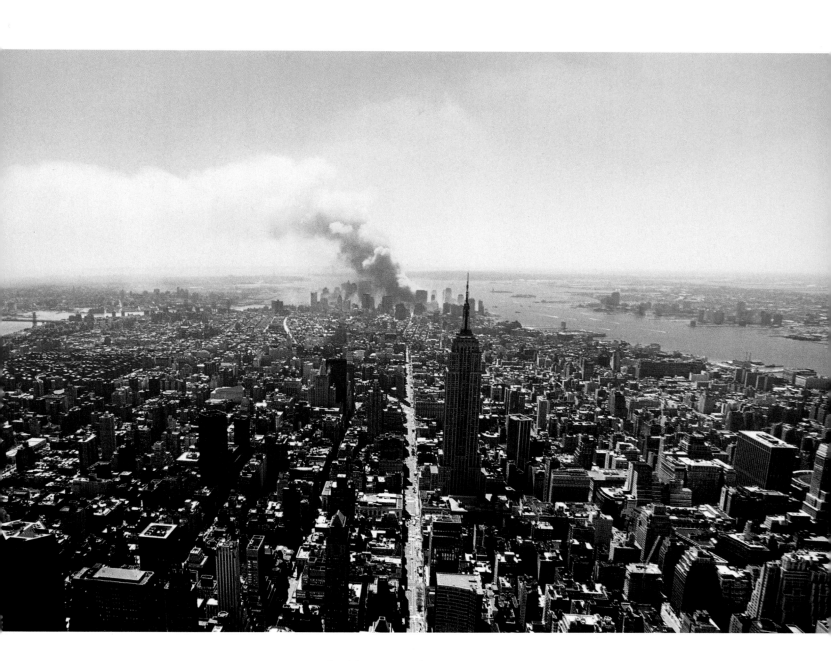

Looking down Fifth Avenue.

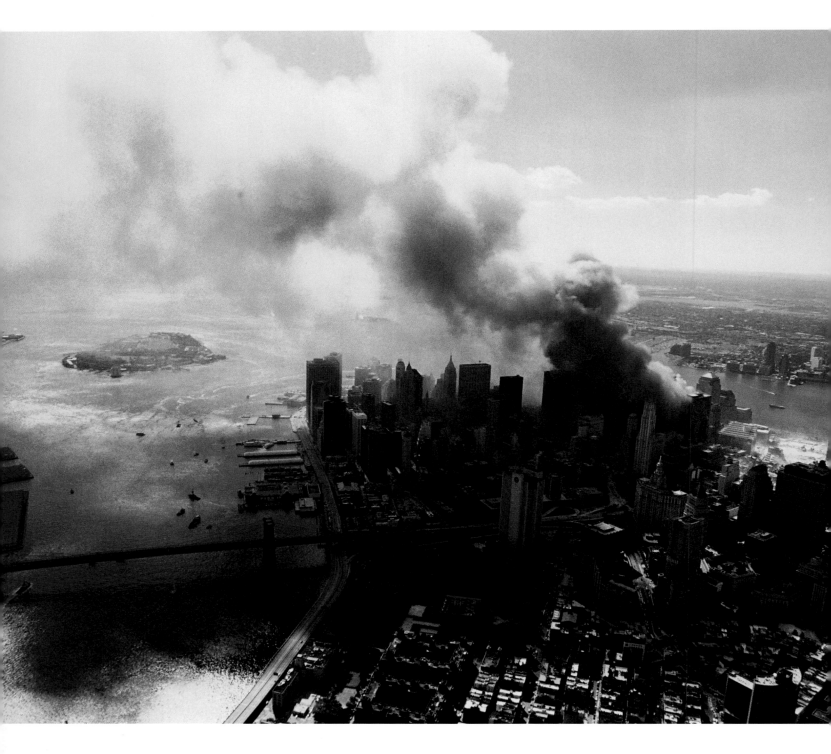

South Street Seaport on the East River, just above the Brooklyn Bridge.

OPPOSITE: Circling back to Ground Zero. Building 7 is still standing.

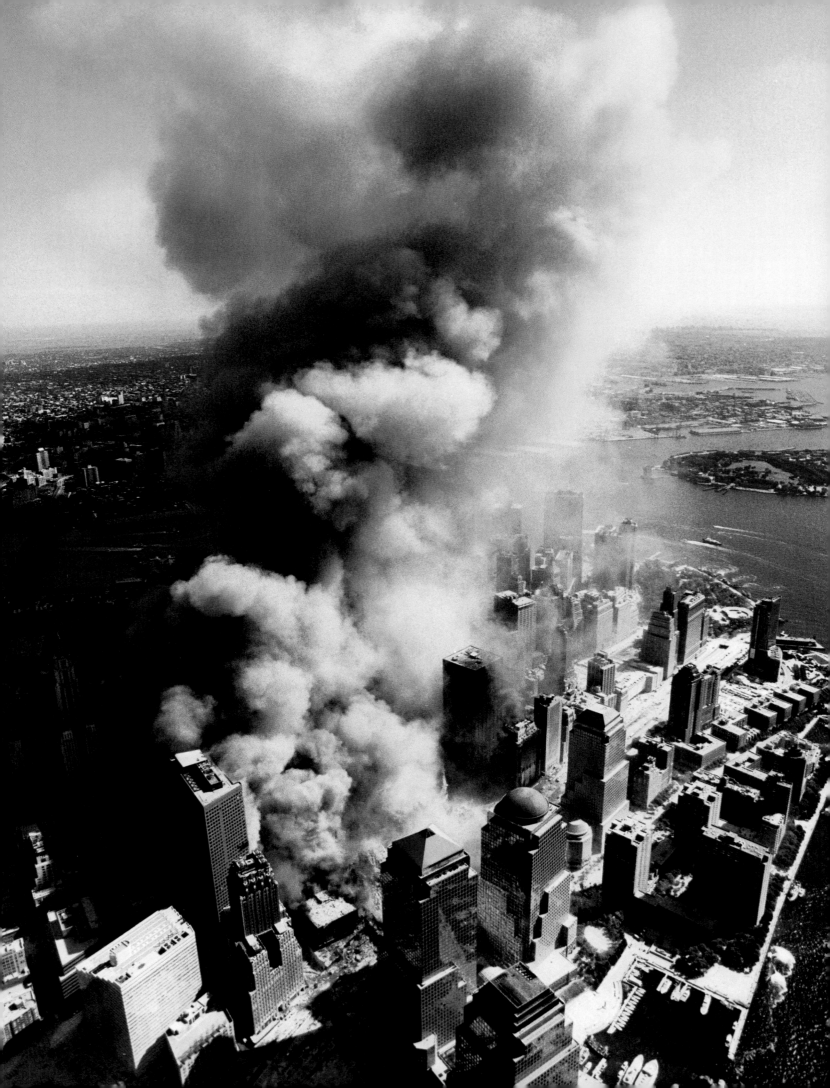

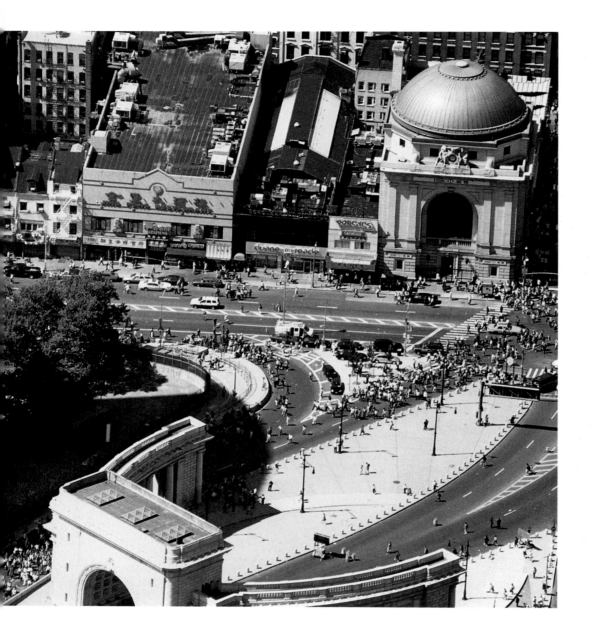

Canal Street at the ramp to the Manhattan Bridge.

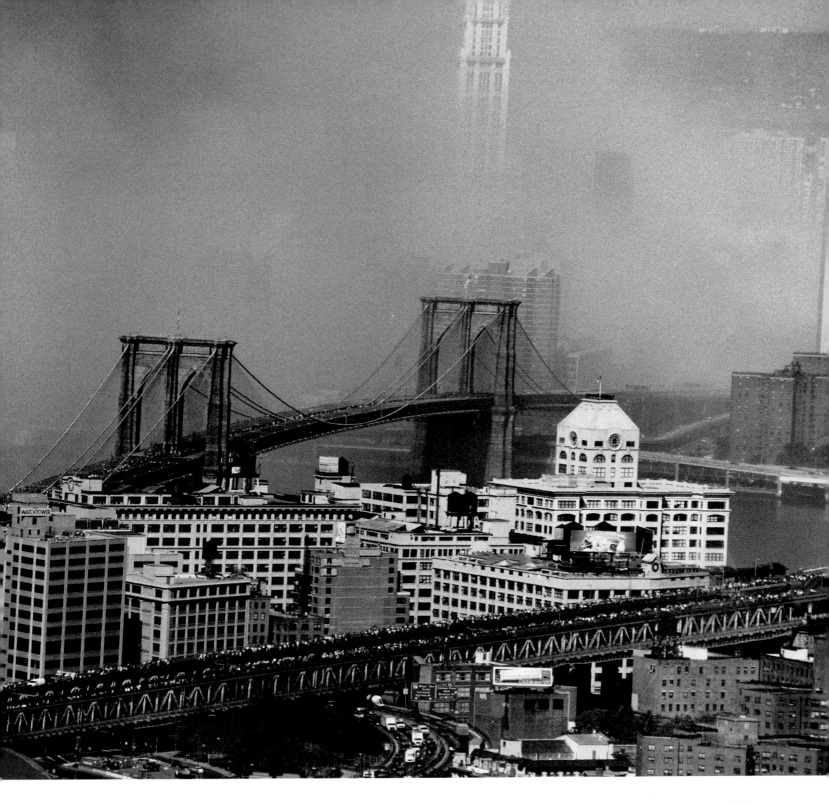

People streaming home across the Brooklyn and Manhattan bridges.

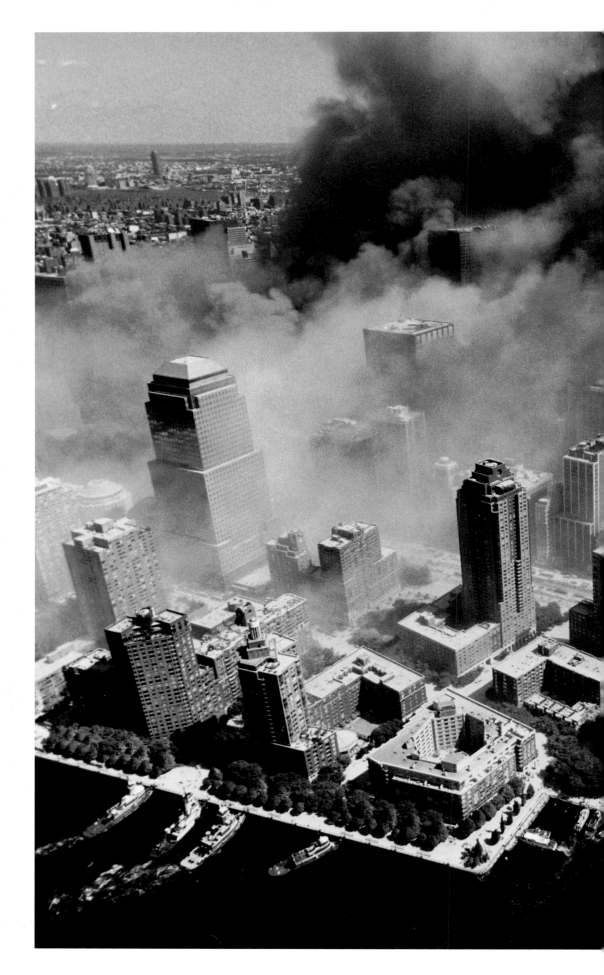

The tip of Manhattan coated in dust. From the right you can see Castle Clinton, the old fireboat pier, the Museum of Jewish Heritage, Battery Park City, and the Brooklyn-Battery Tunnel entrance. Tugboats are lined up along the shoreline to offer assistance.

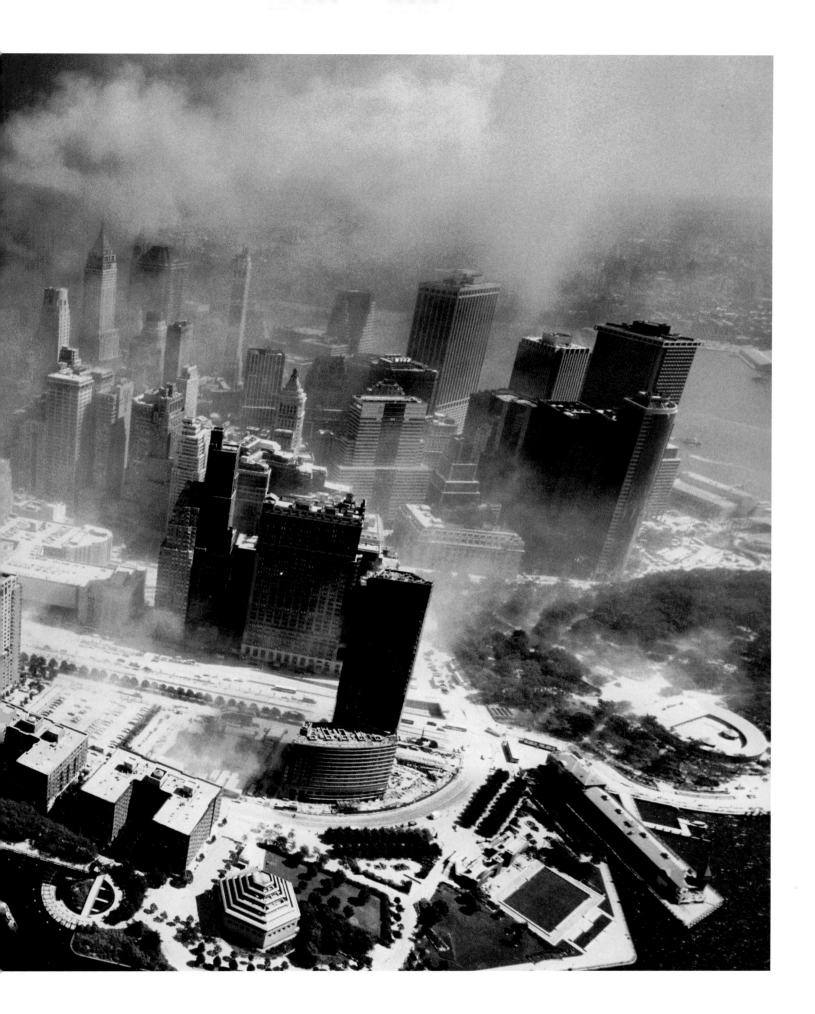

Building 7, next door to the Verizon Building on the lower right, came down at about 5:20 P.M., opening up this view of Ground Zero. Emergency personnel can be seen gathered in the upper right corner.

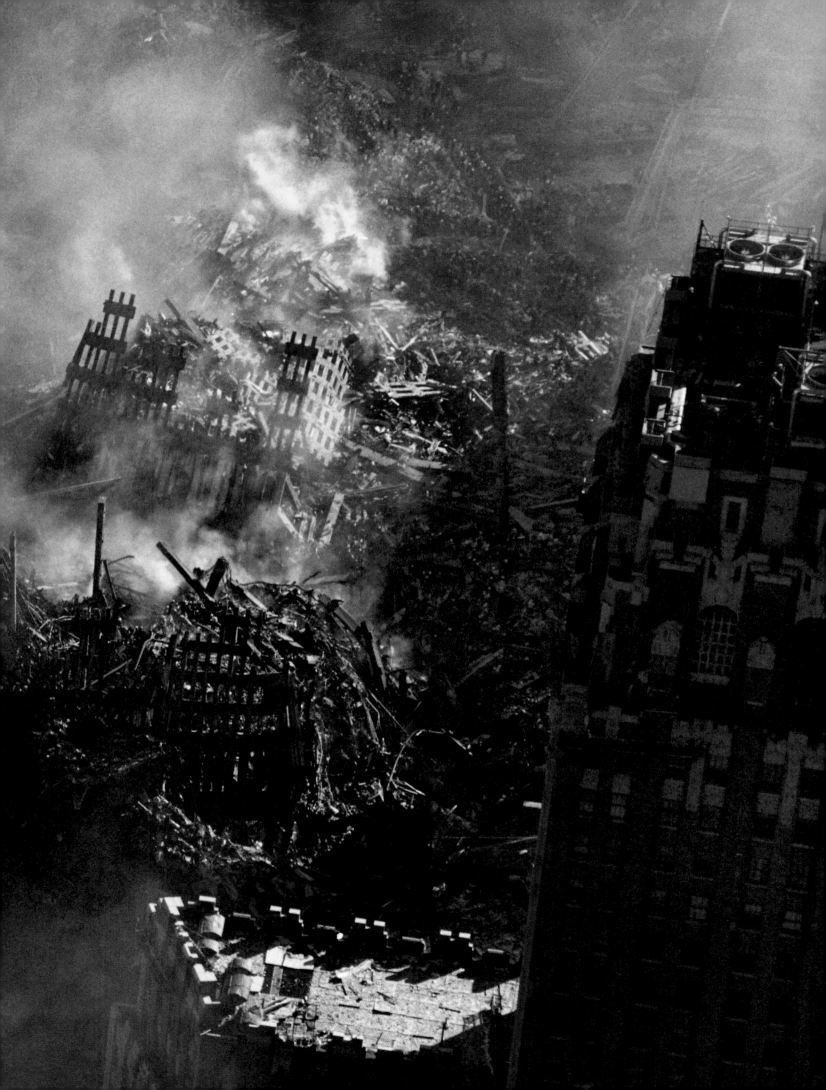

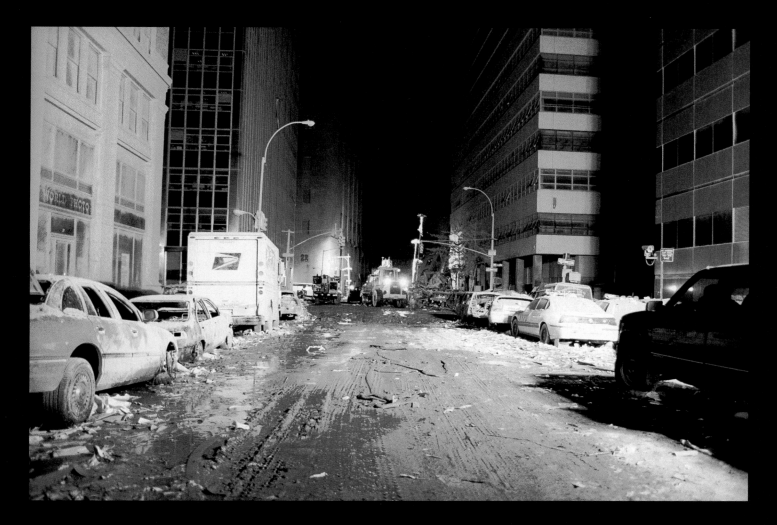

Looking down Washington Street, the night of September 11.

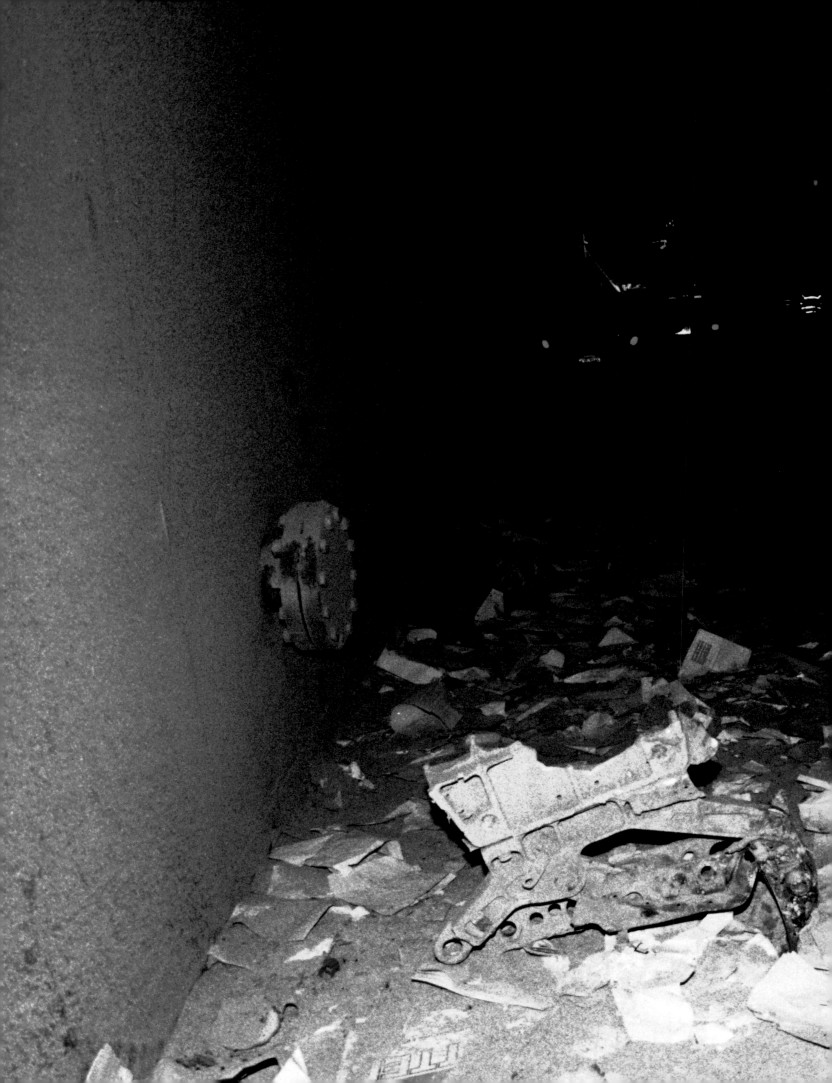

Dust inches thick and debris littered the streets. A fragment of one of the airplanes. In the distance the reflective stripes of firefighters' coats were illuminated by the flash.

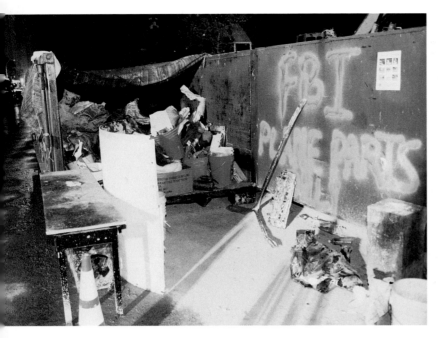

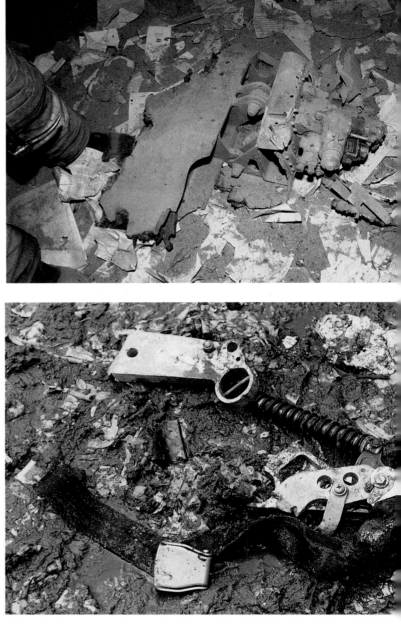

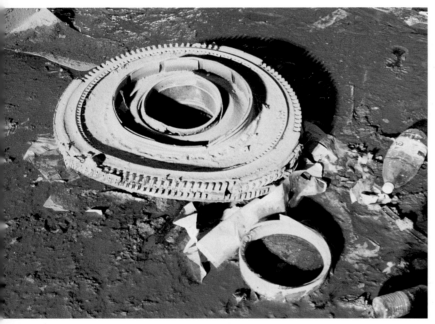

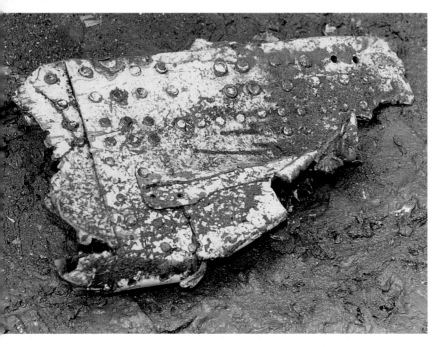

CLOCKWISE FROM TOP: The collection point for fragments of the airplanes that crashed into the towers.

An actuator from one of the planes.

A seatbelt at the corner of Church and Vesey streets.

A piece of the fuselage.

Part of an engine turbine.

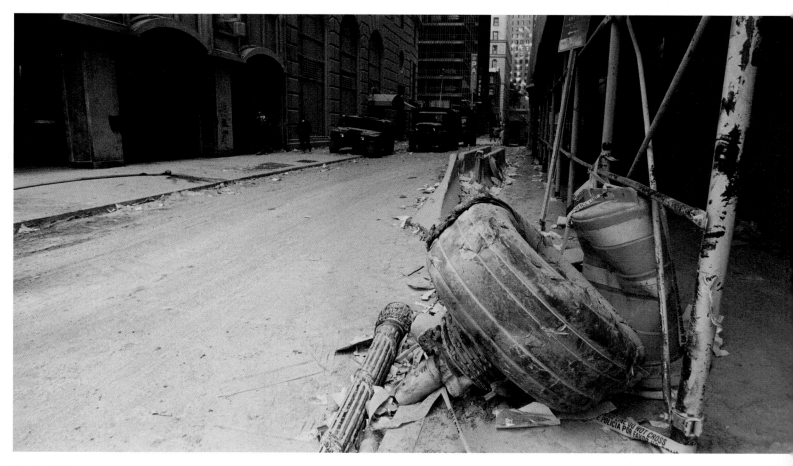

A wheel from one of the airliners, just off Church Street.

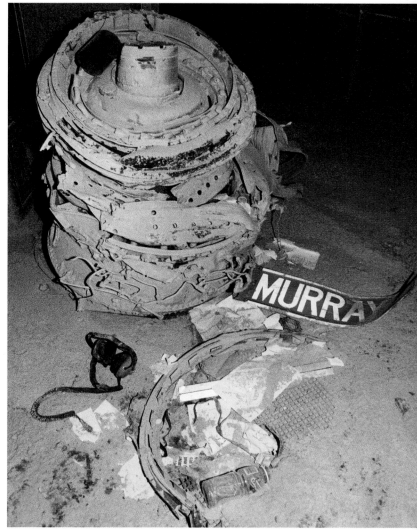

An airplane engine at the corner of
Murray and Church streets.

OVERLEAF: Approaching Ground Zero on foot
in the early morning hours of September 12.
Rescue services have been in position since
shortly after the attack.

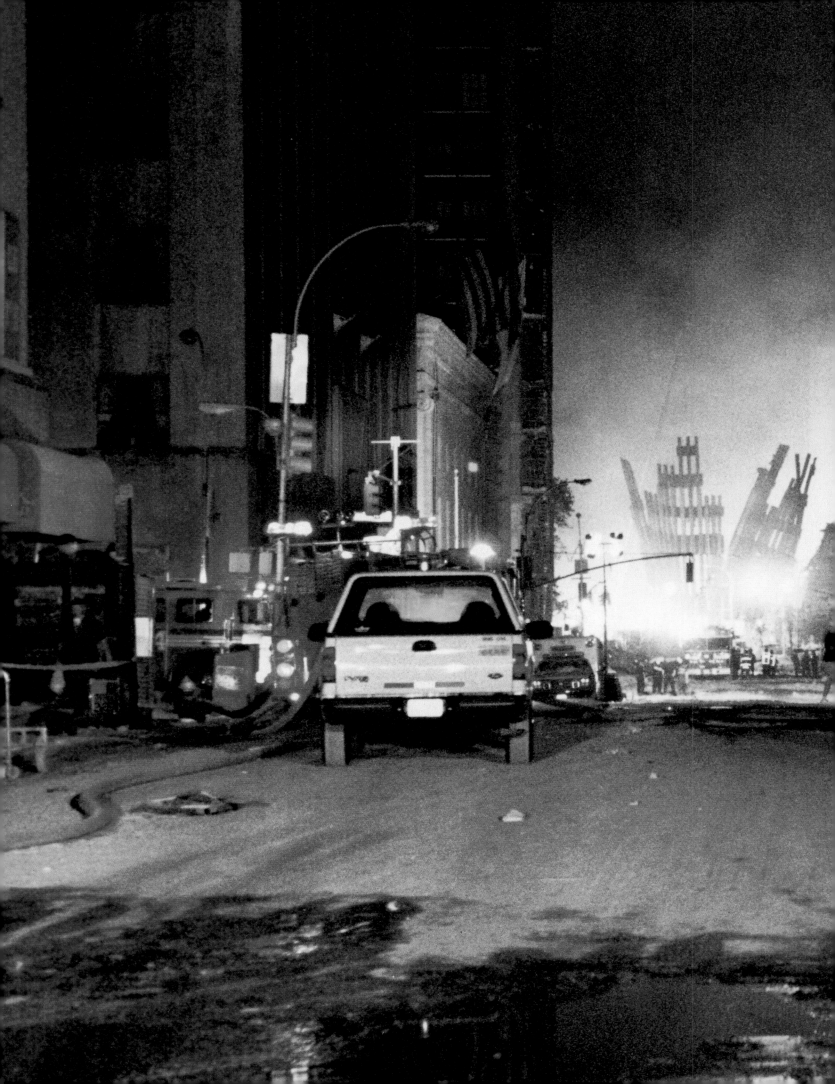

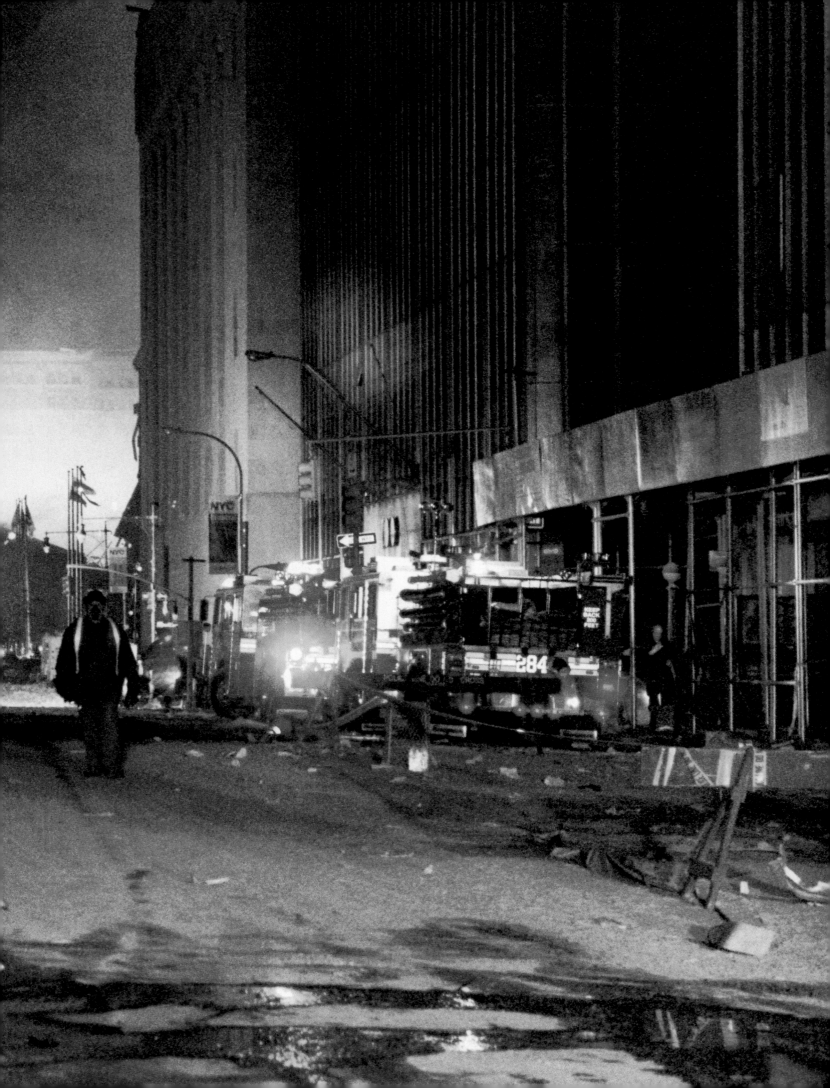

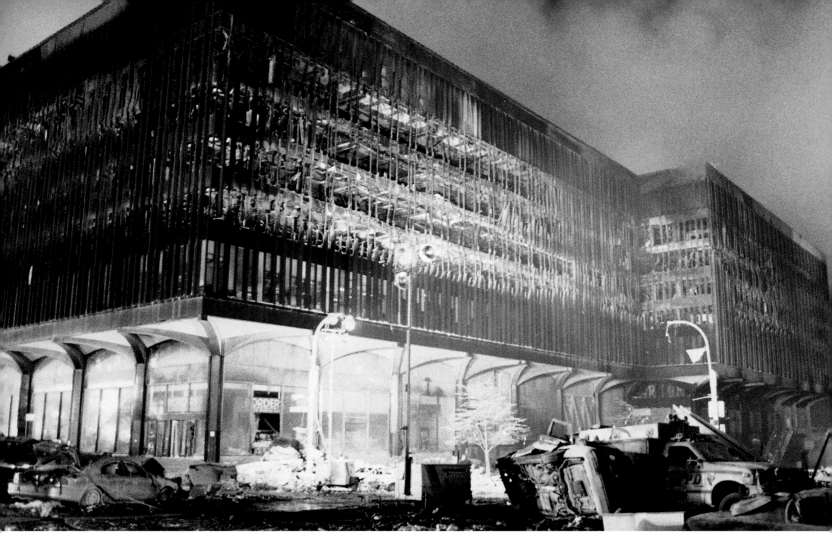

ABOVE: Building 5 of the World Trade Center, on Church Street. BELOW AND OPPOSITE: Along Church Street.

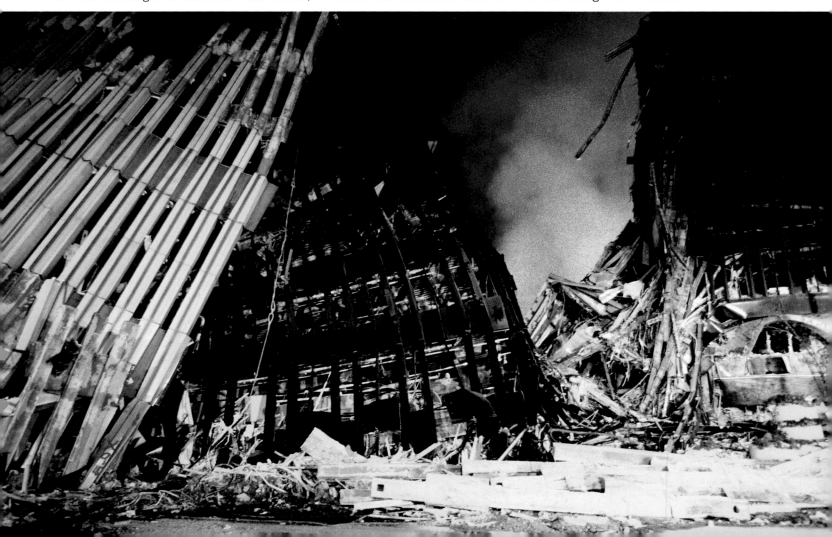

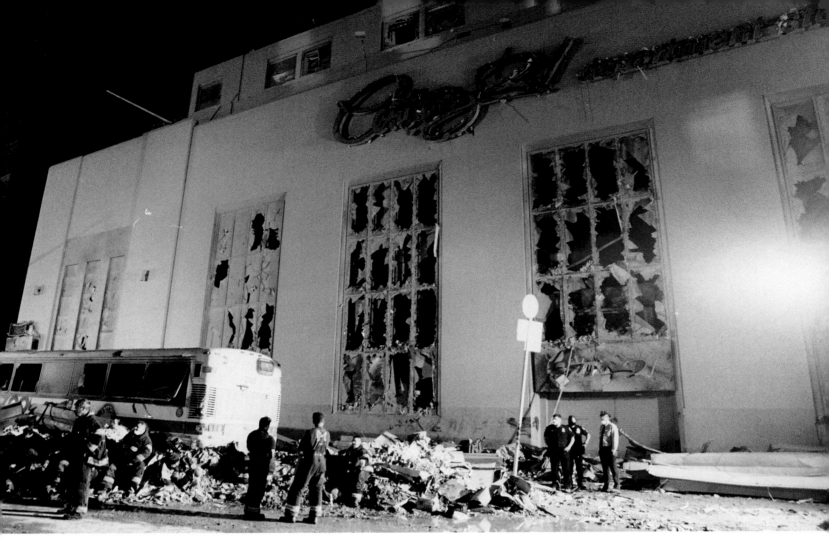

ABOVE: Century 21, at Church and Cortlandt streets, just across from the World Trade Center. BELOW: The Millenium Hilton.

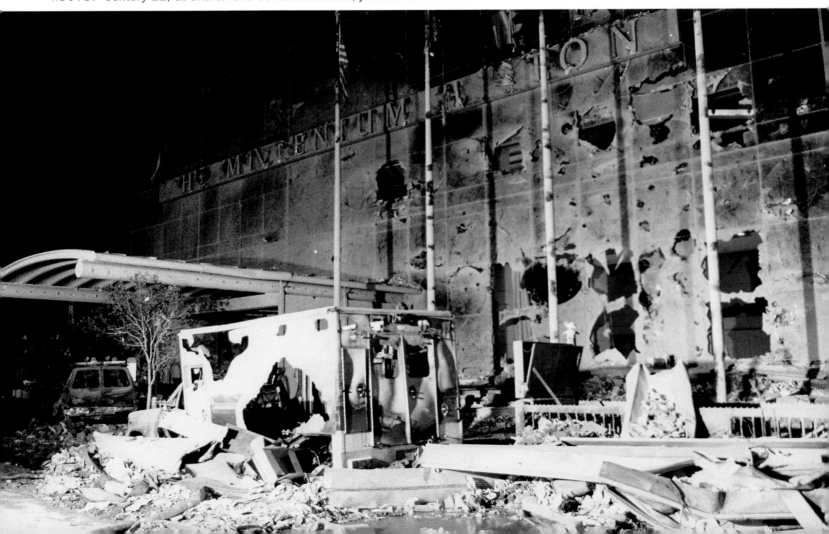

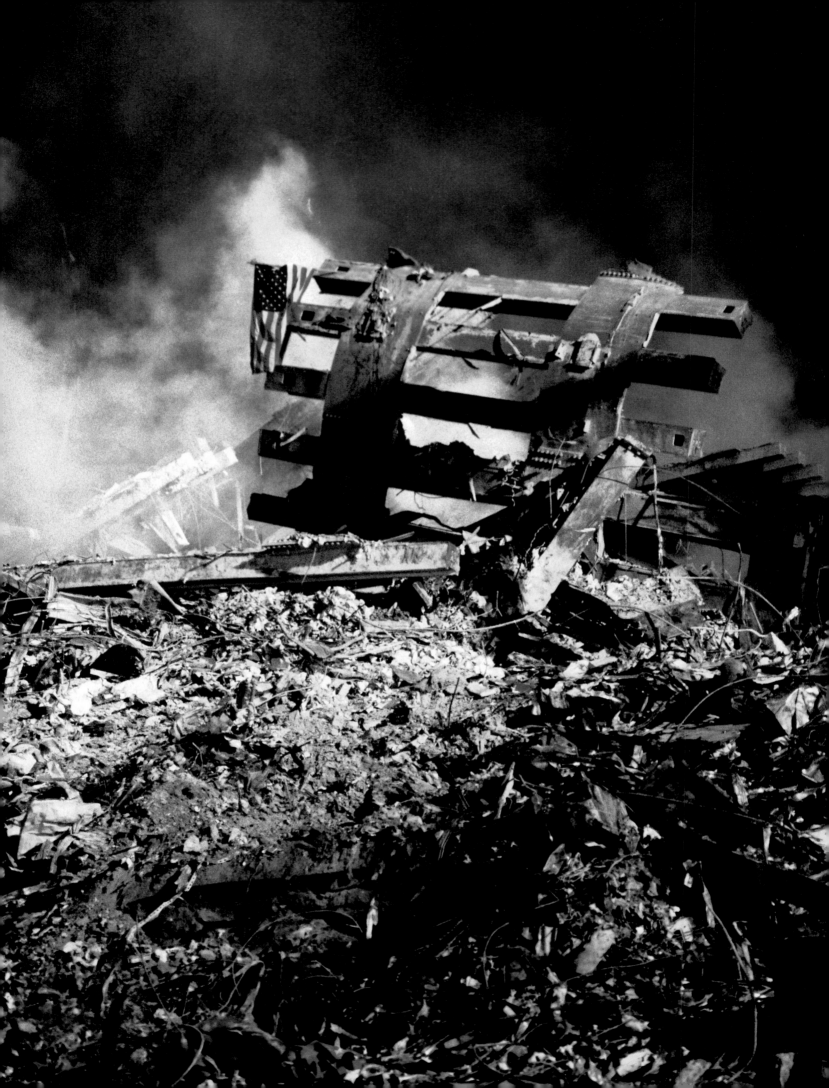

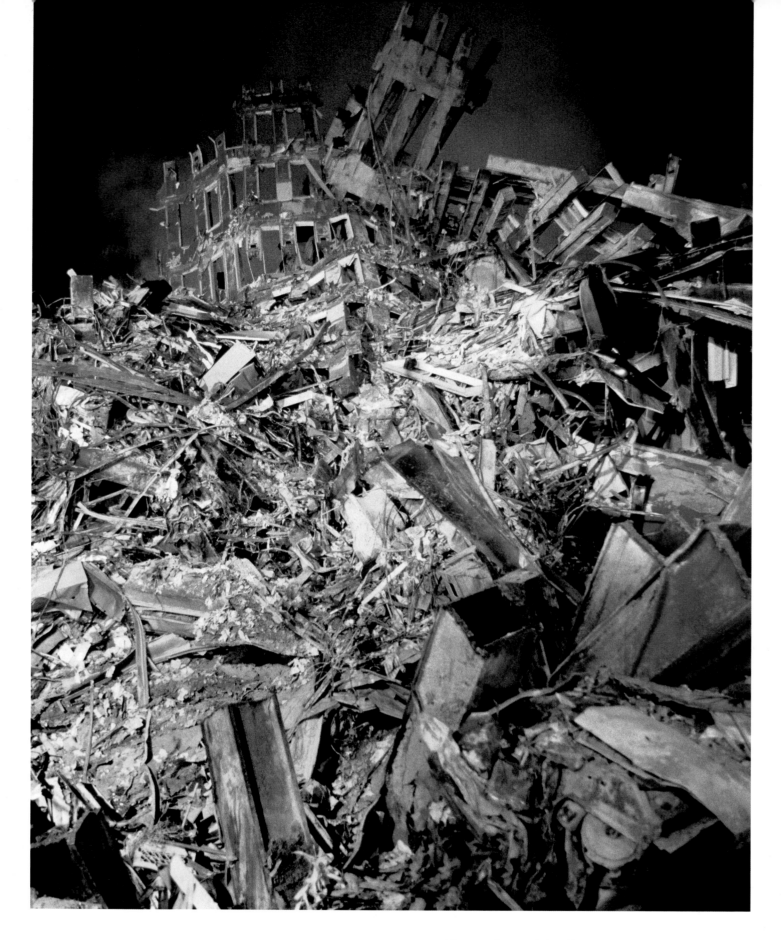

ABOVE AND OVERLEAF: The wreckage of the World Trade Center. Ground Zero.
It was almost beyond comprehension—the utter devastation.

OPPOSITE: It felt great to see this flag. We were down, but not out. The feeling of America's
pulling herself up by the bootstraps would only grow in the following days and weeks.

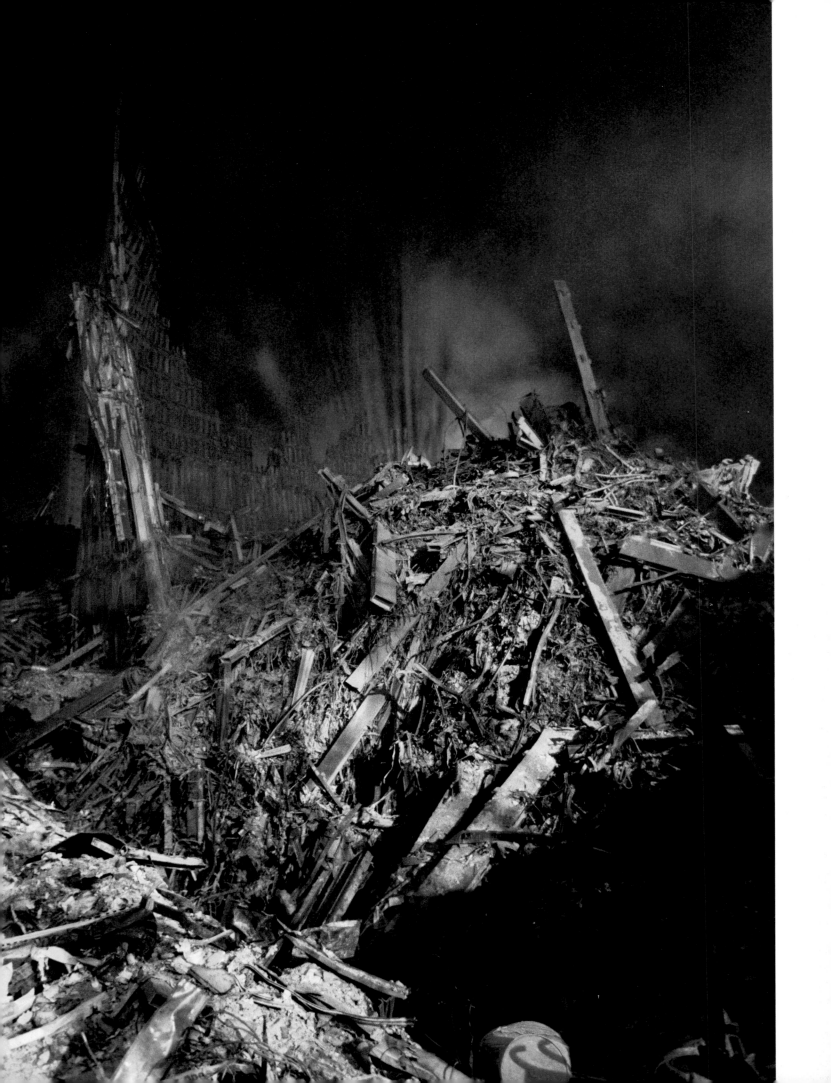

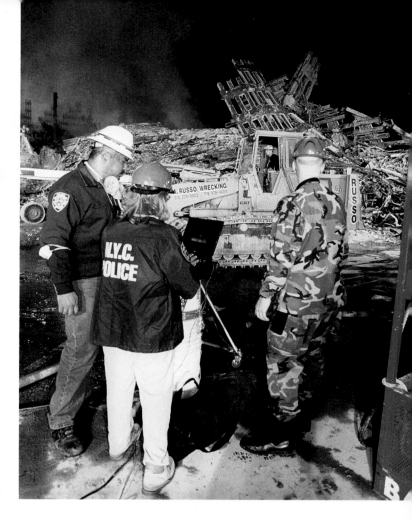

Detective Joe Martinez (*on the left*). They are trying to track and locate a cell-phone signal in the wreckage.

Search and rescue operations in the midst of the wreckage.

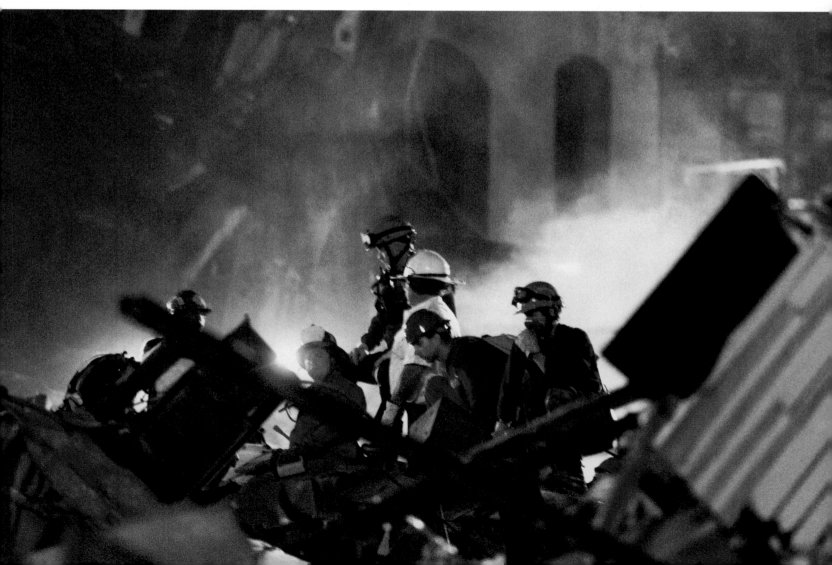

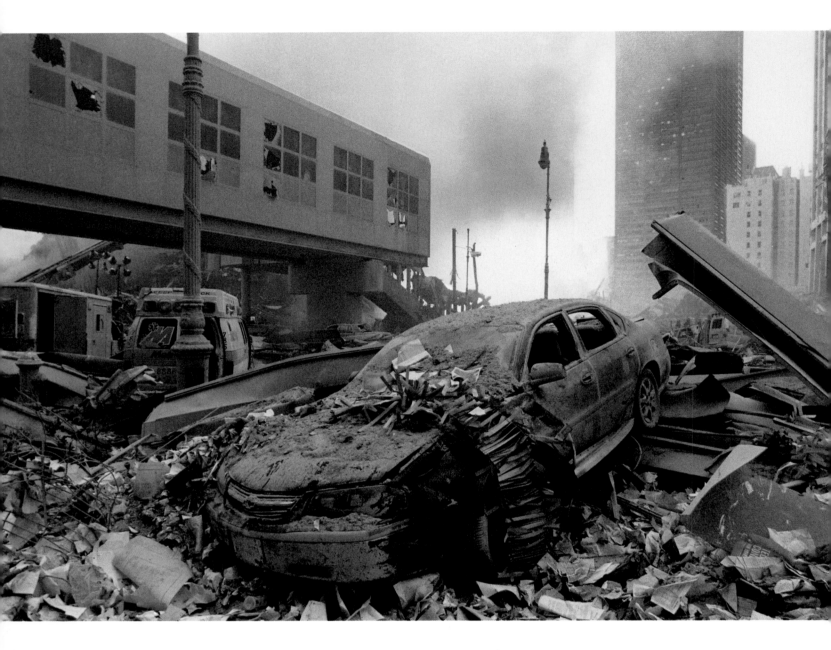

The South Bridge at West and Liberty streets, the southwest corner of the WTC complex.
Everything had an ominous orange glow to it as the morning sun couldn't fully pierce the heavy smoke.

OPPOSITE ABOVE: The plaza area. Part of the antenna from the north tower speared the ground.

OPPOSITE BELOW: This was the first flag-raising ceremony. No one thought to invite the media.

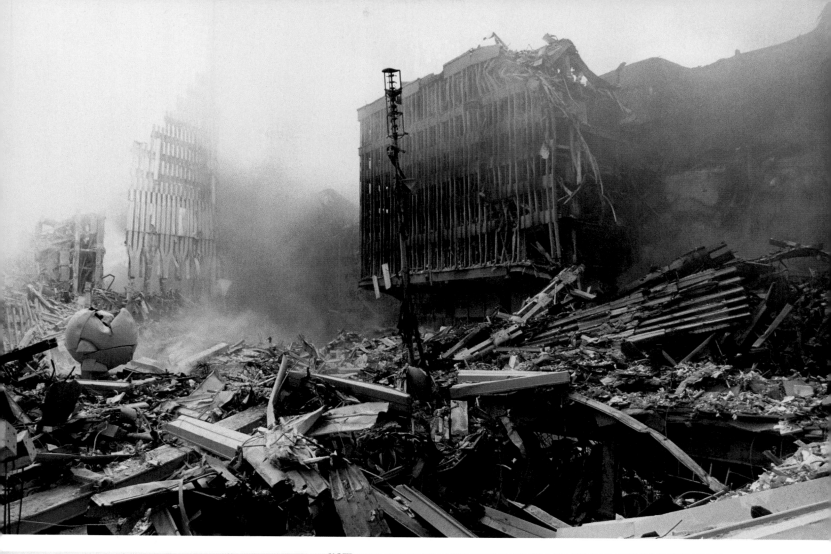

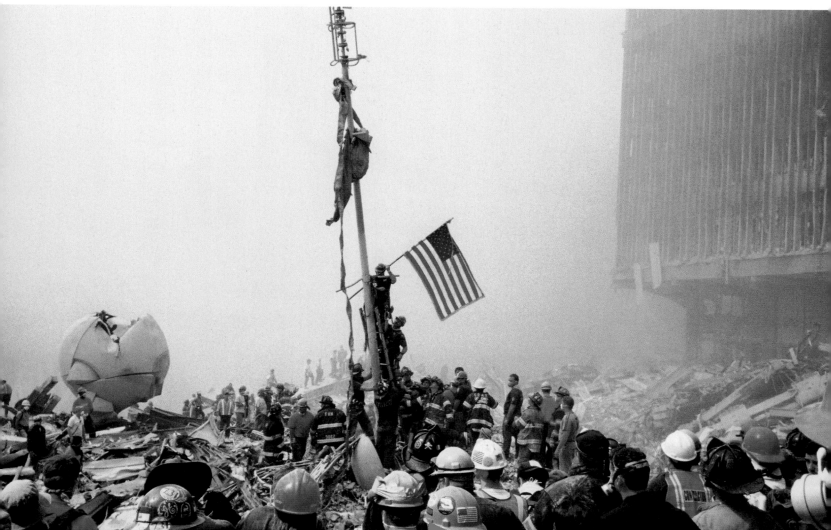

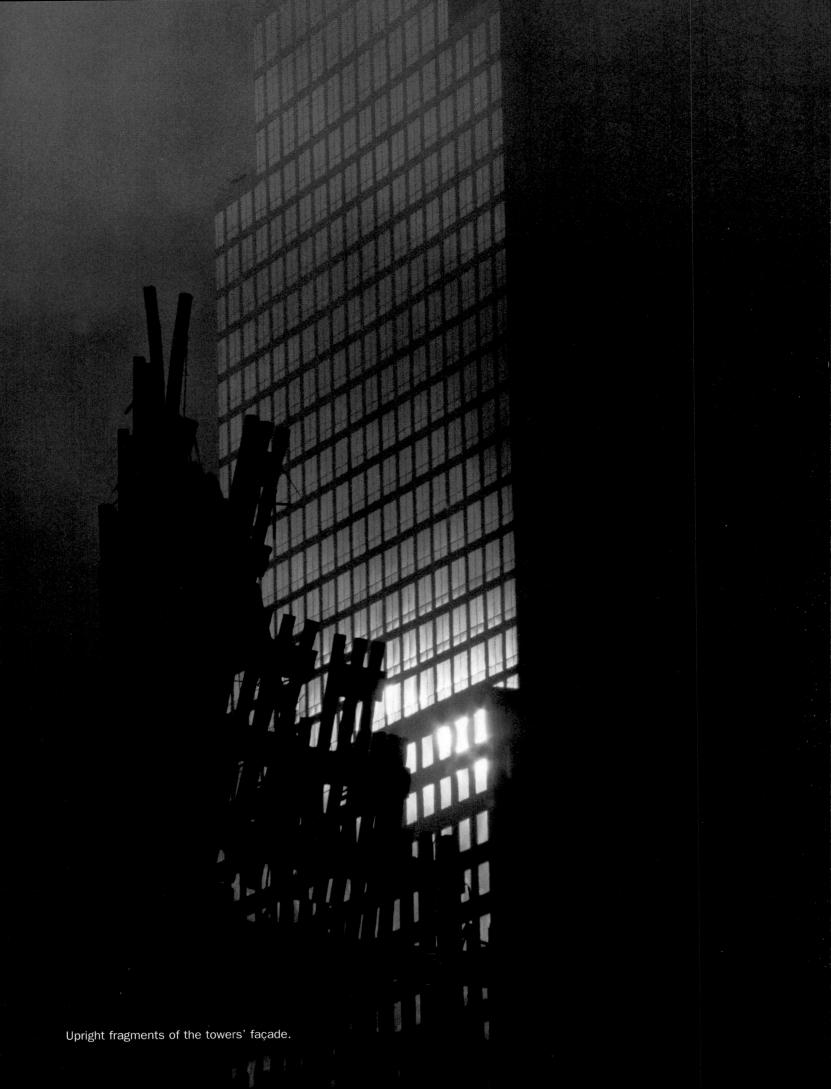

Upright fragments of the towers' façade.

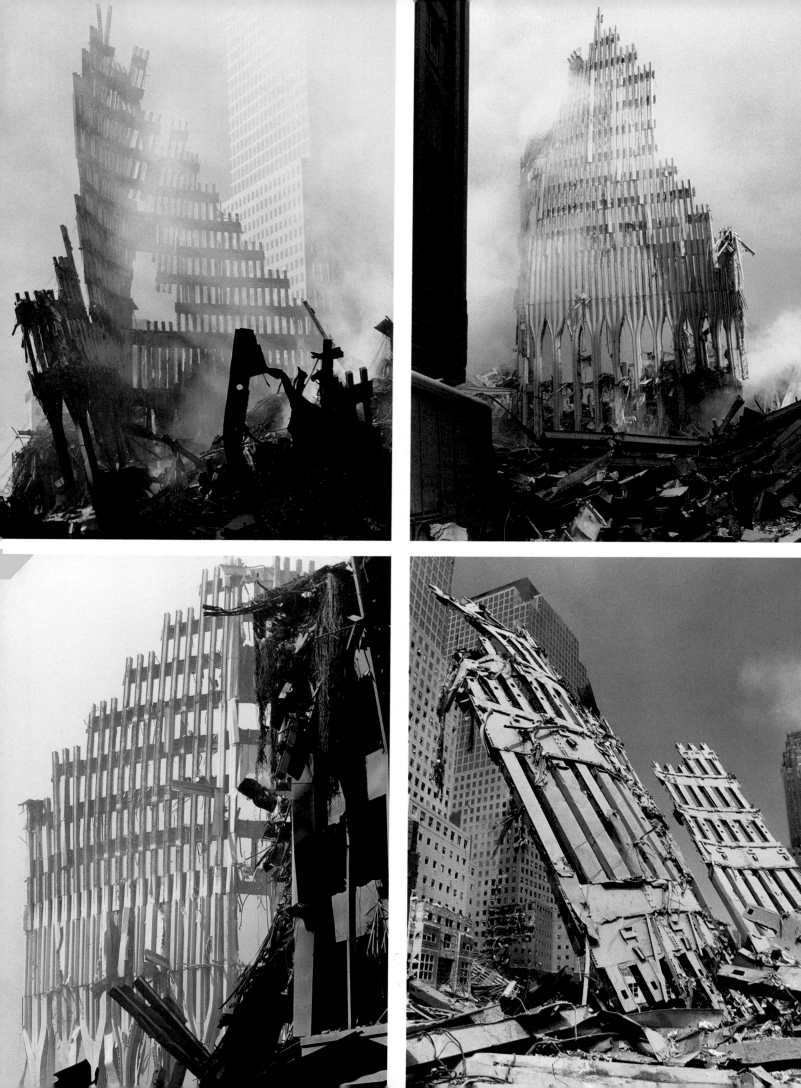

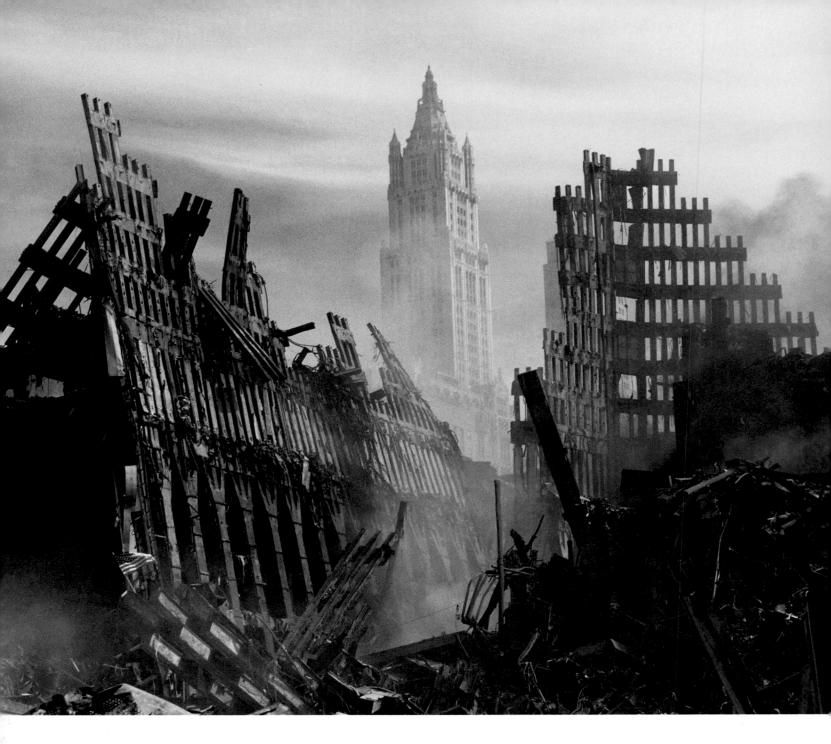

The Woolworth Building through the wreckage. It was the world's tallest building from 1913 to 1931.

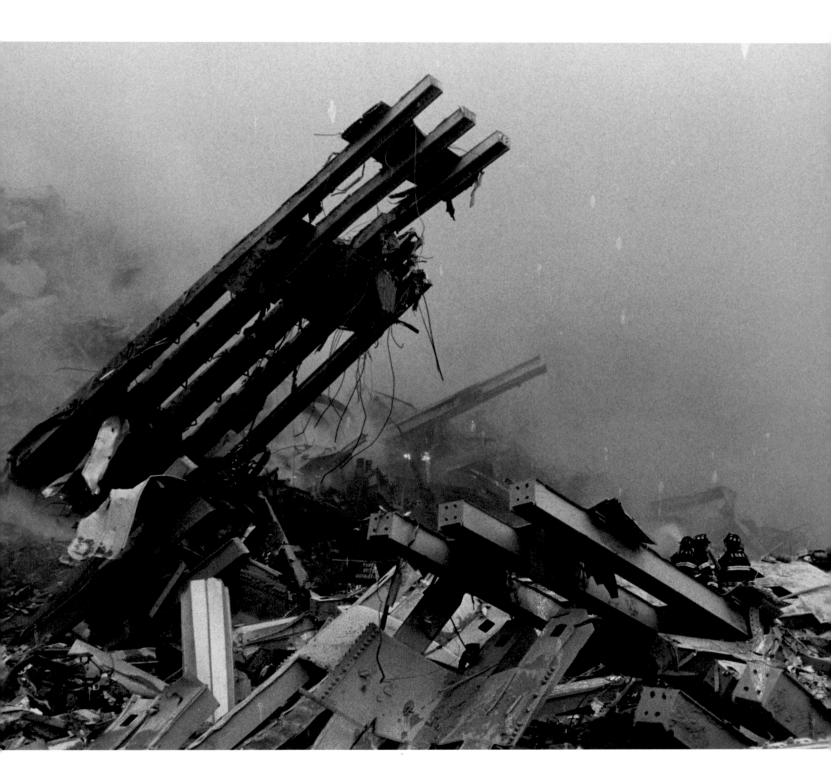

Firemen searching the wreckage for signs of life. This is the plaza area; Church Street is behind us.

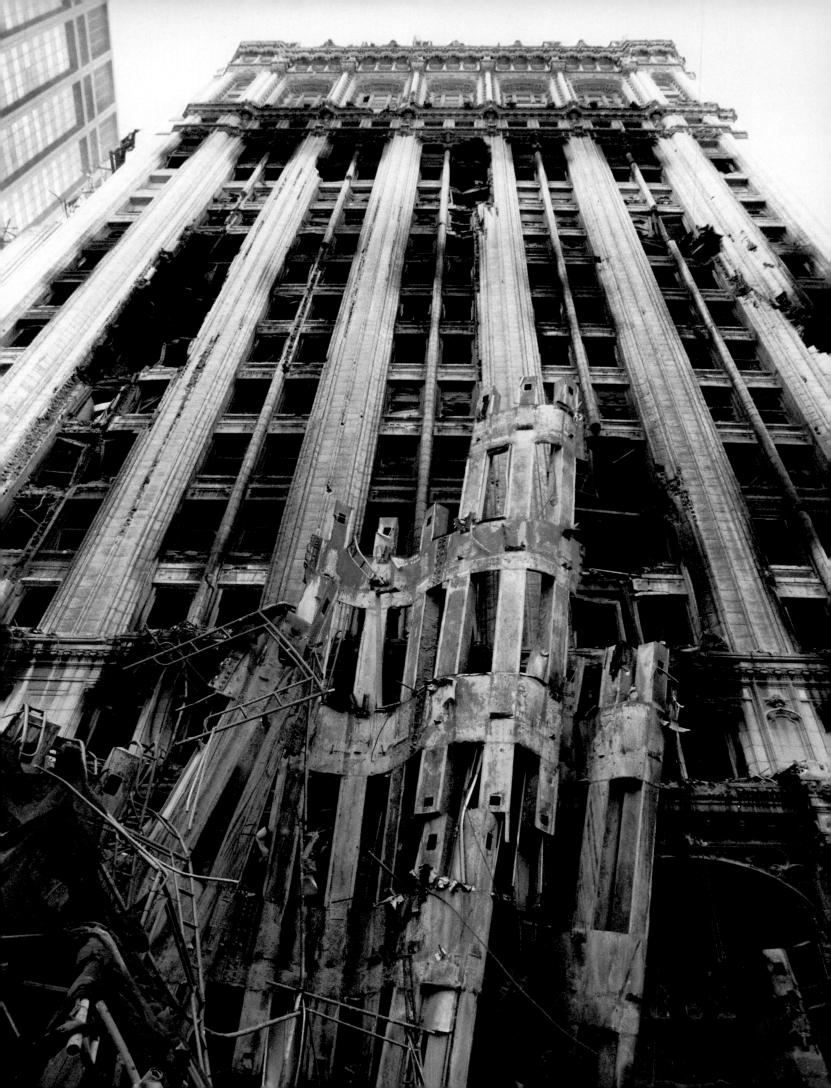

OPPOSITE: The Liberty Street façade of
90 West Street, a landmark building from 1907.
It was designed by Cass Gilbert, as was the
Woolworth Building.

RIGHT: More wreckage.

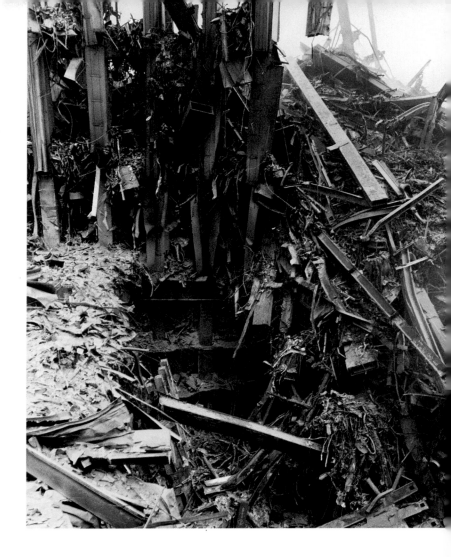

LEFT: The Bankers Trust Building on Liberty Street.

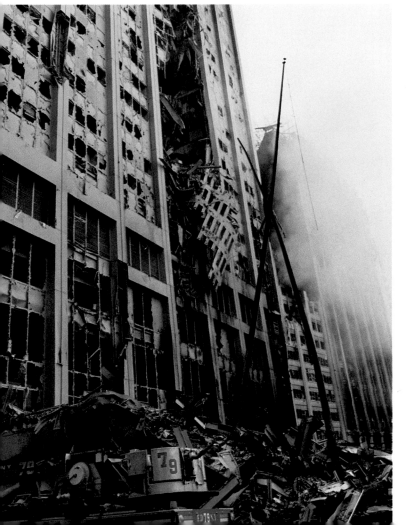

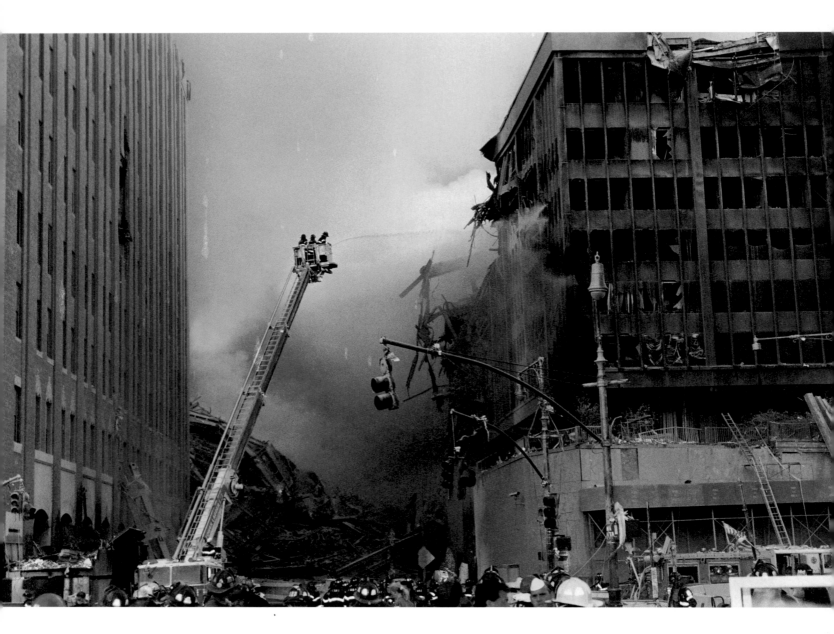

Hosing down building 6 of the World Trade Center. The Verizon Building is to the left.
Crumpled building 7 lies between the two buildings.

OPPOSITE: Hosing down building 7 from the roof of the Verizon Building.

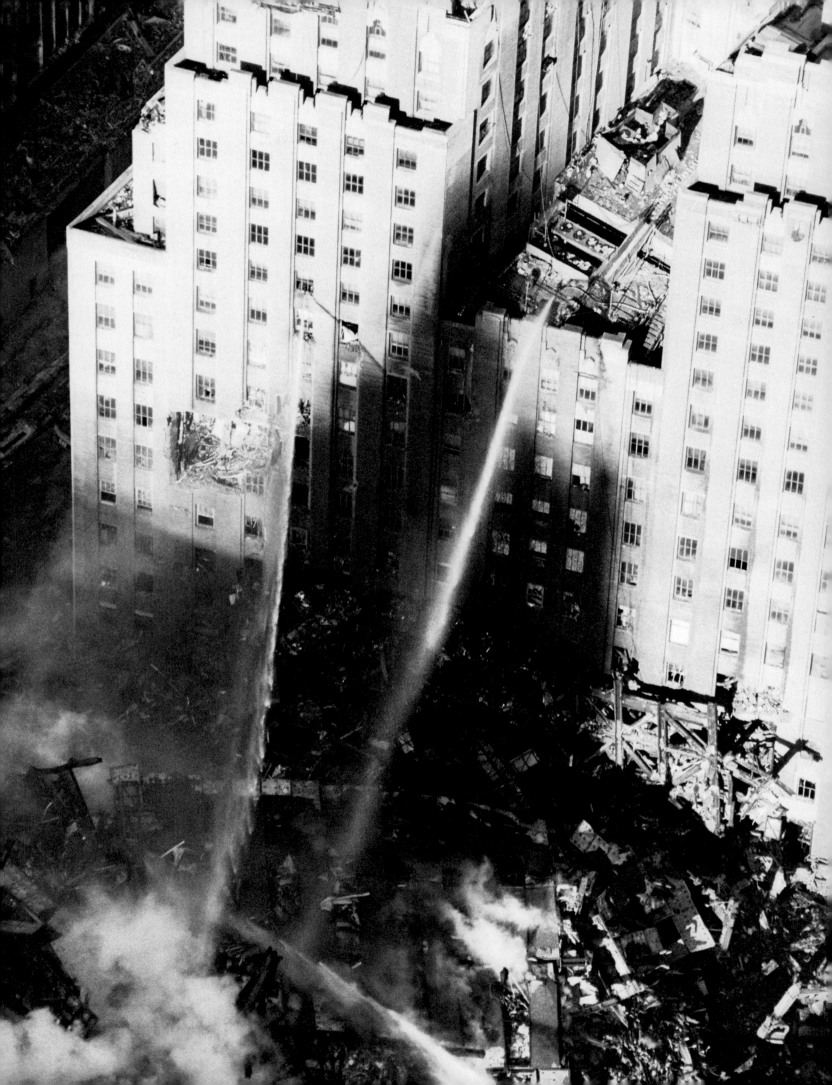

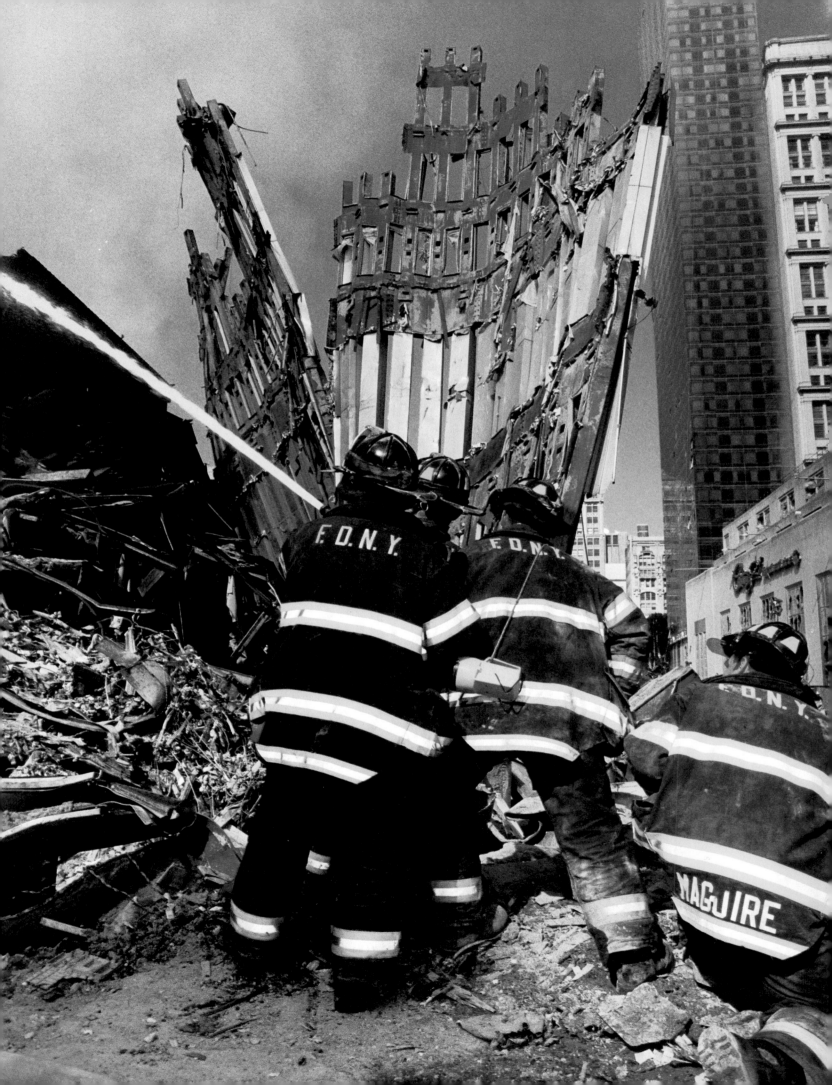

OPPOSITE: Along the Church Street side.

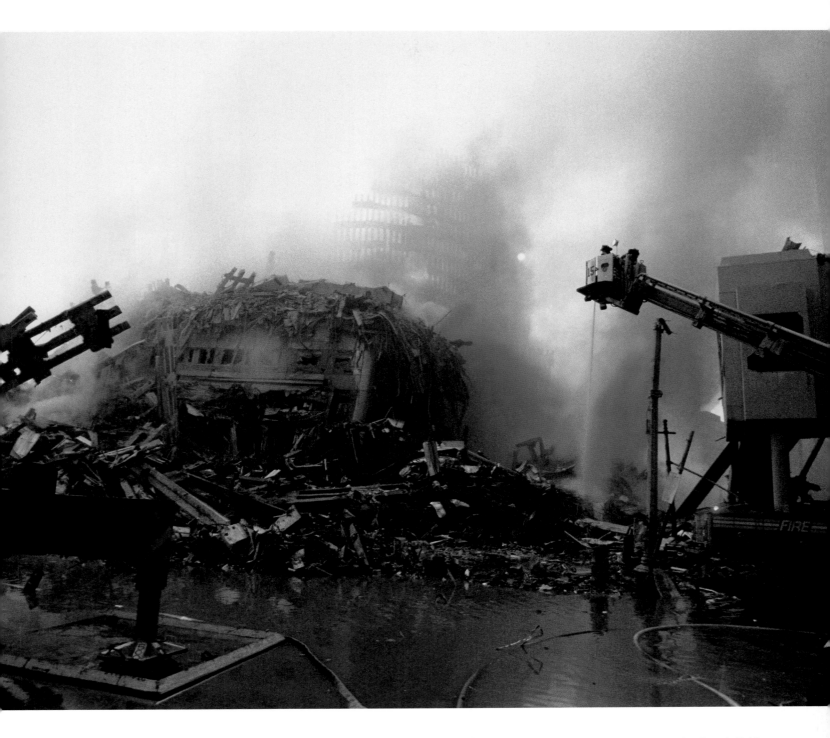

Firefighters near the South Bridge.

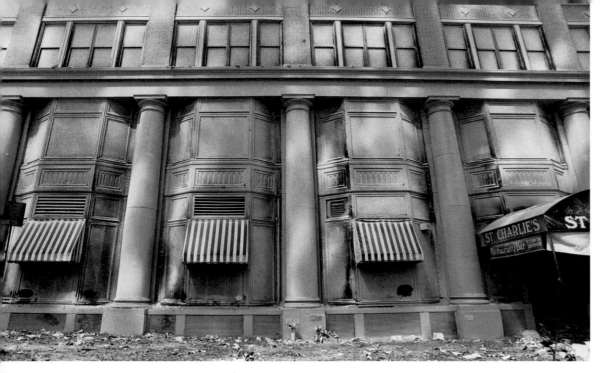

Dust covered everything; there was no color. A restaurant on Albany Street.

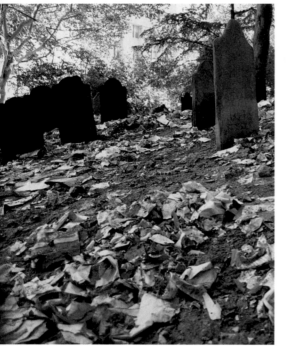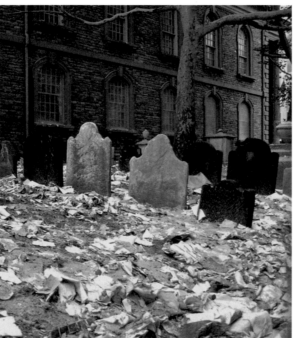

St. Paul's churchyard. George Washington attended this church while he was president— New York was the capital then.

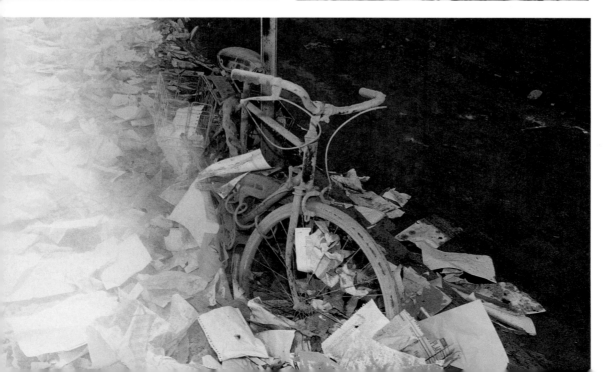

An abandoned bicycle.

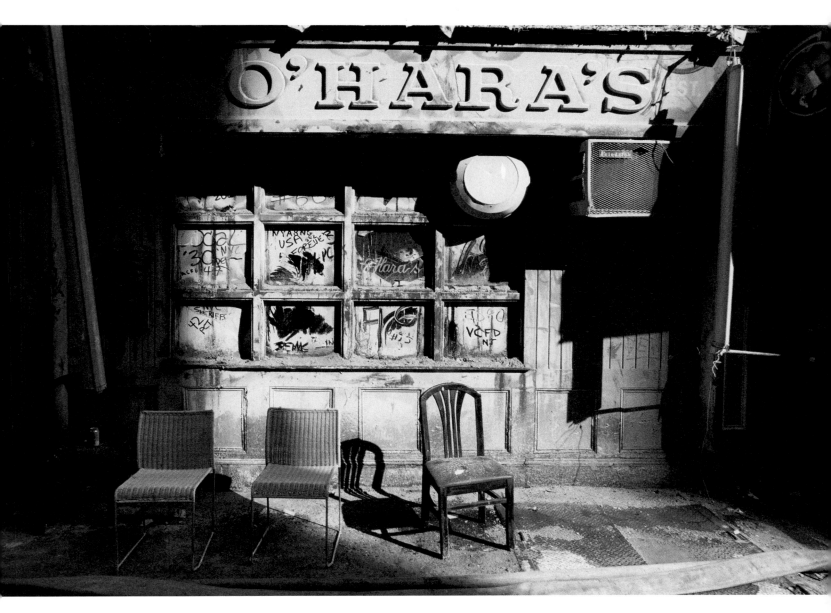

O'Hara's on Cedar Street, just near the local firehouse.

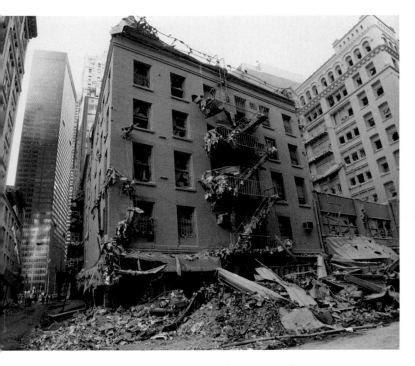

Office paper, dust, and debris festoons a fire escape.

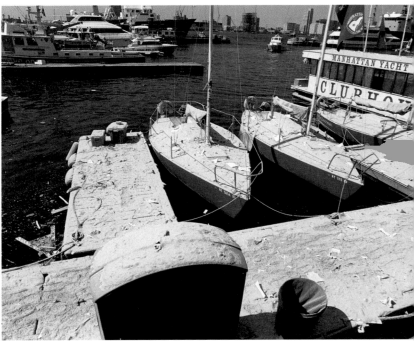

The yacht basin.

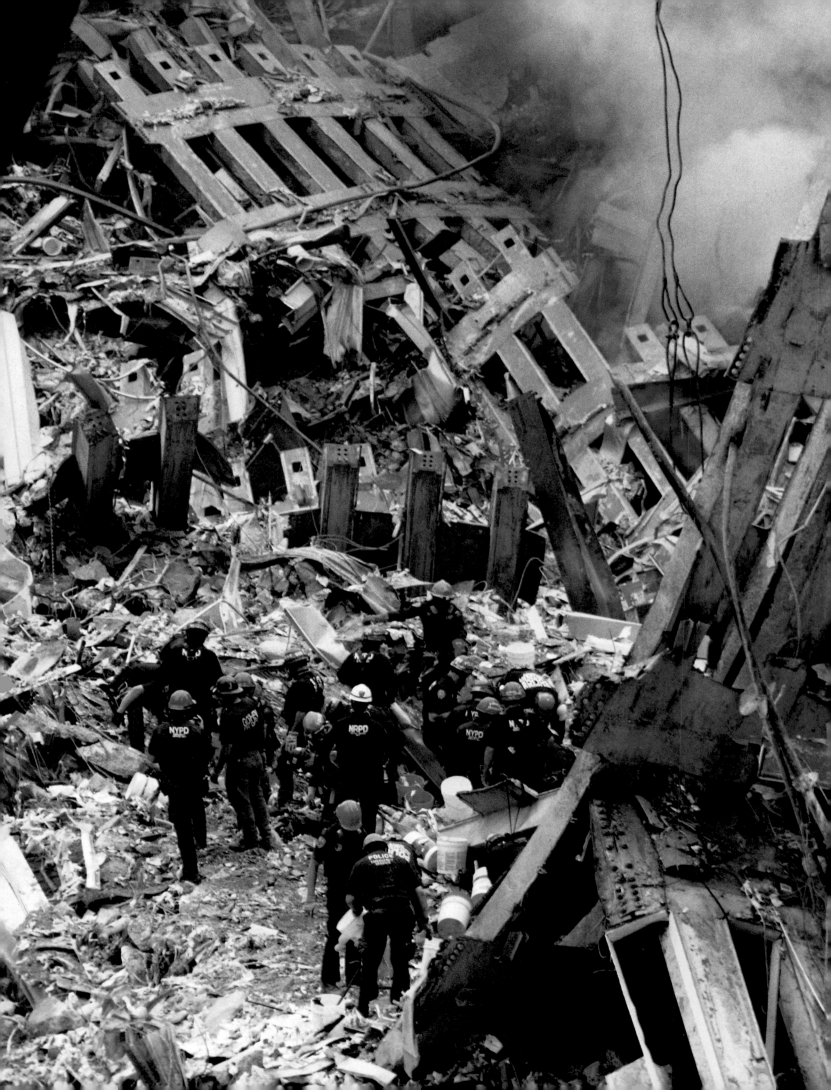

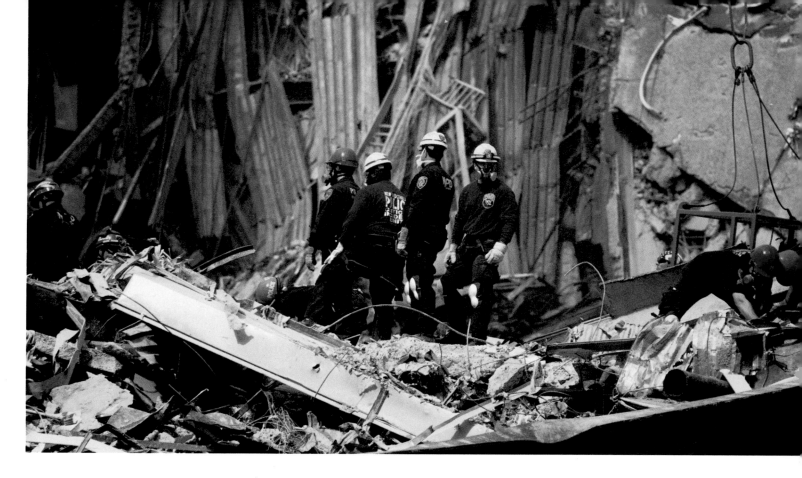

OPPOSITE: It seemed like such an impossible task, so overwhelming, but the feeling of confidence and determination was infectious. This was the best of people coming up against the worst.

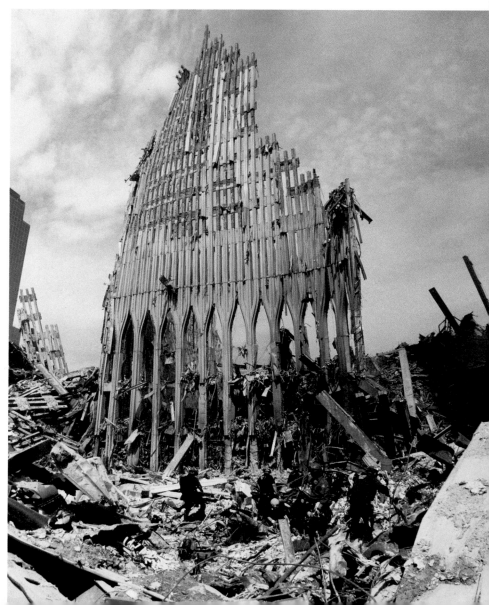

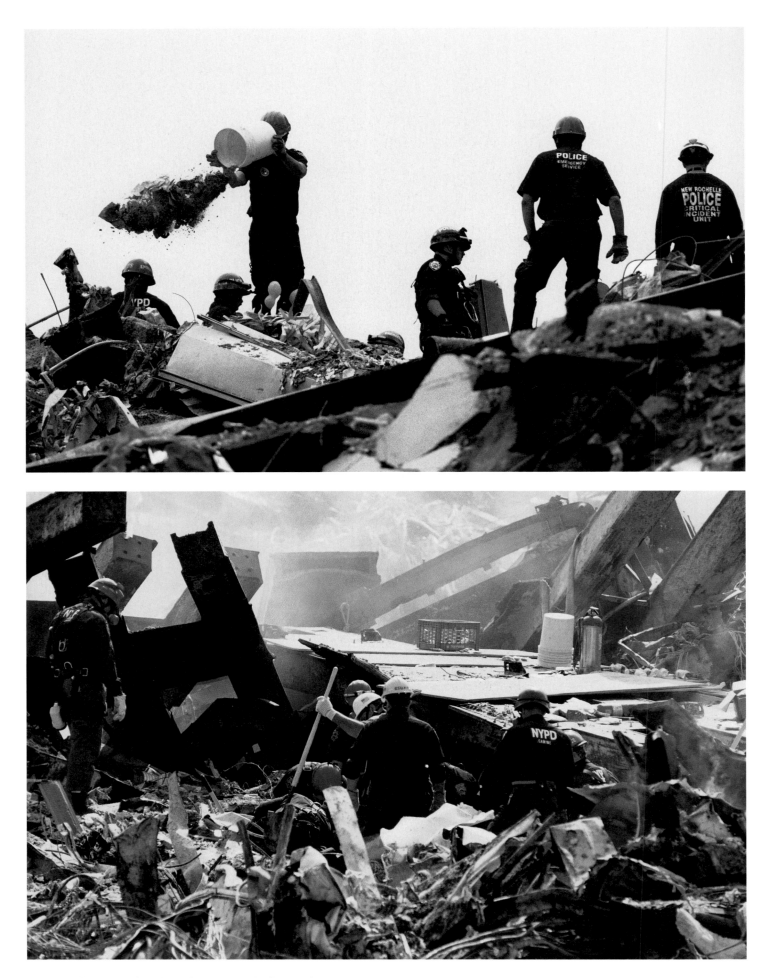

ABOVE: We never felt despair—the level of commitment was too great.
BELOW: Search and rescue operations.

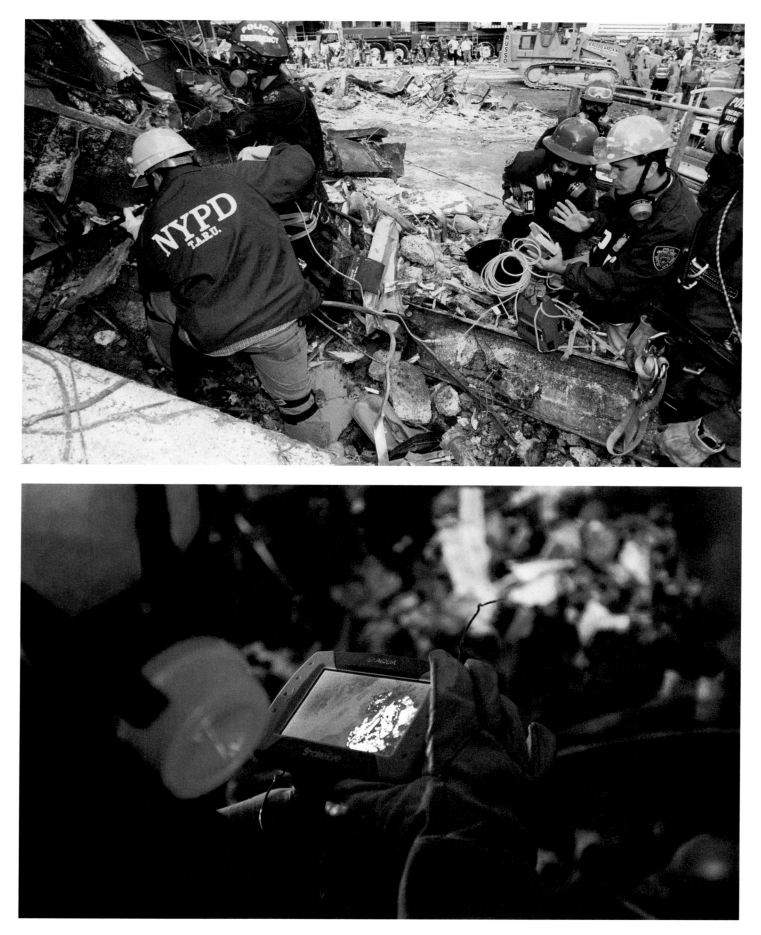

Detective Sanjiv Panchal is using an infrared pole camera to probe within the rubble while Detectives Fran Smith and Mike Sartoretti direct him from what they are seeing on the monitor. The construction workers would move some of the wreckage, then the K-9 officers would go in with their dogs. If a scent was picked up, everything would stop and the technical unit would go in to look. This process was repeated over and over again for months, day and night.

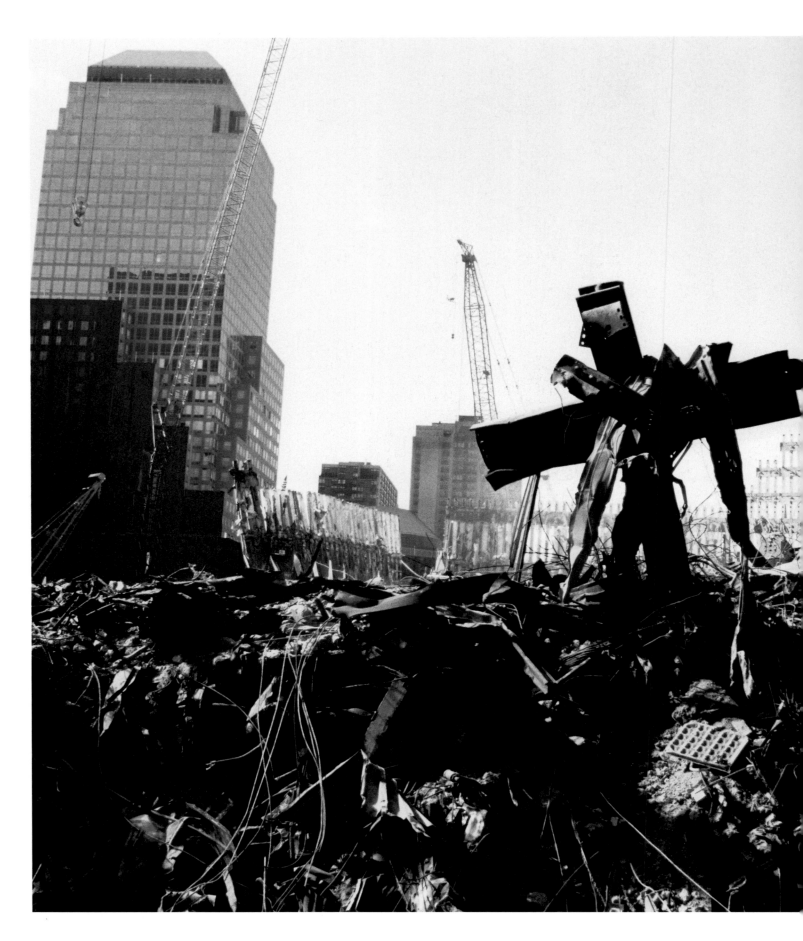

Crosses jutting out of the wreckage were common and were left as they were as long as possible.

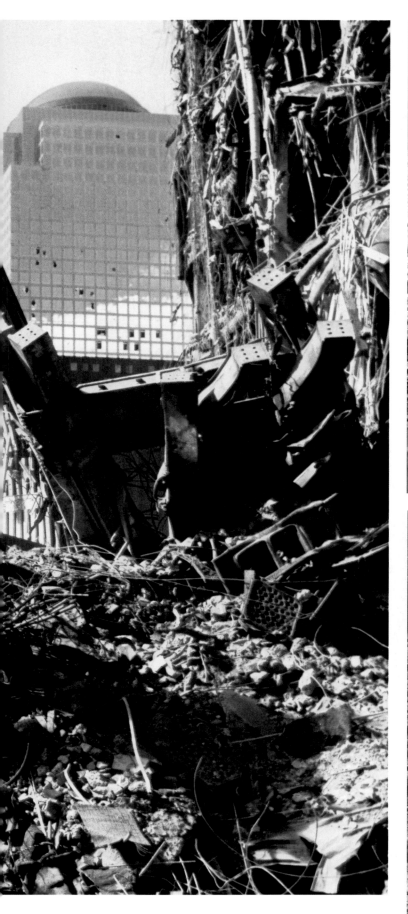
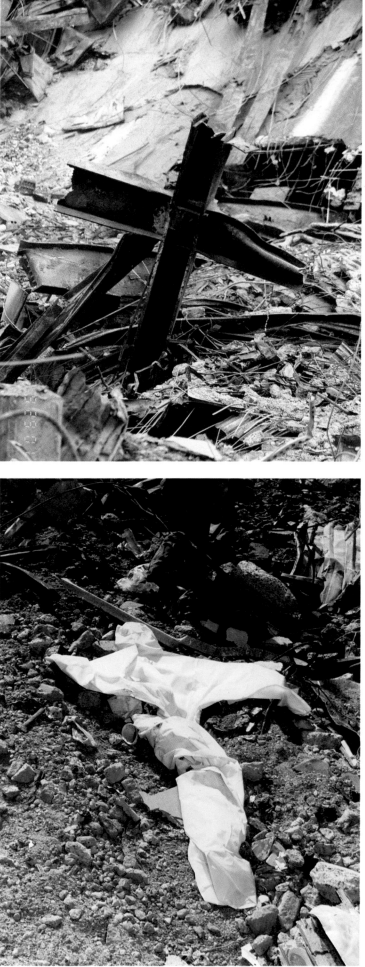

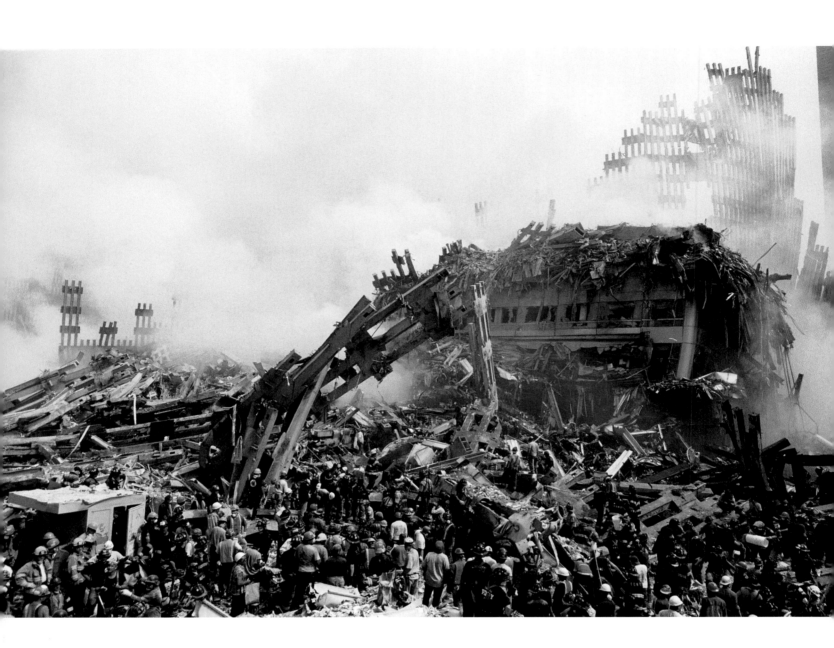

A B O V E H A L L O W E D G R O U N D

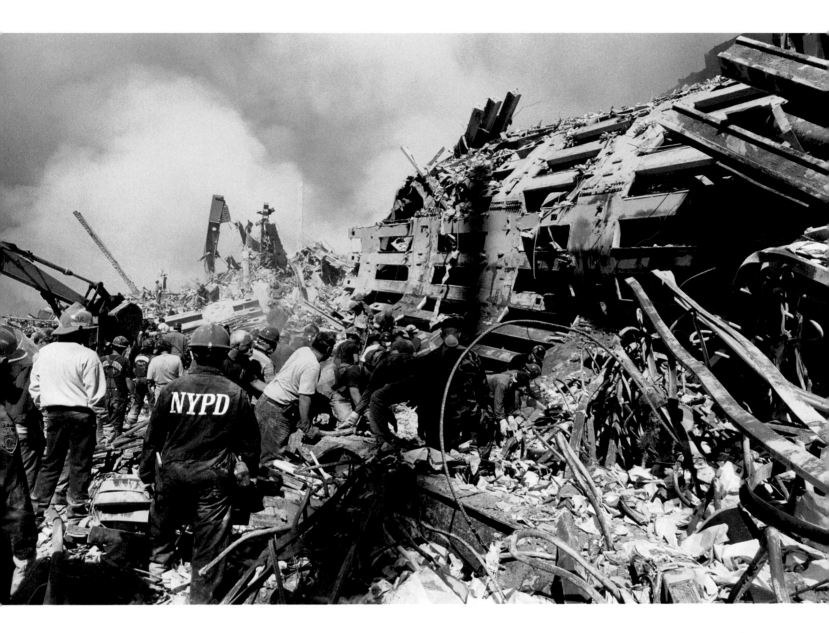

It was thought that someone might still be alive here. A scent was picked up and everyone mobilized, hoping to find a survivor. After almost an hour, no one was found alive. The searching went on continually, inch by inch. Hazards were everywhere. If you moved one thing, something else would shift or fall.

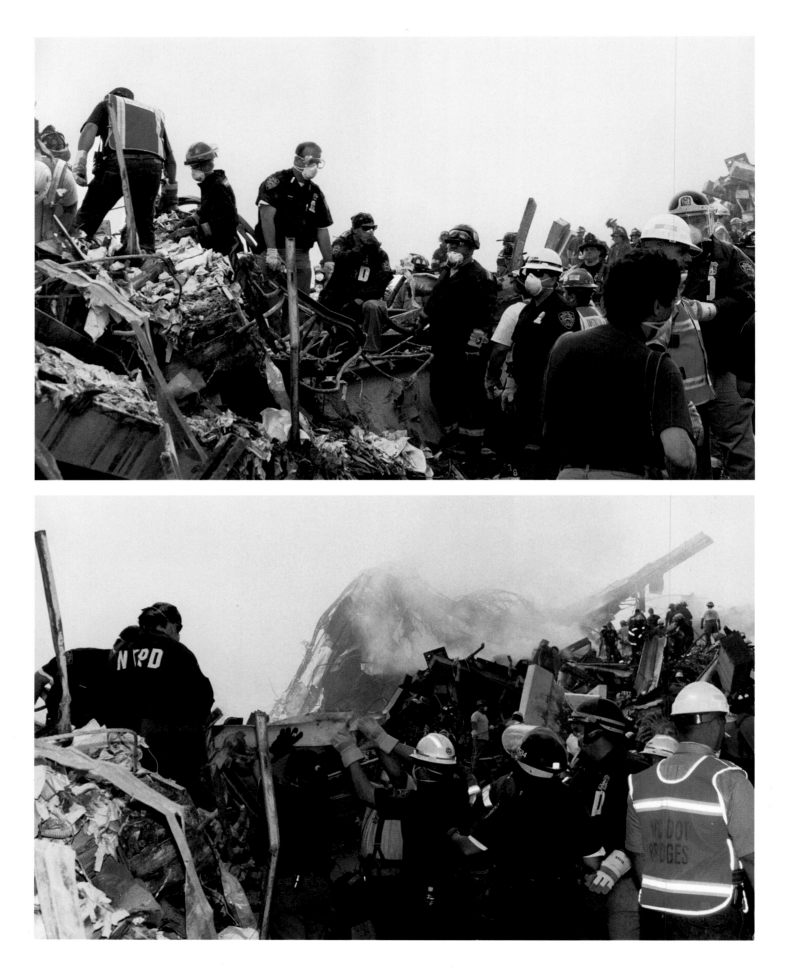

Cleanup began at the same time that search and rescue operations were going on.

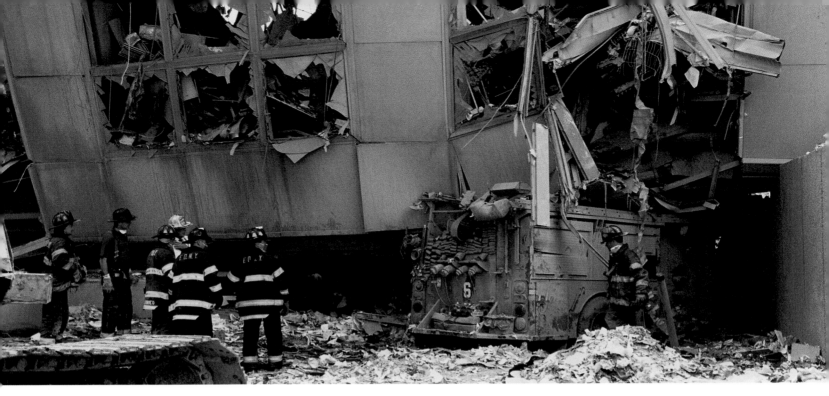

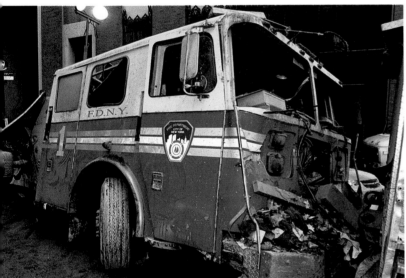

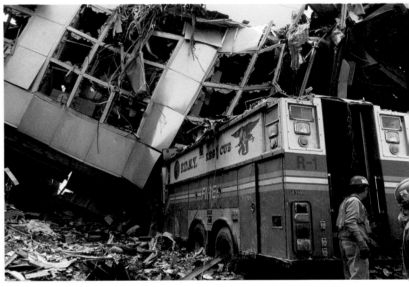

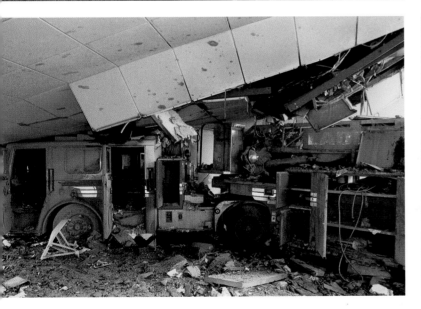

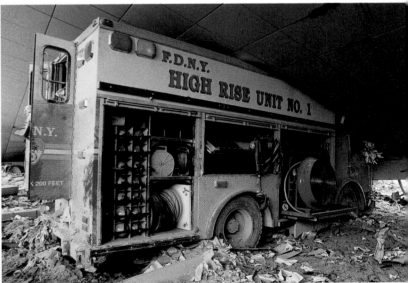

Damaged and destroyed fire trucks were everywhere.

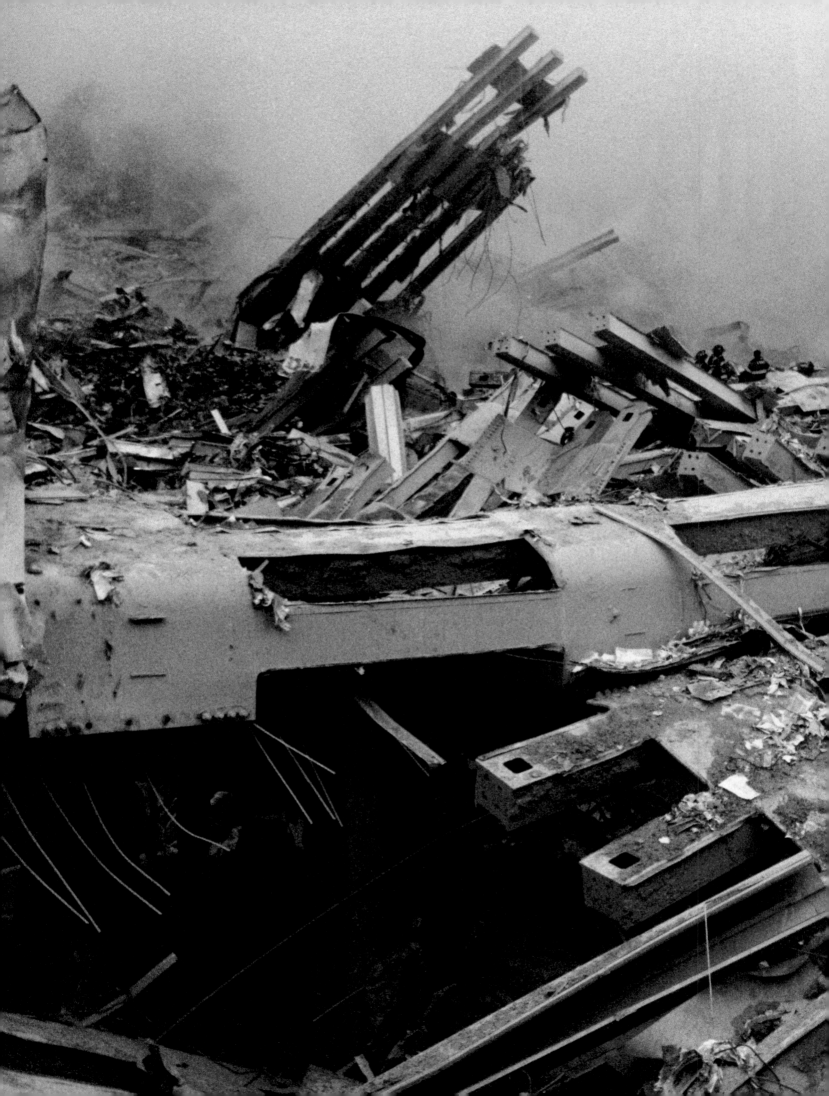

Sergeant John McLoughlin of the PAPD was the last person pulled out alive from the wreckage. He was trapped thirty feet below the surface for twenty-two hours. In the distance, rescuers are gathering at the site.

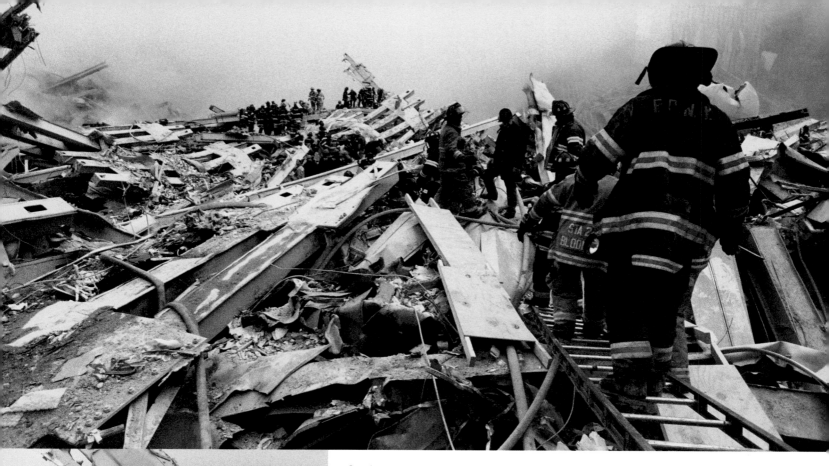

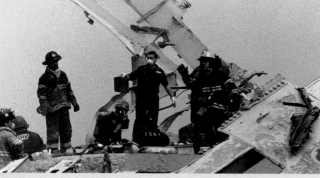

Getting to him was treacherous. A makeshift ramp of plywood planks and ladders formed a path to where he was—and the path to get him out.

Here he is being passed along in a gurney, handed off through a gauntlet of rescue workers. As he went by, everyone he passed started clapping. The clouds of smoke above seemed to amplify the sound. The clapping got louder and louder as he got closer to the street, where an ambulance was waiting.

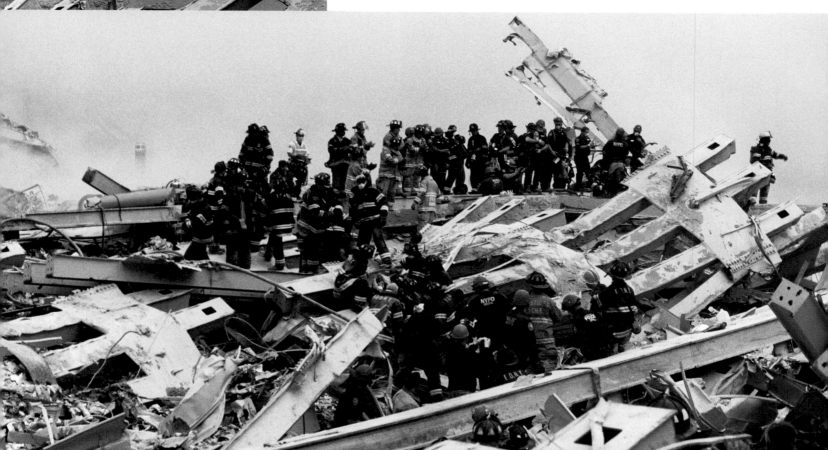

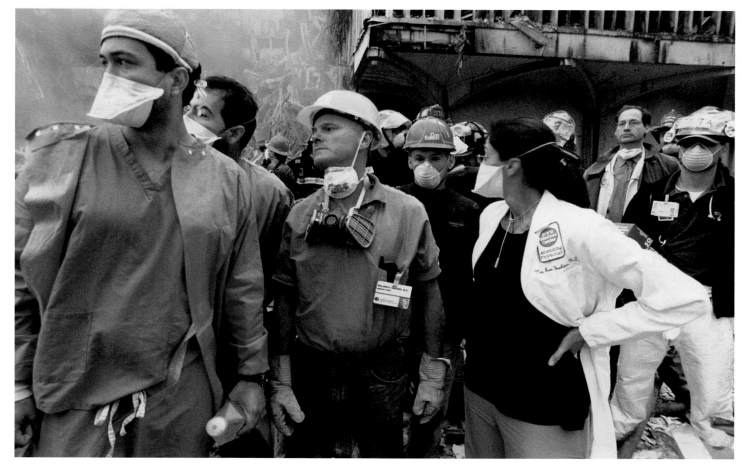

An array of medical personnel was standing by, ready to attend to Sergeant McLoughlin. His ordeal was far from over.

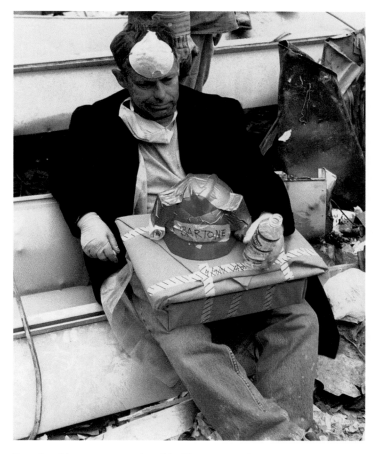

Ready with an amputation kit. There was the possibility they would have to amputate his legs to extricate him from the wreckage.

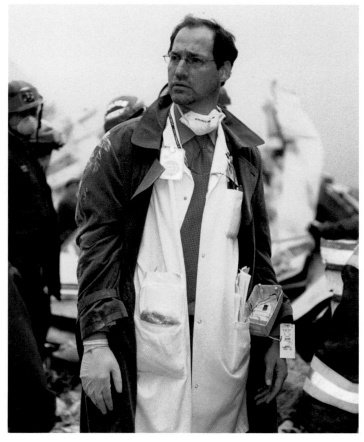

The sandwich in the pocket is not on this doctor's mind.

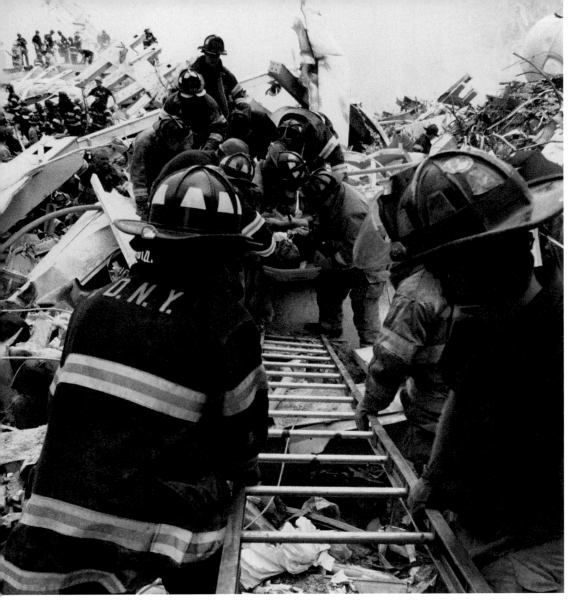

Everyone wanted to help, to be a part of it. These men came from all over.

Detective Paul Digiacomo and firefighters waiting.

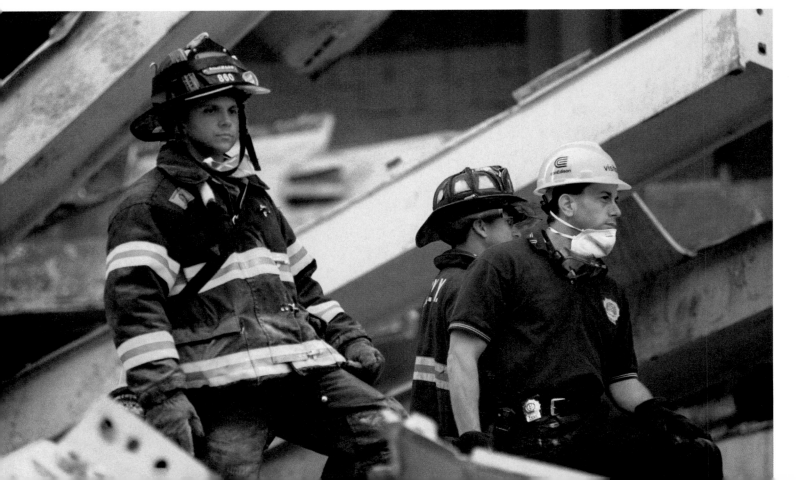

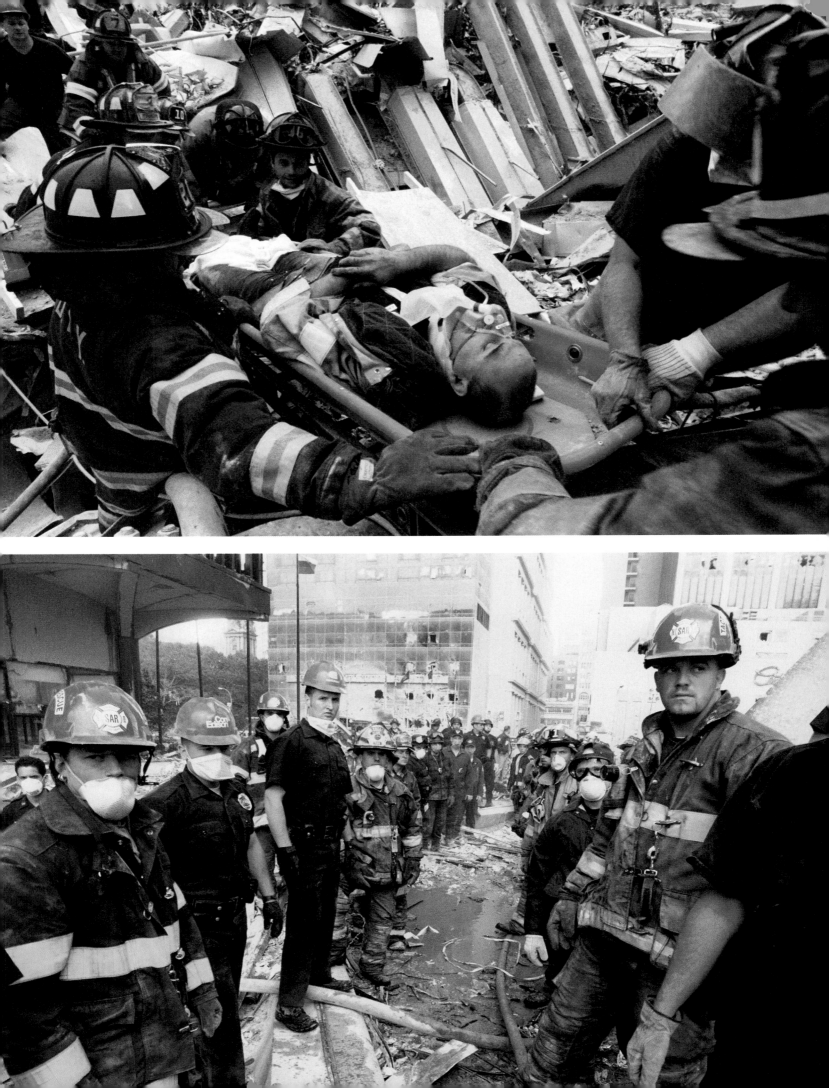

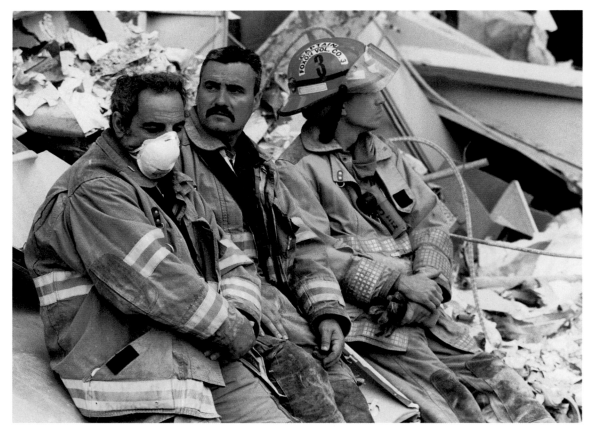

Firefighters resting on the edges of Ground Zero. It was grueling work, emotionally exhausting, but everyone was determined to do his best.

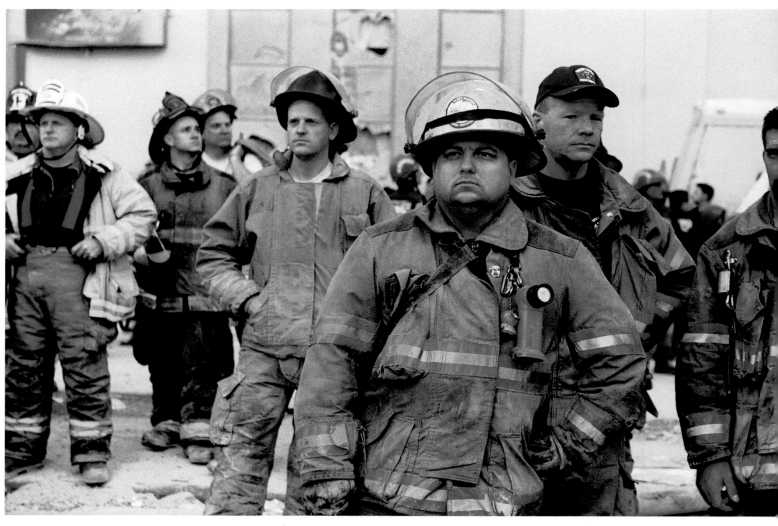

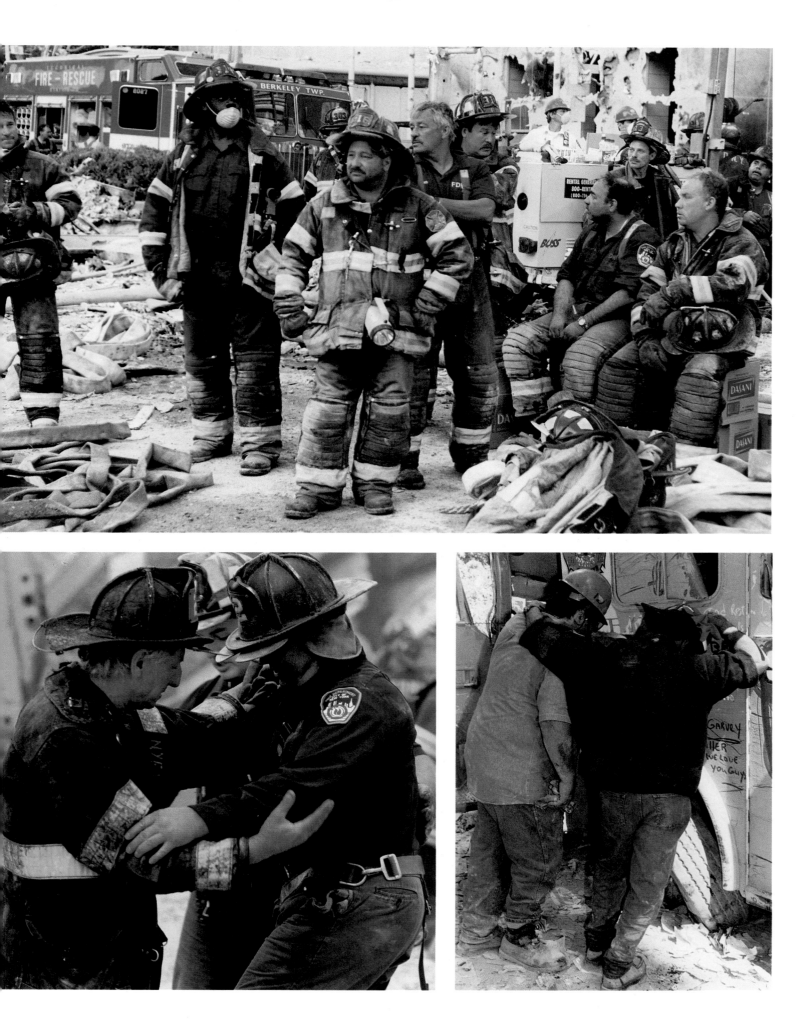

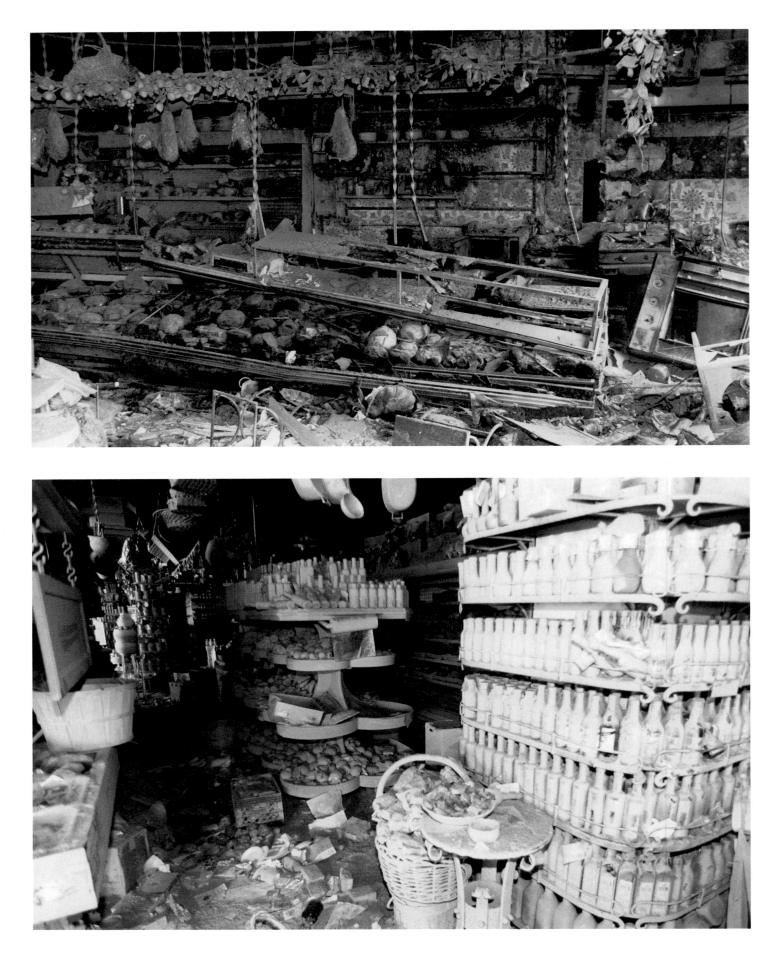

Interiors of the Amish Market on Cedar Street.

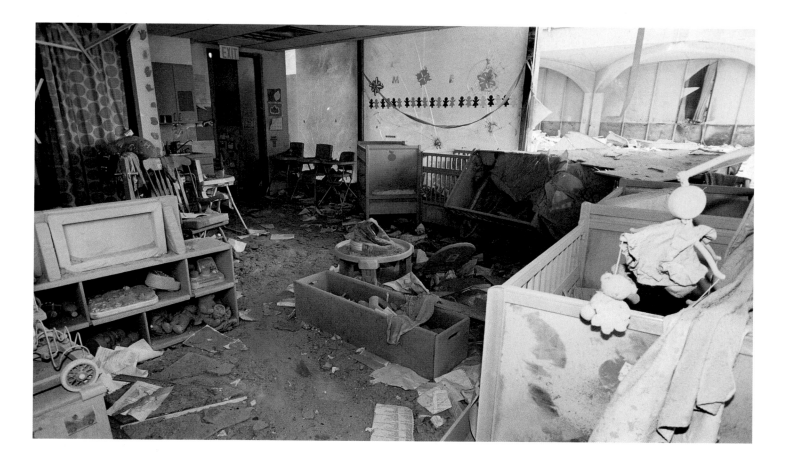

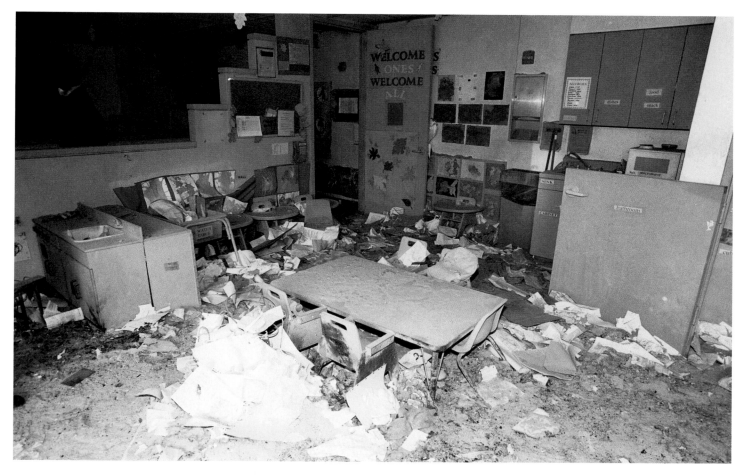

A day-care center in building 5 of the World Trade Center.

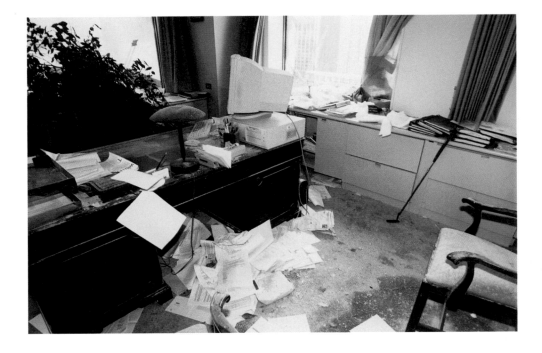

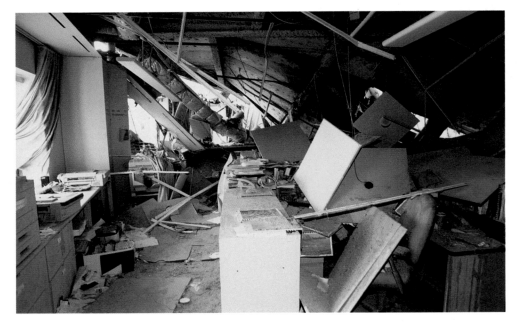

Offices on the tenth floor of 3 World Financial Center.

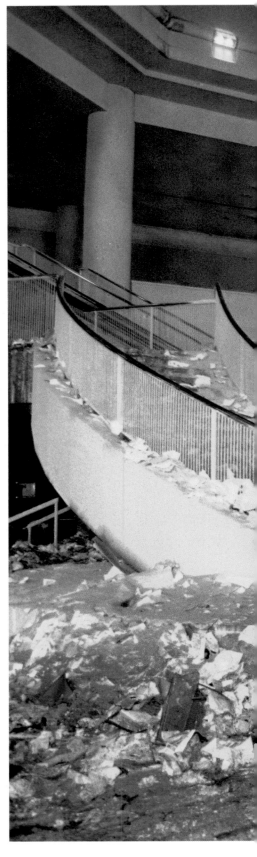

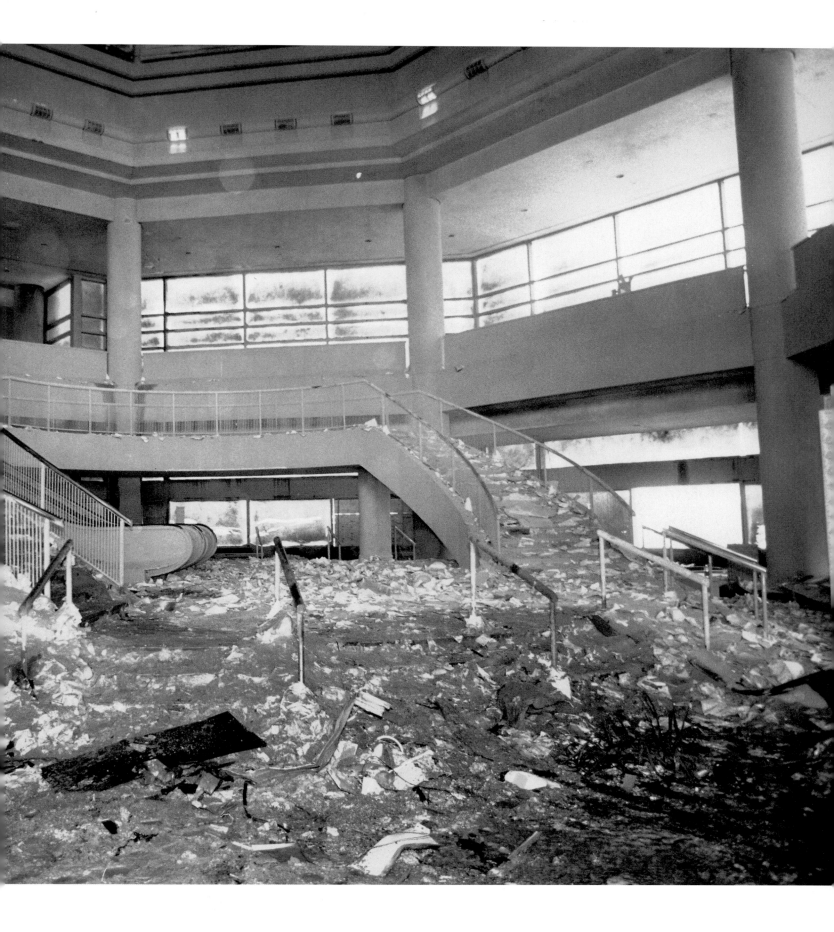

OVERLEAF: The windows blew out of buildings all around the World Trade Center.

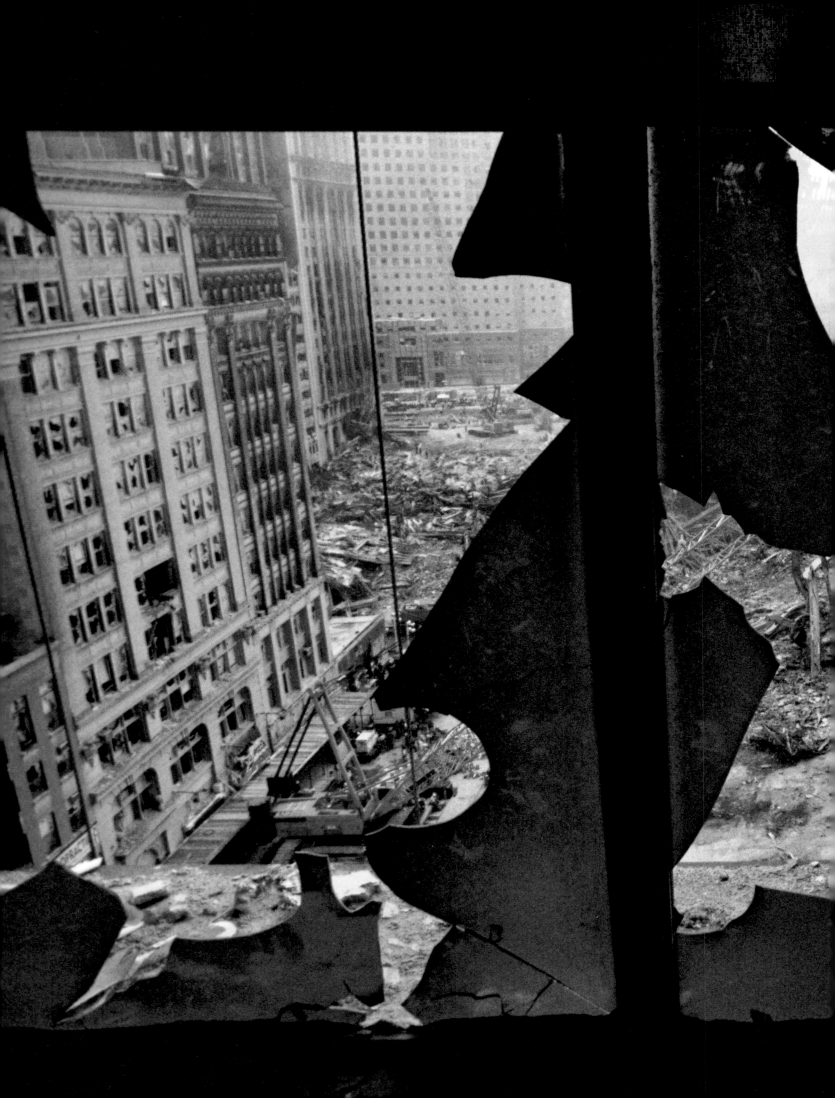

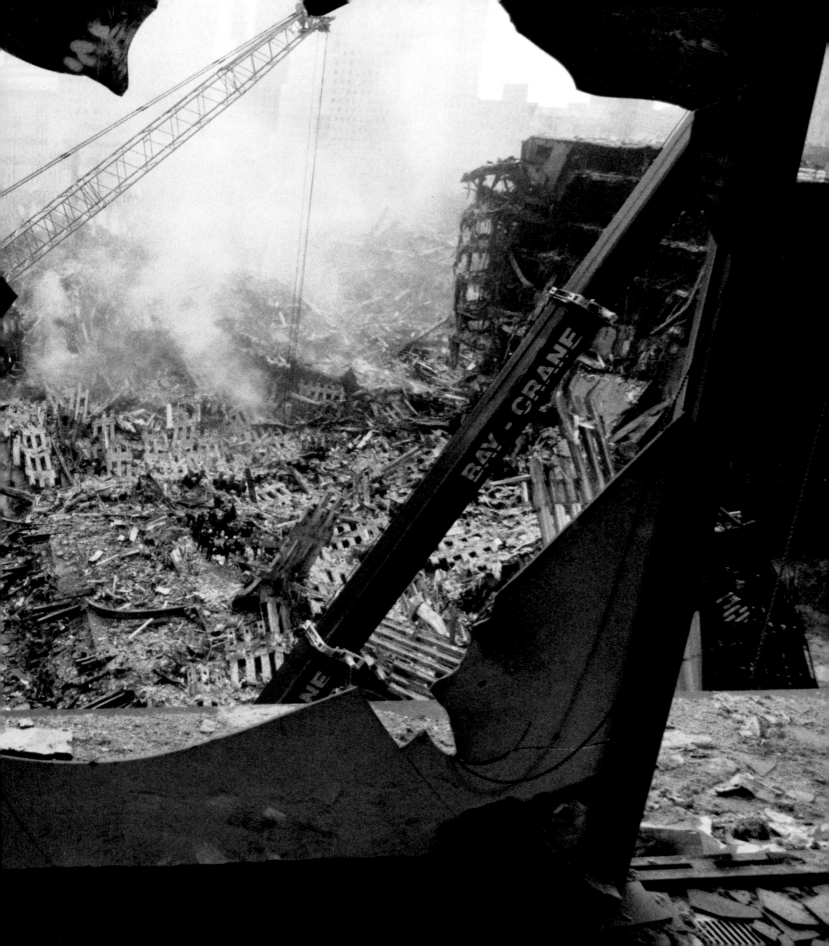

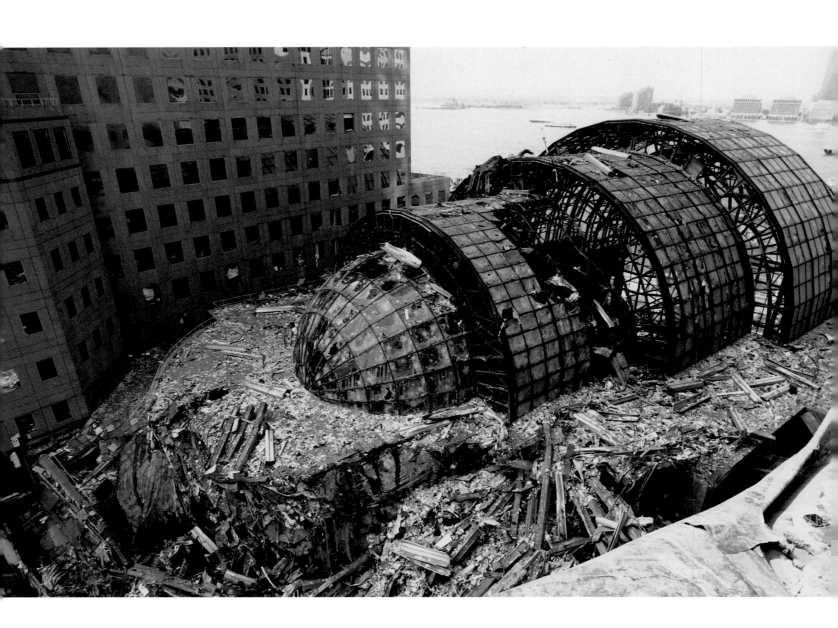

The Winter Garden roof and interior. Even weeks later bits of glass were falling, sounding like chimes.

OVERLEAF: In this shot above the Winter Garden, Detective Dave Fitzpatrick catches his reflection in a window. As he walked away, a steel beam fell from above and landed on the spot where he had just been standing. He was fifteen feet away and the impact lifted him off his feet.

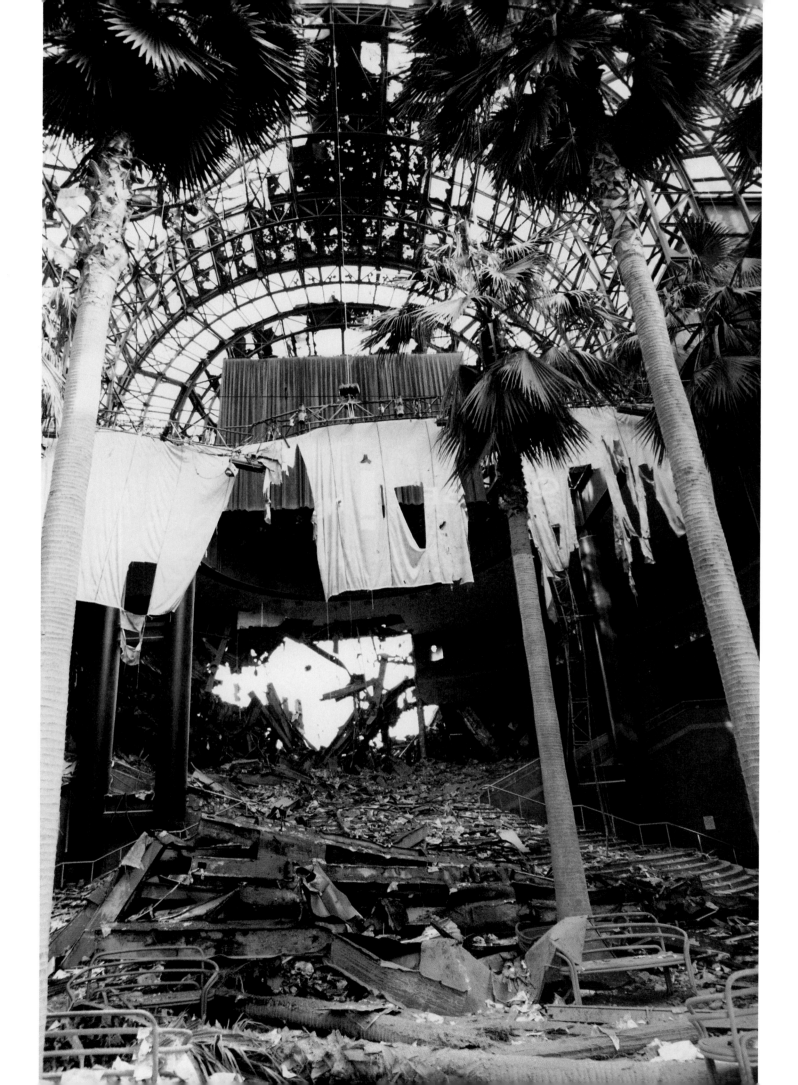

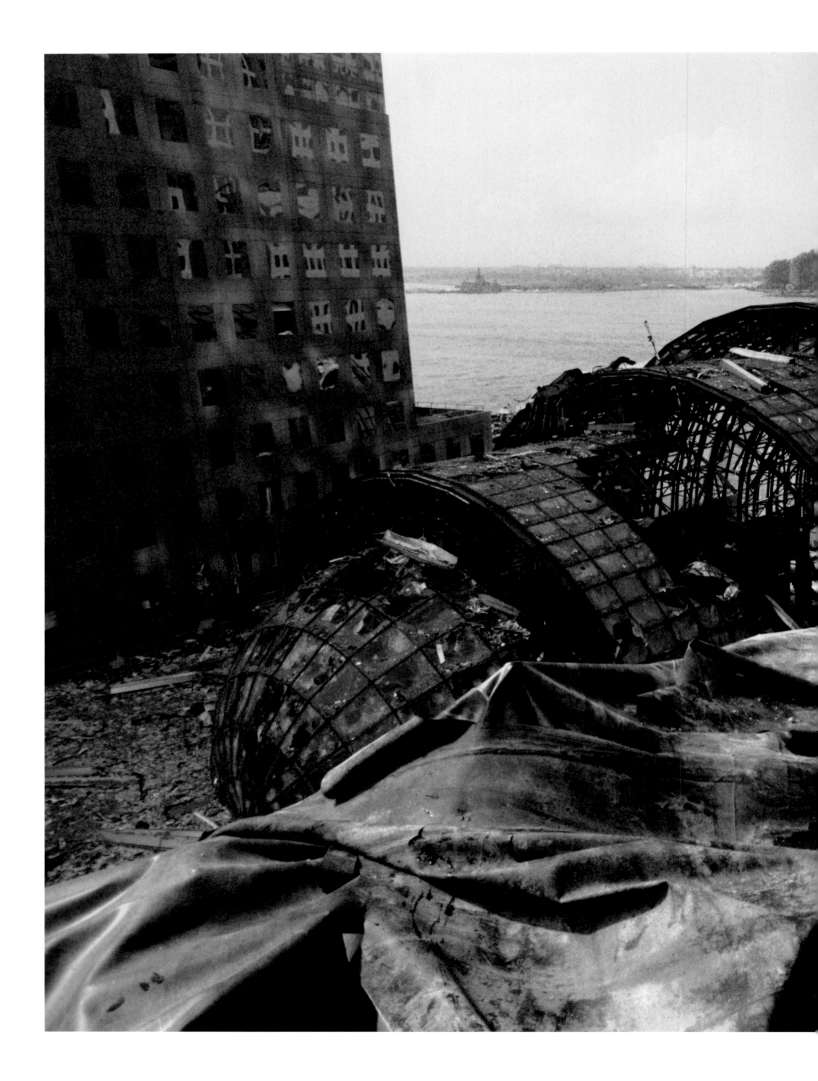

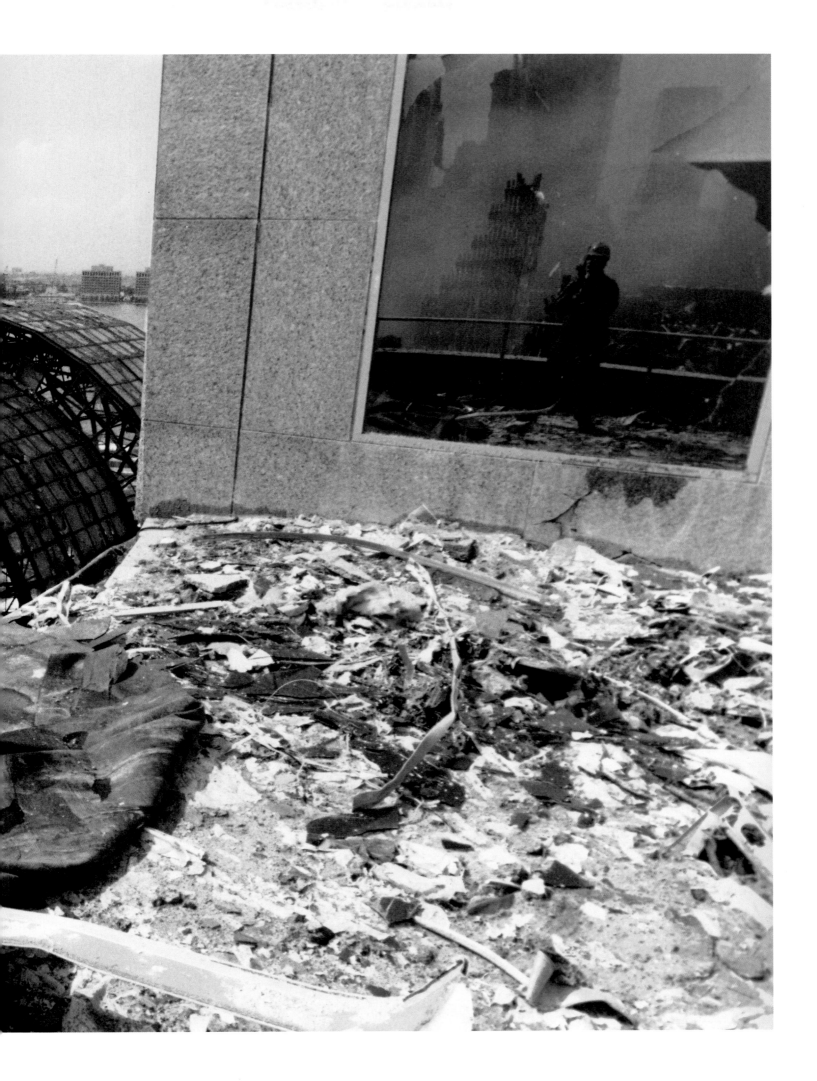

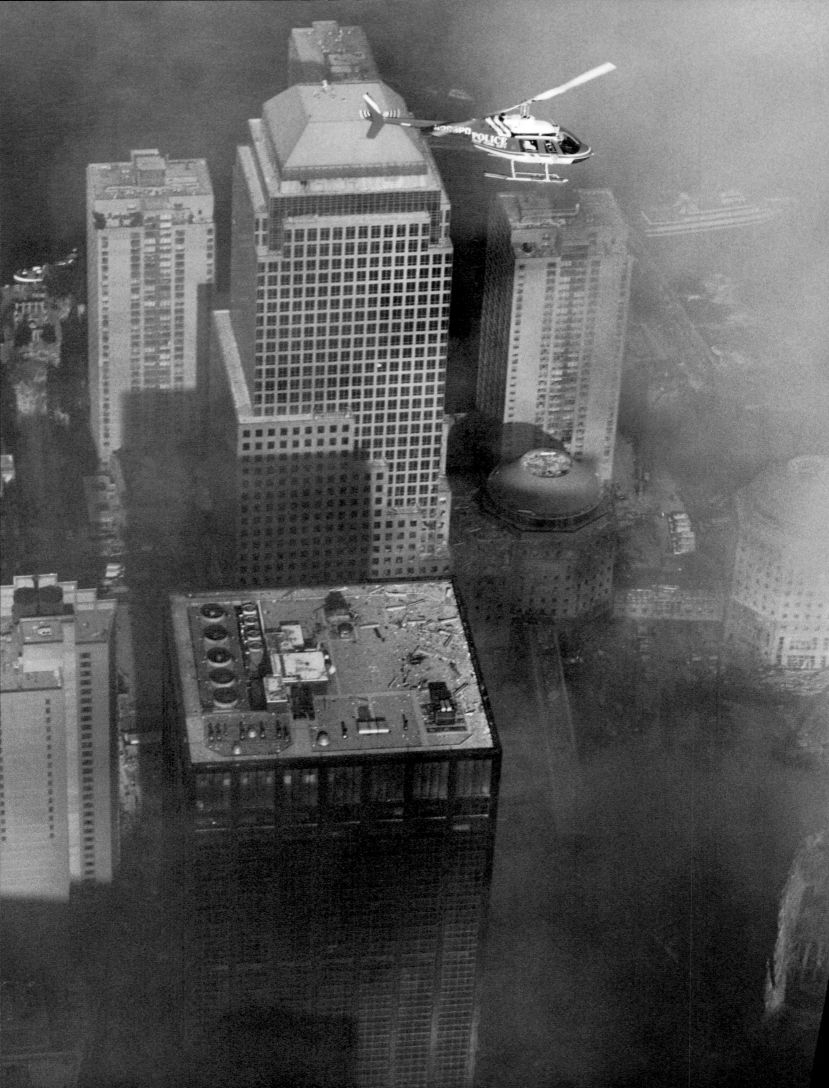

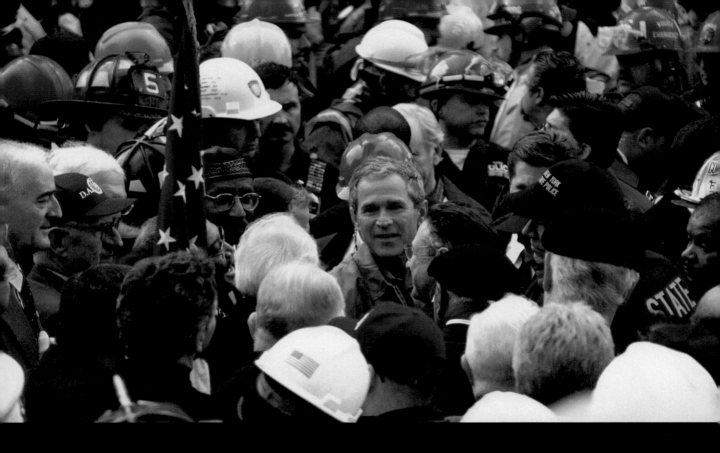

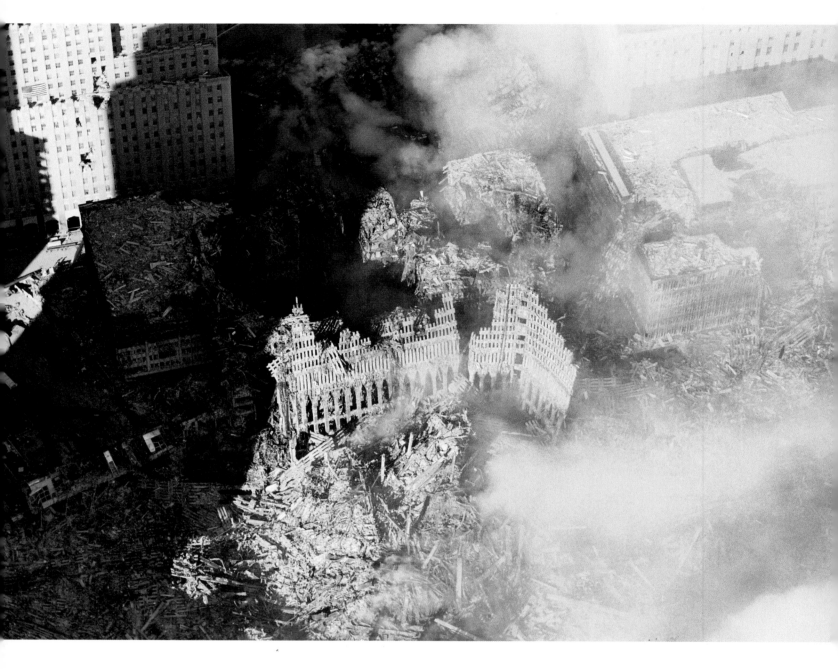

Above Ground Zero, September 15. The remains of the north tower, or 1 World Trade Center, with the remains of buildings 5, 6, and 7 in the rear.

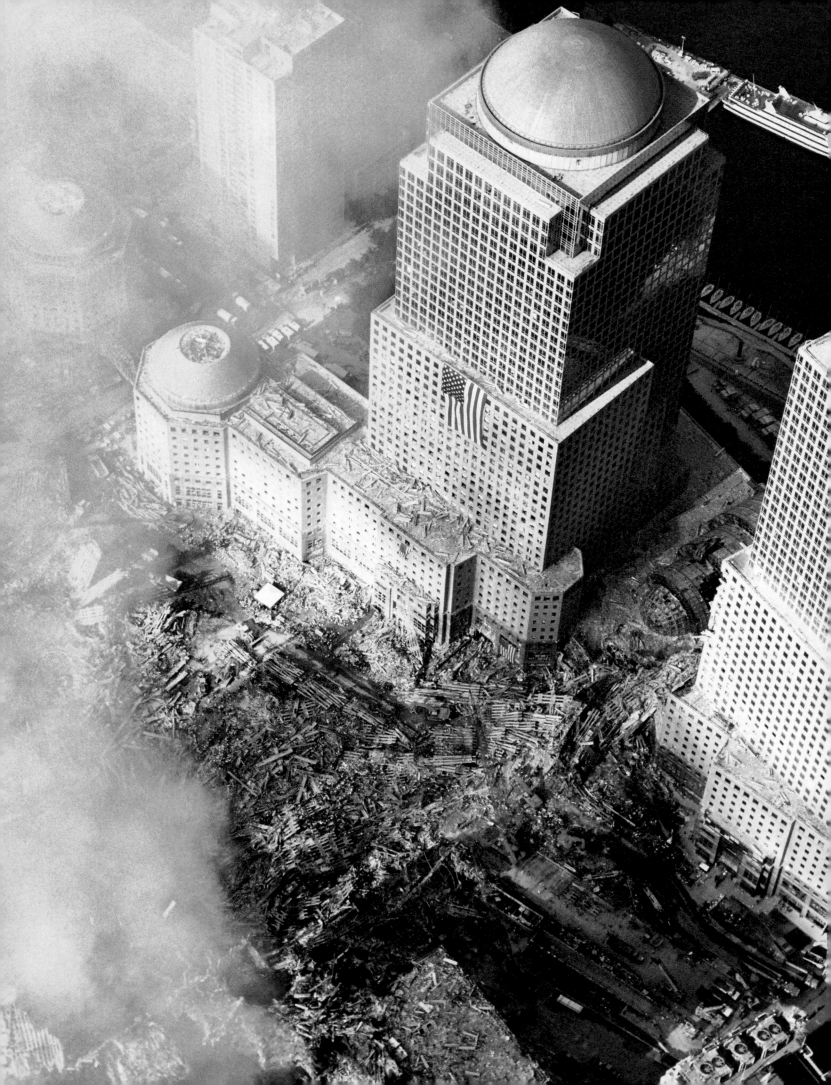

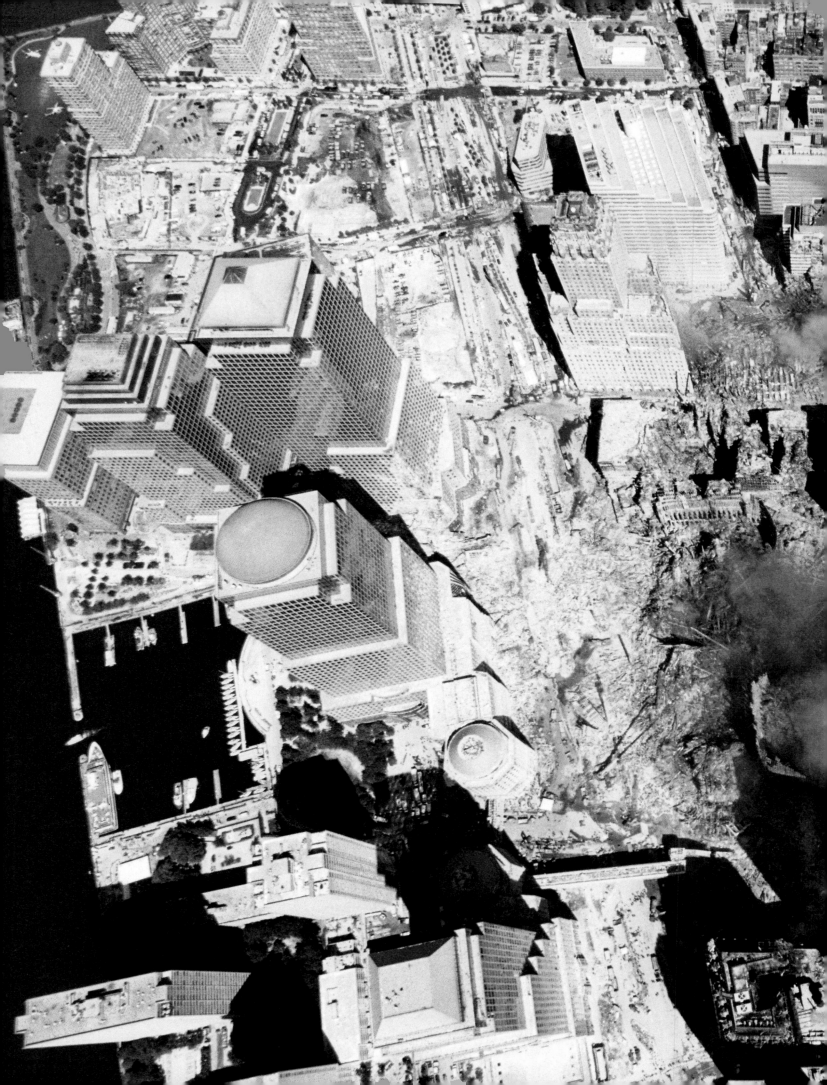

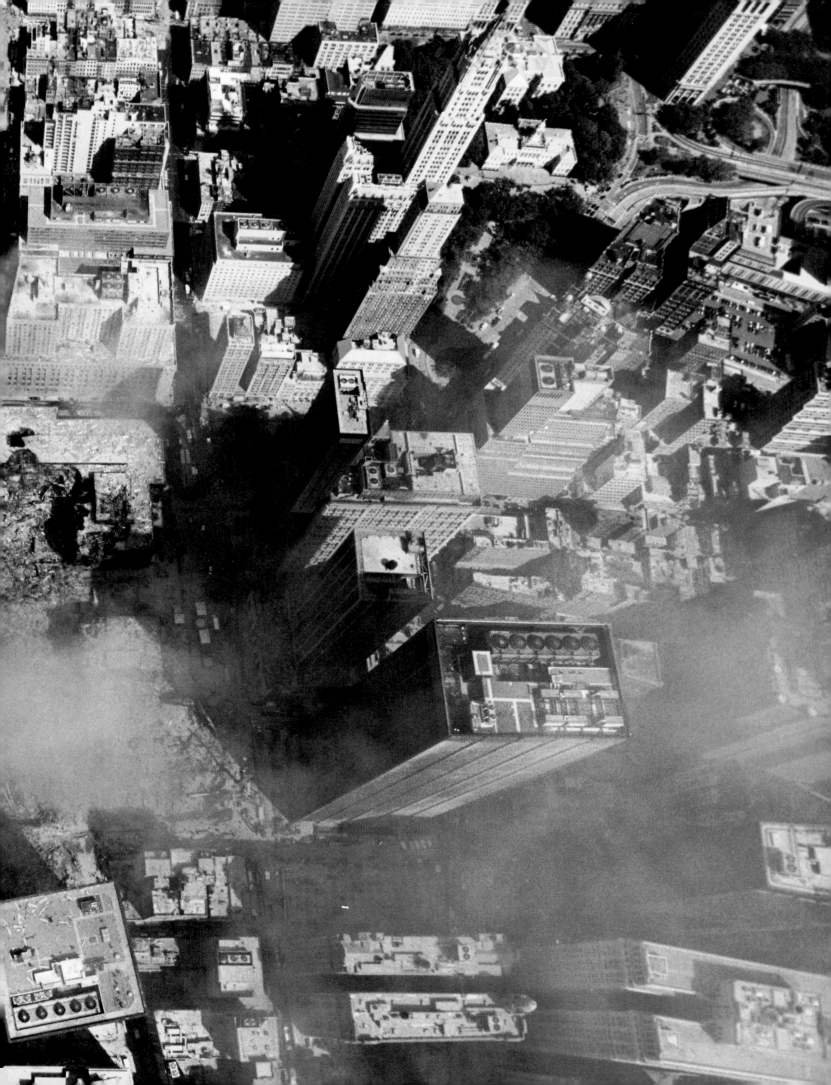

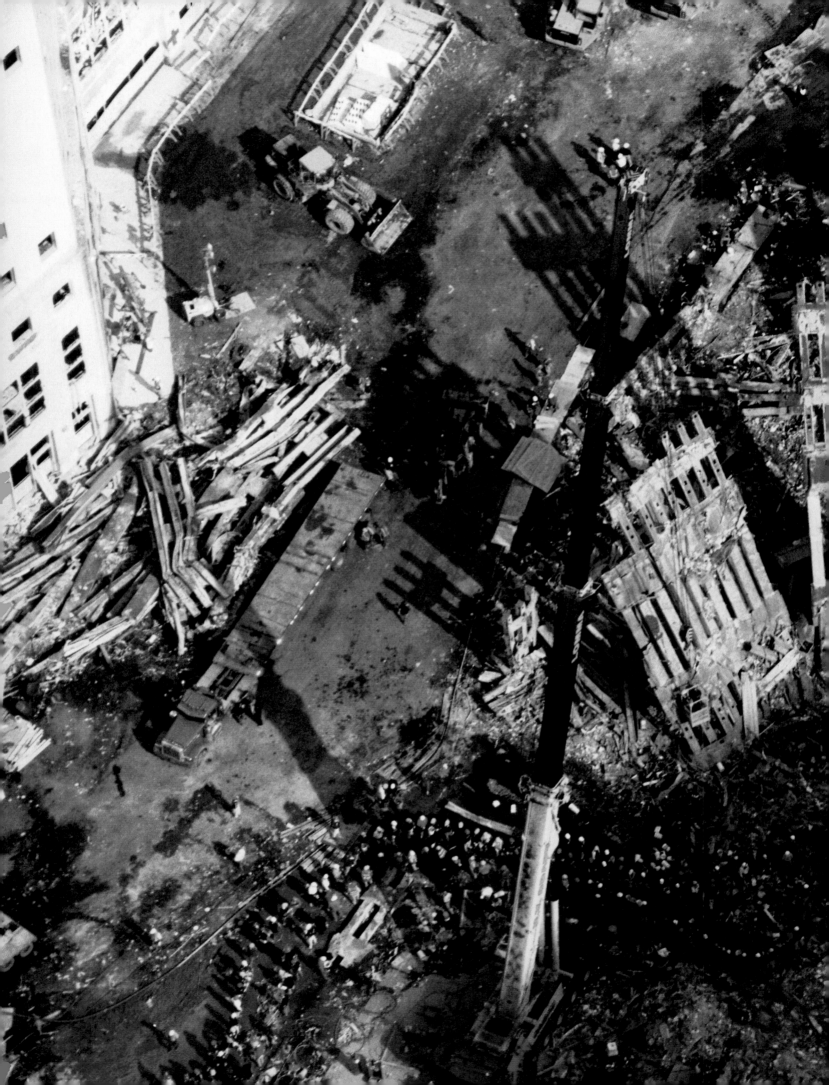

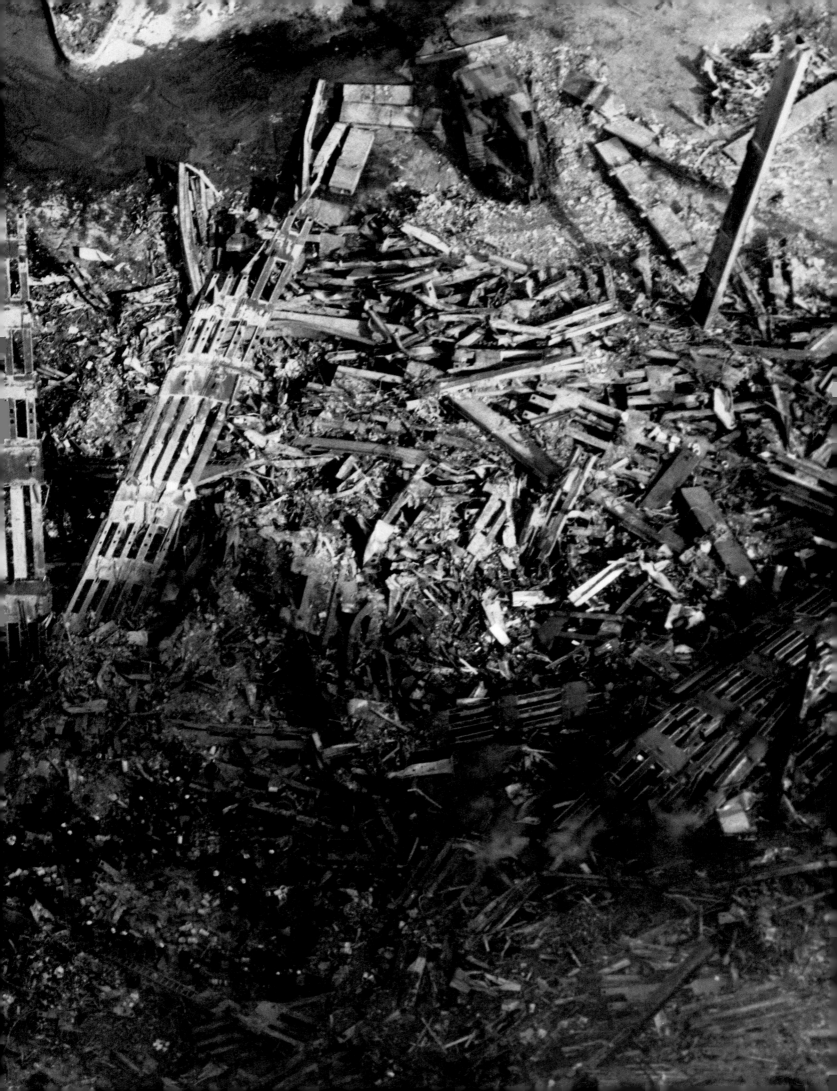

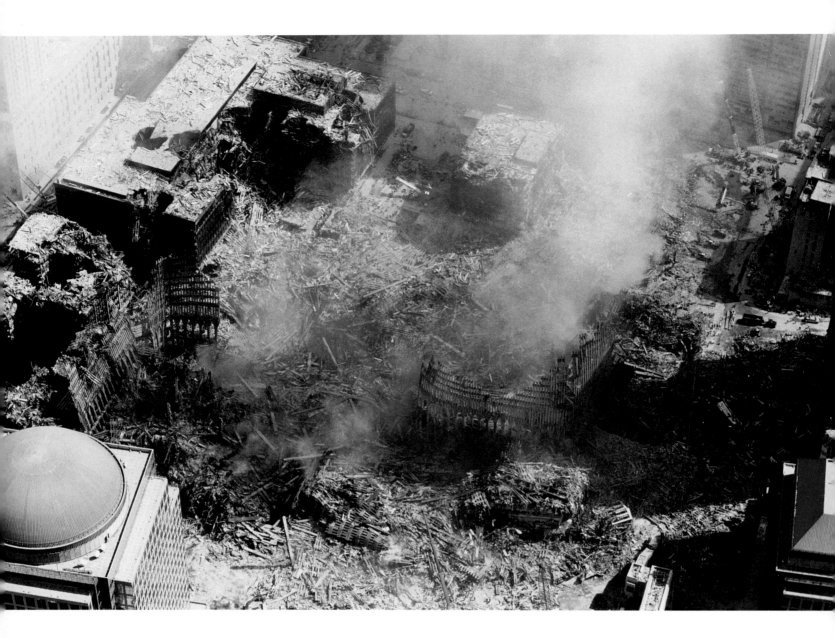

Looking east above Ground Zero. 1 WTC (north tower) to the left and 2 WTC (south tower) to the right, September 17.

OPPOSITE ABOVE: The remains of building 6 and the north tower, September 17.

OPPOSITE BELOW: Ground Zero, September 18. West Street is at the bottom of the picture, Vesey Street is on the left, Liberty Street and the South Bridge are to the right.

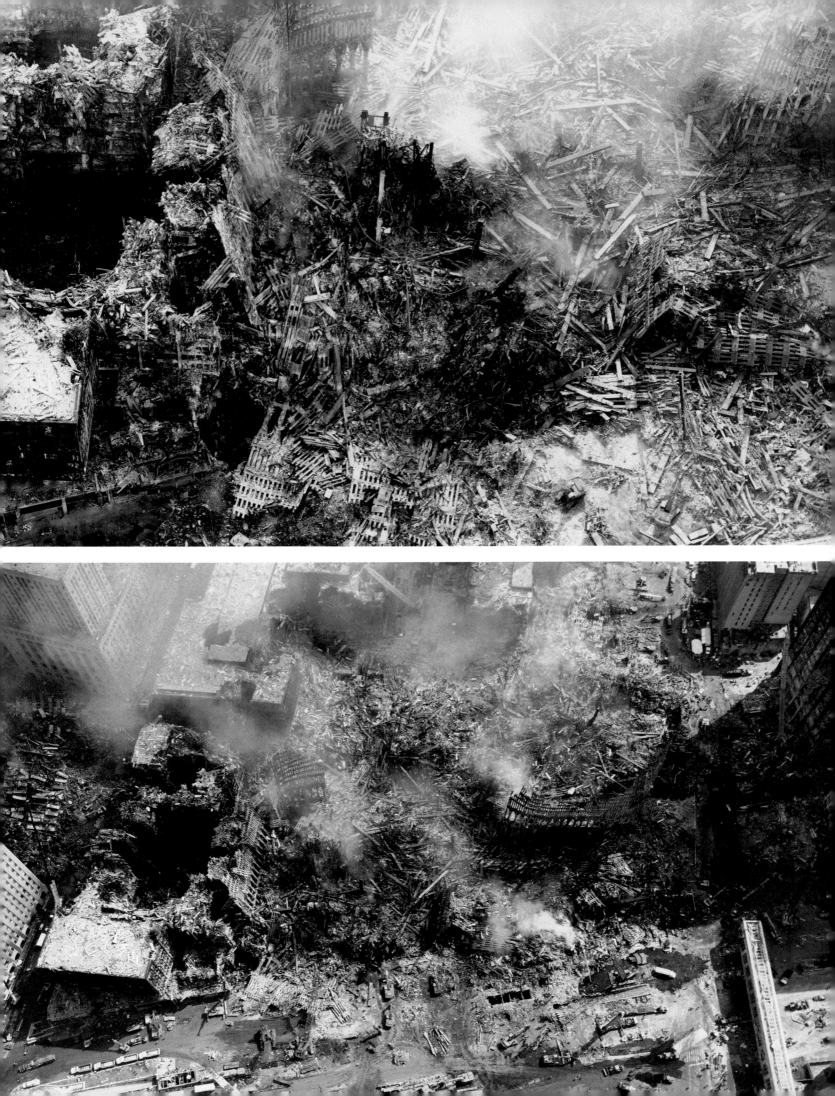

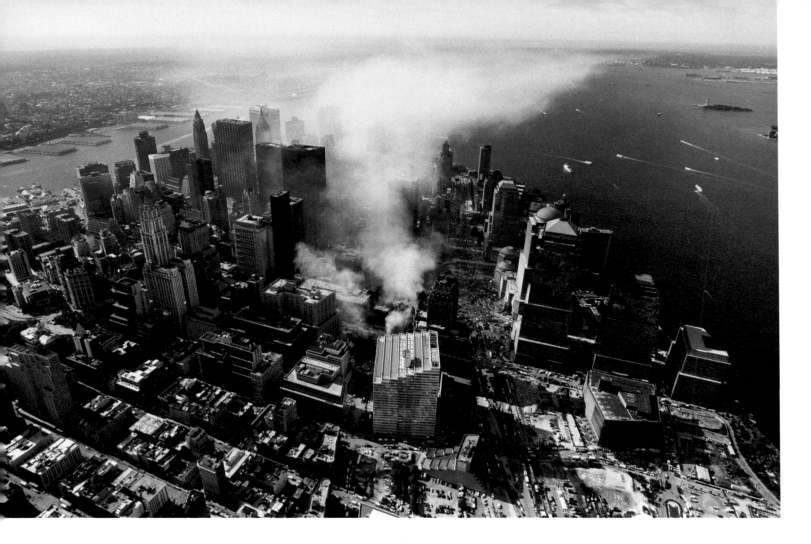

Lower Manhattan, September 18.

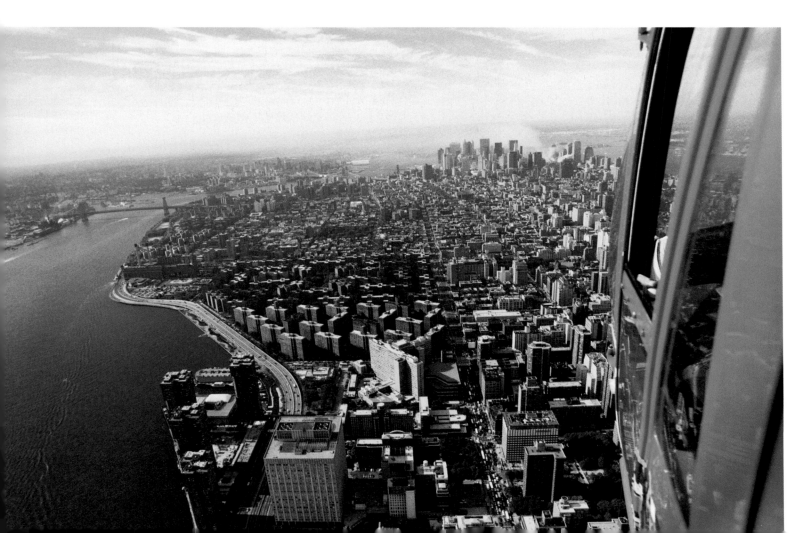

Fresh Kills Staten Island landfill on Staten Island was reopened to receive the wreckage from the World Trade Center. Trucks carrying tons of debris arrived at the three-hundred-acre site daily. It was gruesome work sifting through the material, searching for evidence and recovering personal effects and human remains.

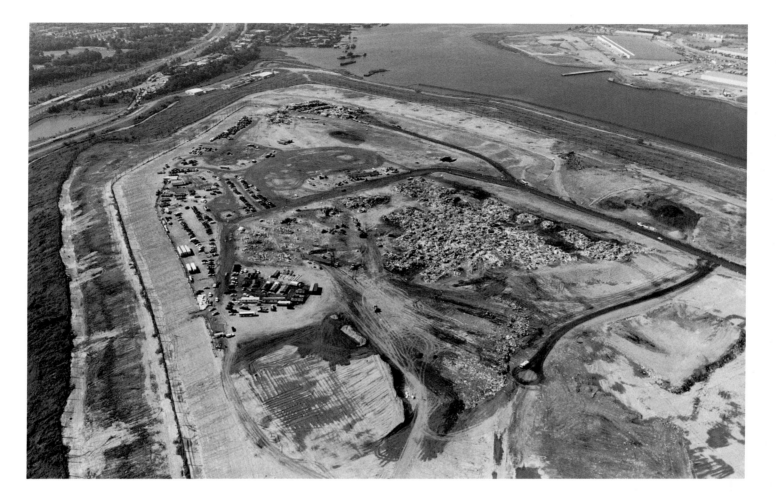

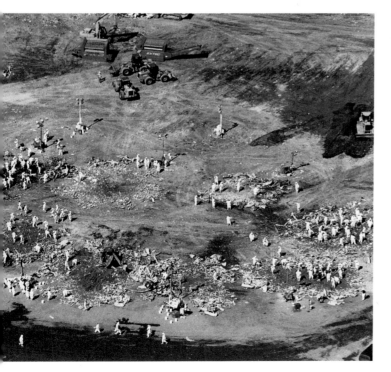

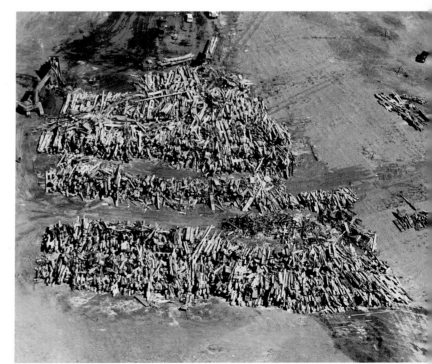

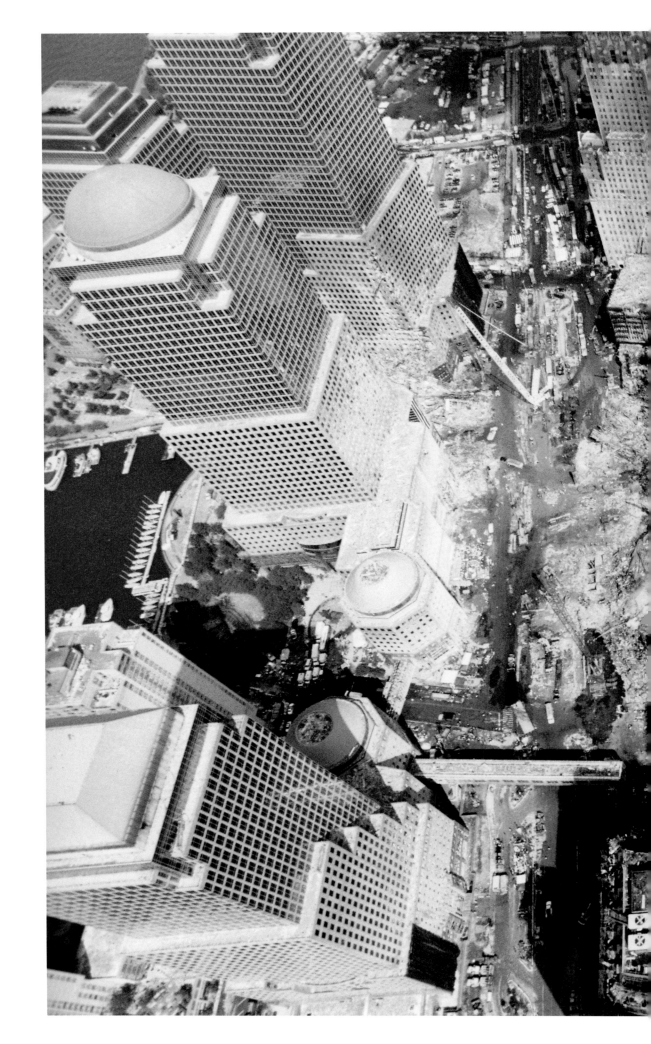

Ground Zero, September 21. West (*left*) and Church (*right*) streets have been cleared. A tarred path has been laid for the crane, on the lower left by South Bridge.

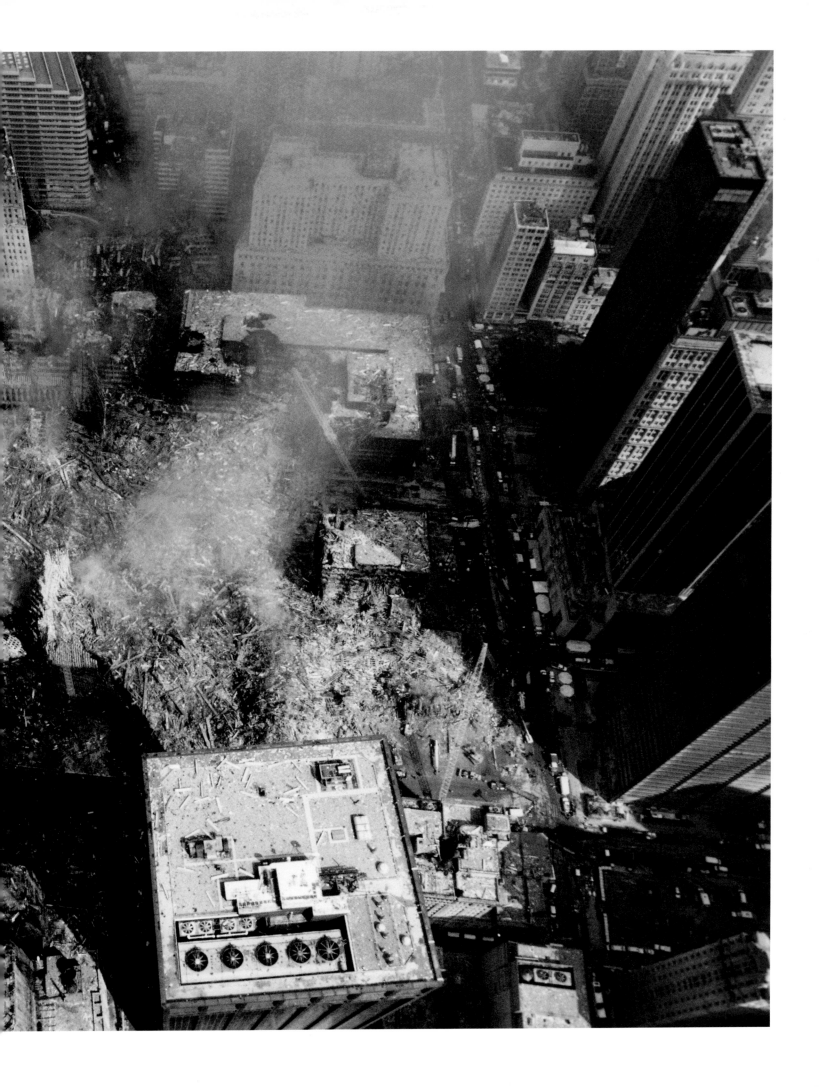

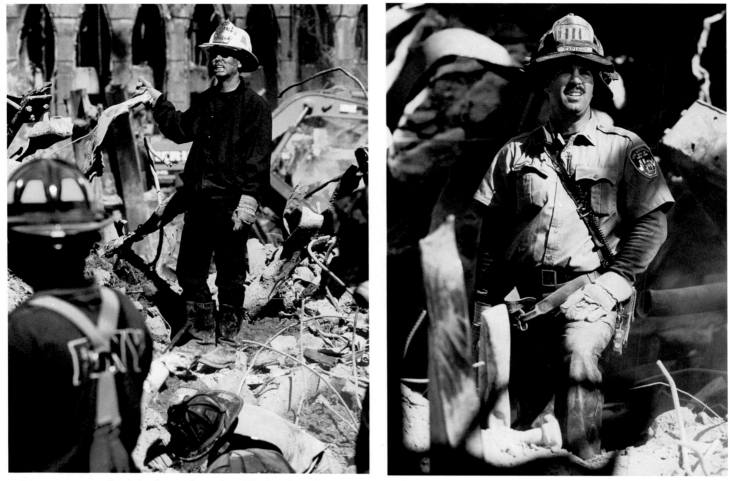

ABOVE RIGHT: Captain Steve Geraghty. His brother, Ed, a battalion chief, has been missing since September 11.

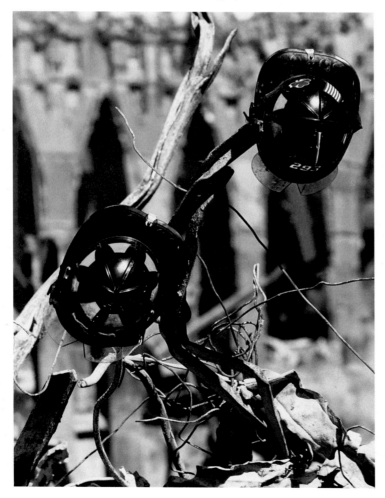

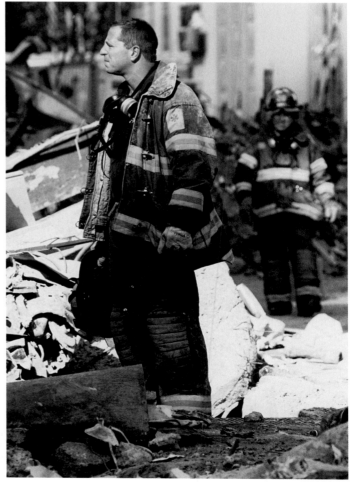

Portraits of firefighters. No one was found alive after September 12, but people refused to give up hope. After a couple of weeks, though, the search for survivors became, admittedly, a search for bodies. The firefighters searched tirelessly for their fallen comrades.

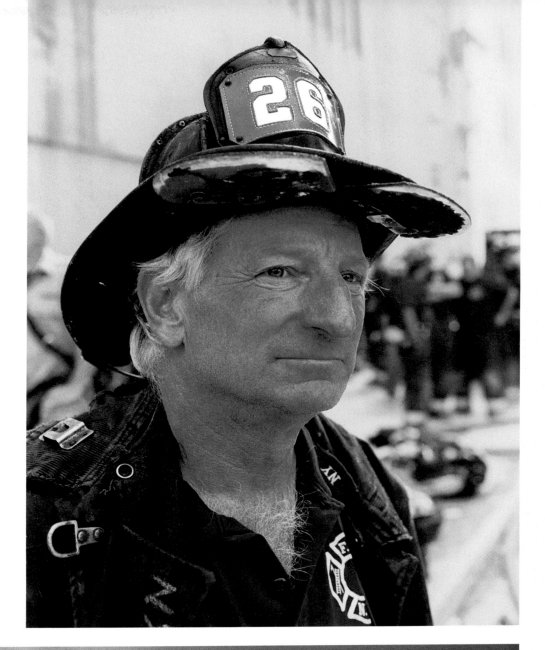

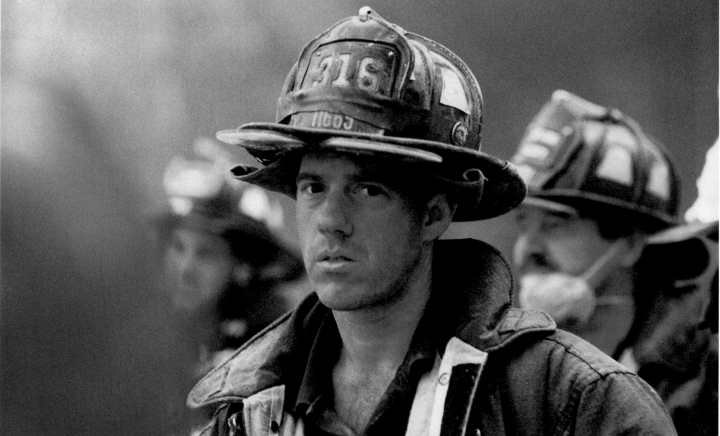

A MEMORIAL SERVICE AT GROUND ZERO, OCTOBER 11. THIS WAS THE FIRST OF MANY MEMORIALS AT GROUND ZERO.

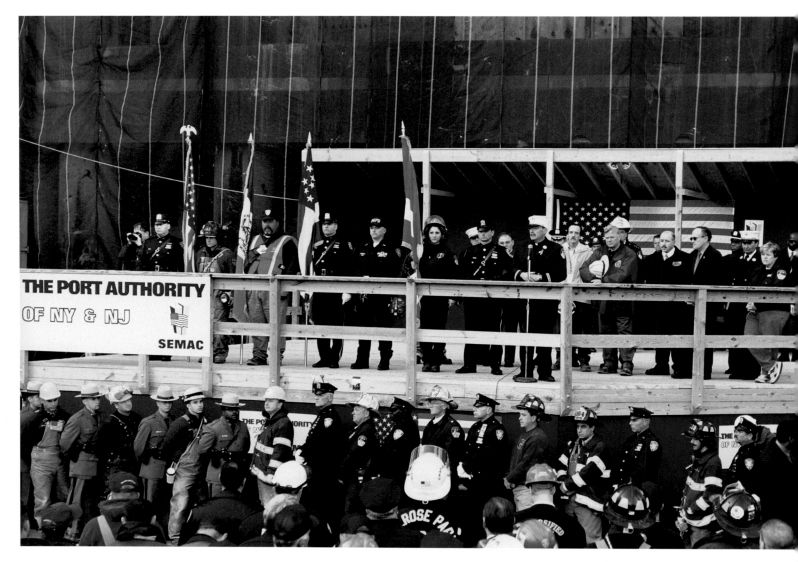

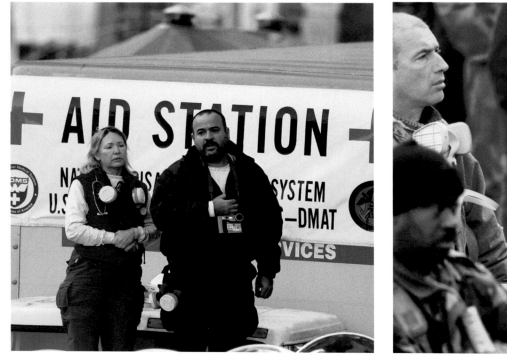

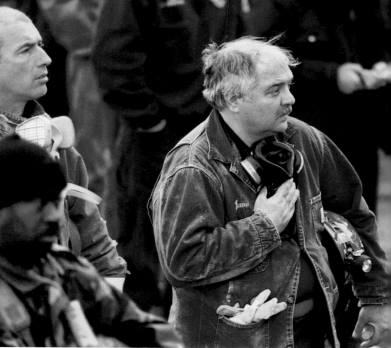

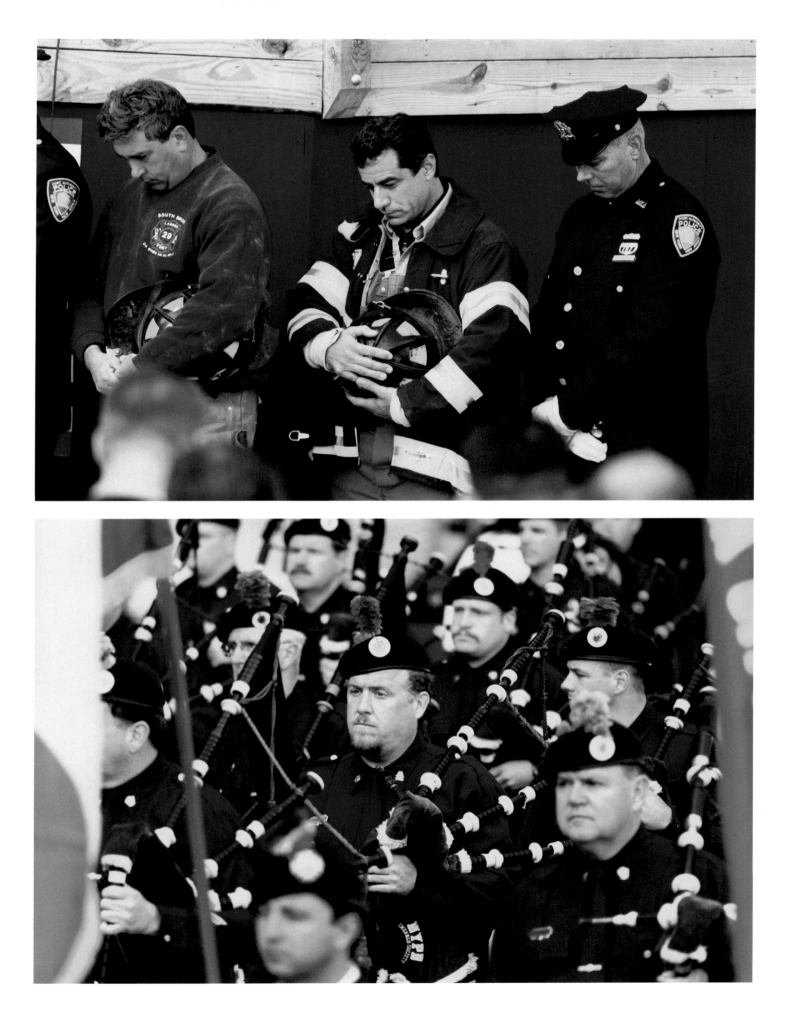

THE CLEANUP OPERATION WAS A MAMMOTH UNDERTAKING FRAUGHT WITH DANGER BUT, ALL IN ALL, INJURIES WERE FEW AND MINOR AND THE JOB, EXPECTED TO TAKE AS MUCH AS A COUPLE OF YEARS, WOULD BE ALMOST COMPLETED WITHIN EIGHT MONTHS.

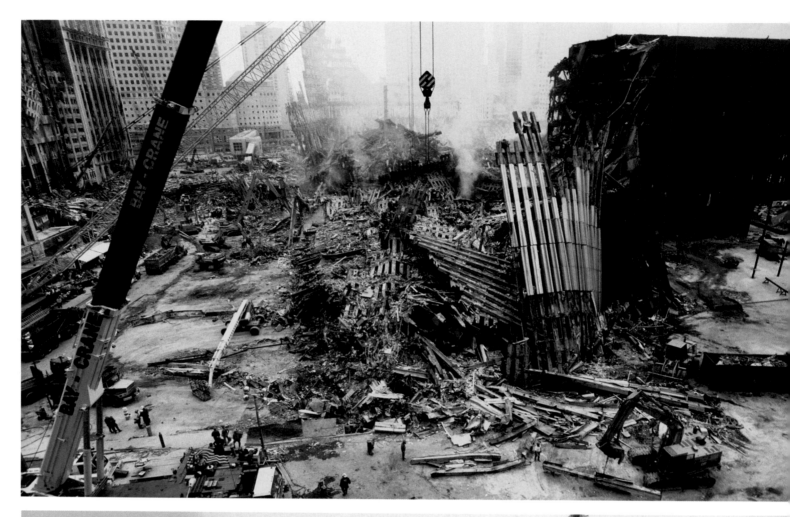

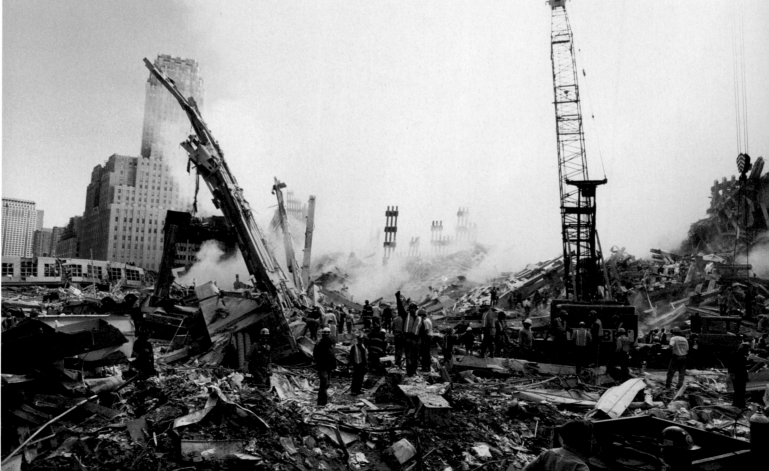

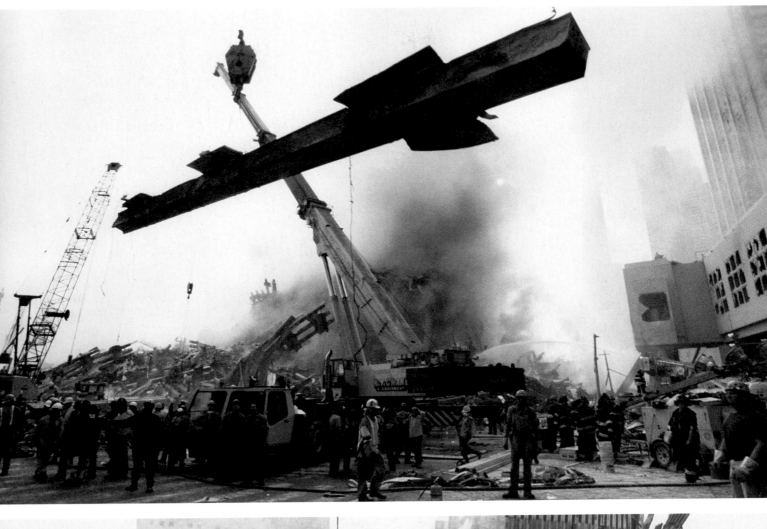

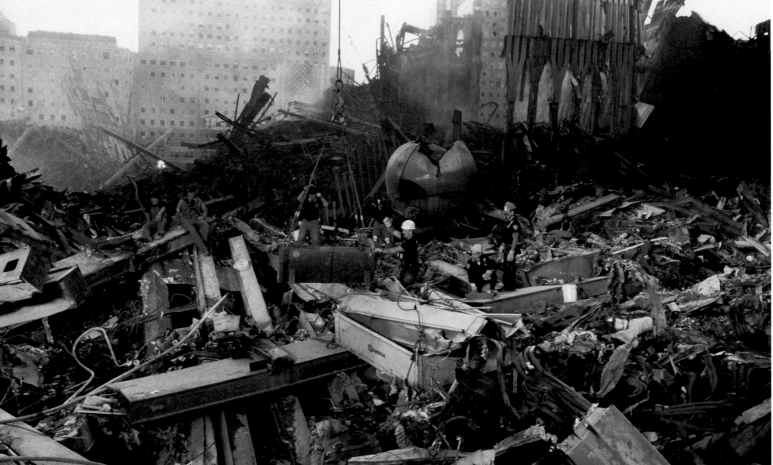

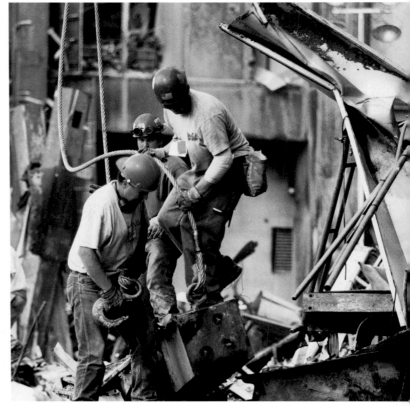

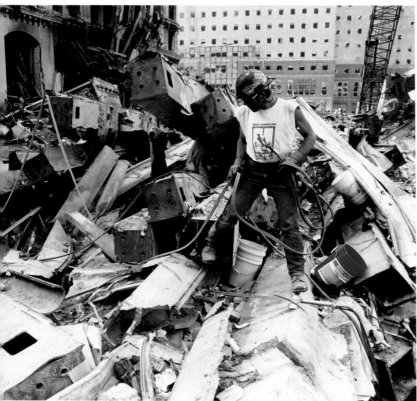

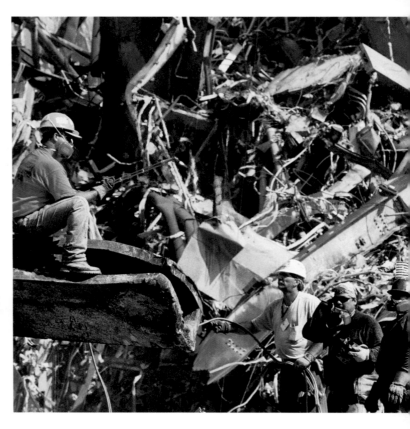

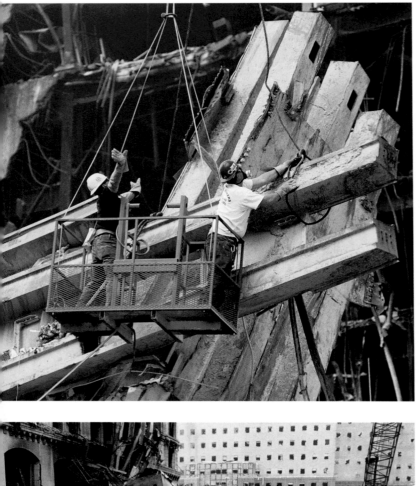

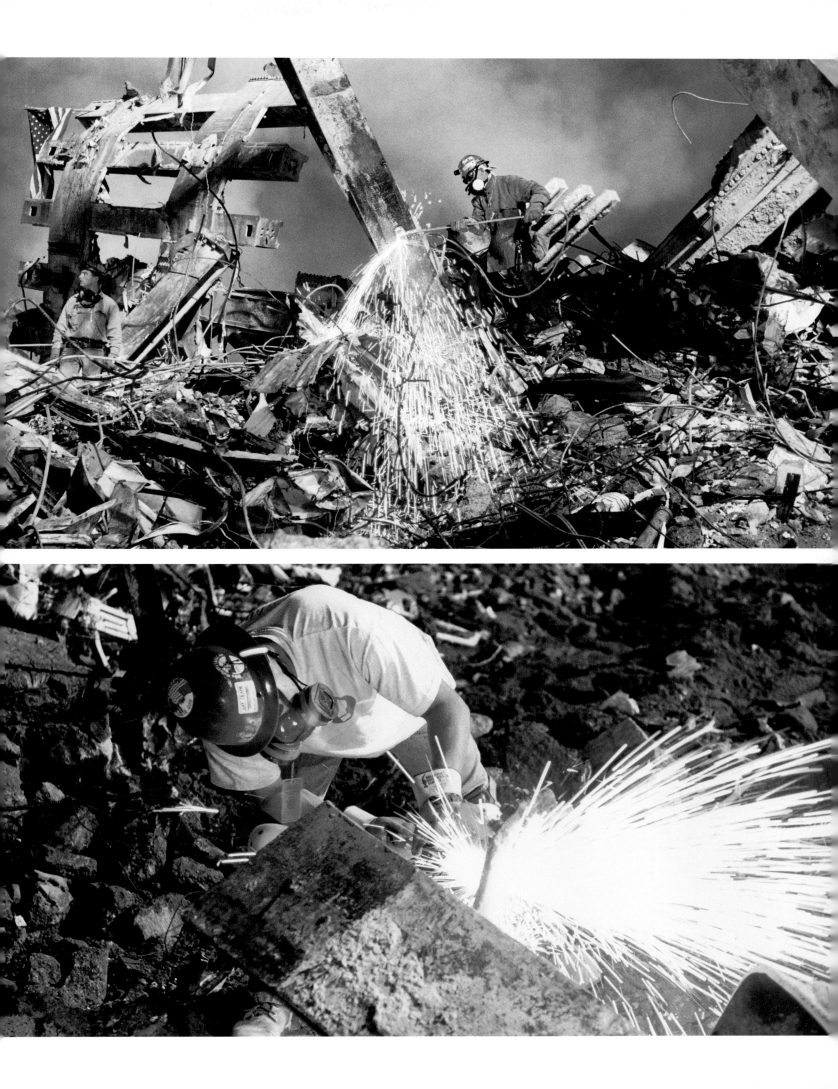

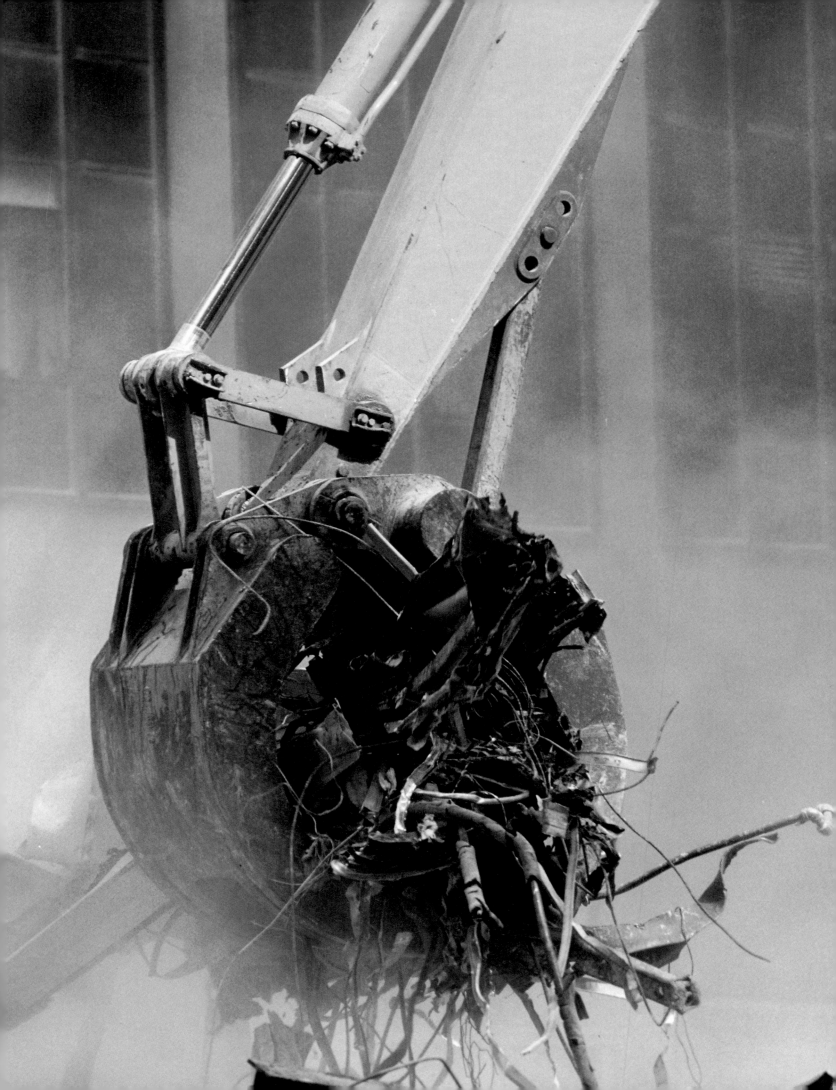

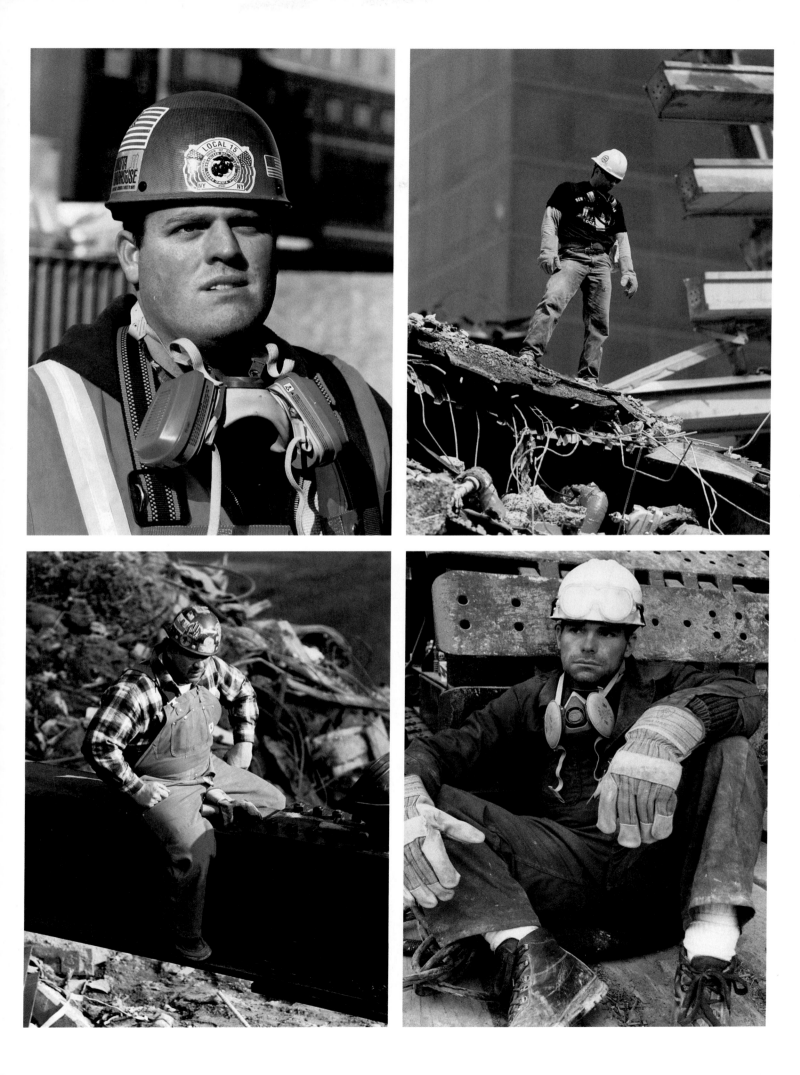

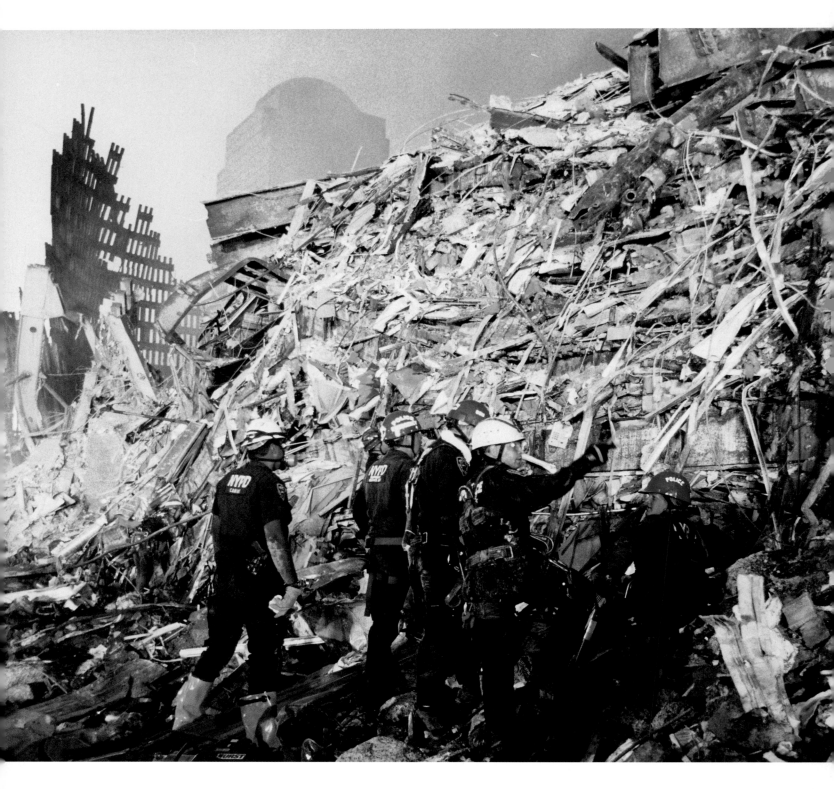

OPPOSITE ABOVE LEFT AND RIGHT: The dogs were incredible. They sensed they had an important job to do. They also seemed to know that a quick waggle of the tail would make you feel good.

OPPOSITE BELOW LEFT: Detective Mike Werner about to make a physical check of an area before he brought in the pole camera.

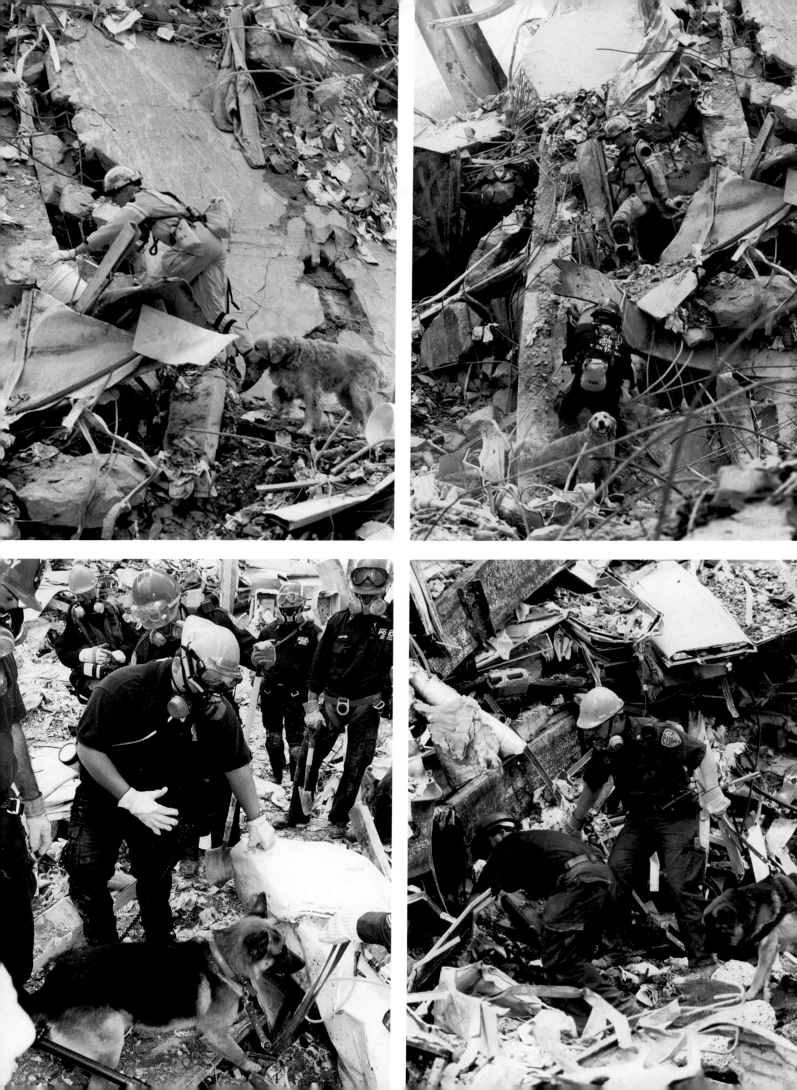

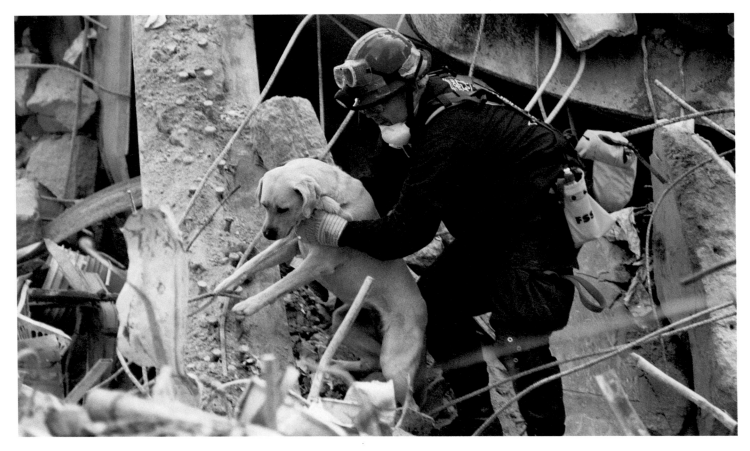

ABOVE: Teamwork.
BELOW: After September 12, no one was found alive, and the dogs were distressed not to locate survivors.
It became necessary to stage situations where "survivors" were found by the dogs to keep up their morale.

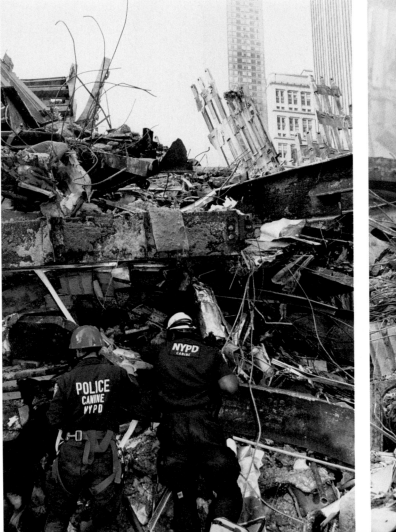

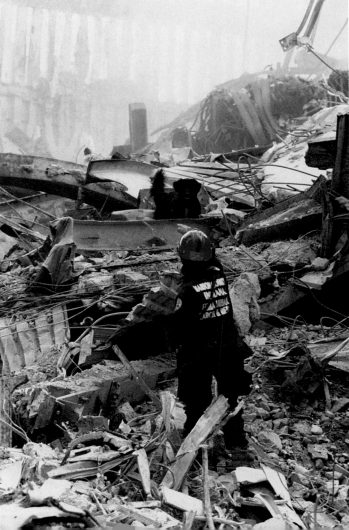

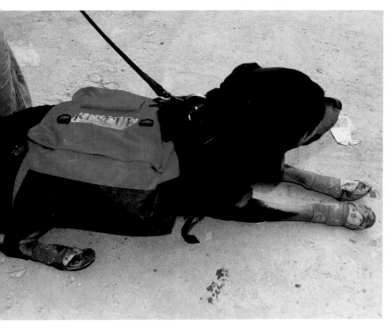

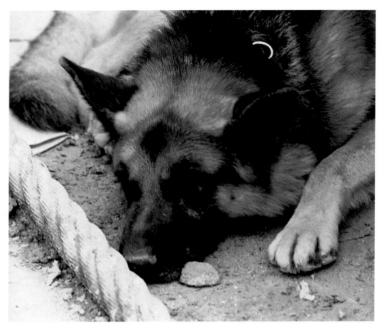

ABOVE LEFT: Some dogs needed paw pads to walk over the jagged terrain, but most of the dogs didn't like using them.

ABOVE RIGHT: A well-deserved rest.

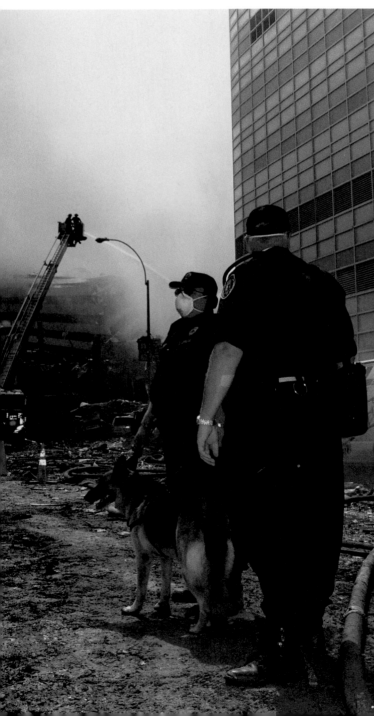

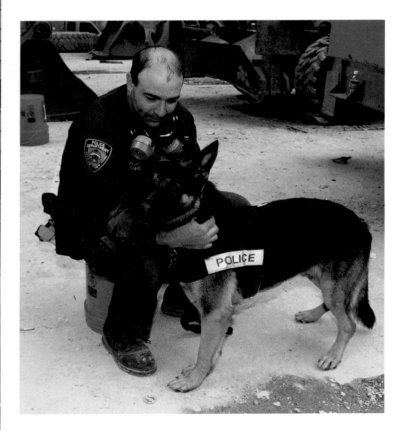

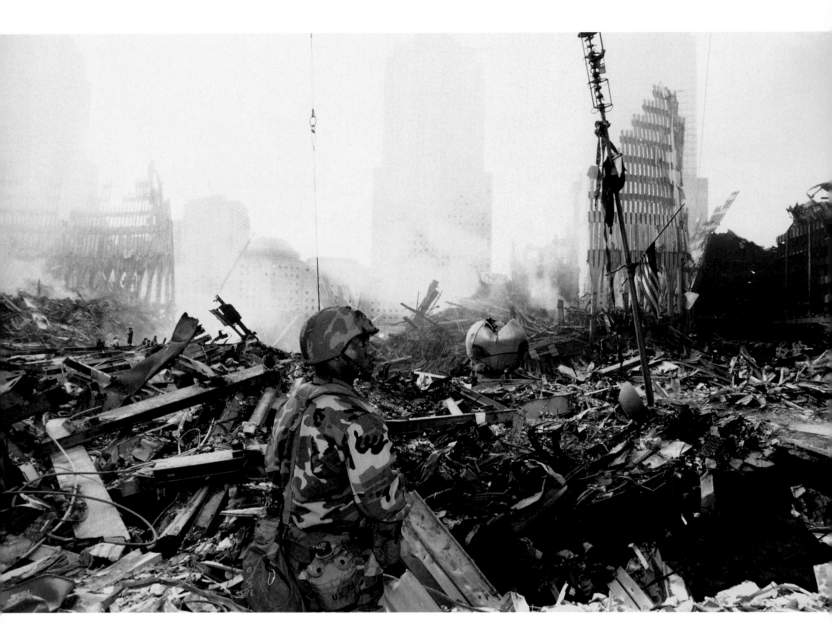

A national guardsman on duty at Ground Zero and on the perimeter.

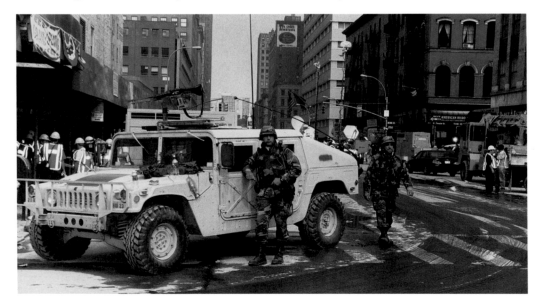

OPPOSITE: A firefighter contemplating the ruins.

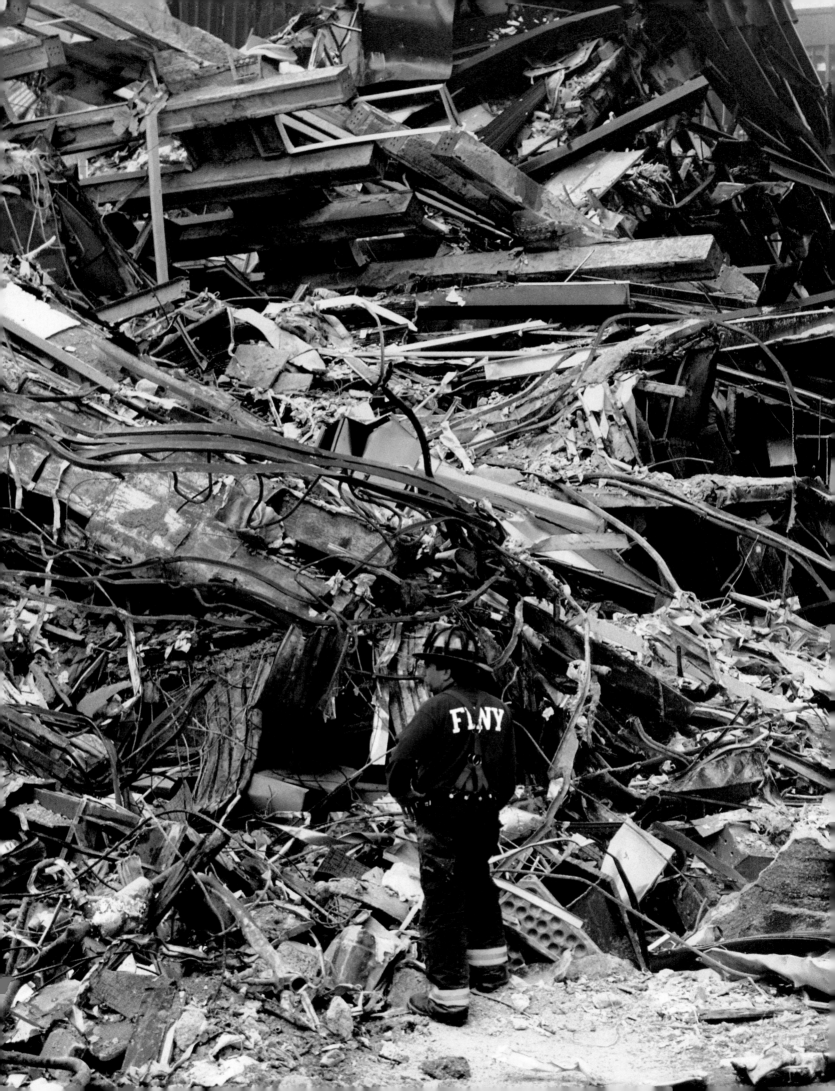

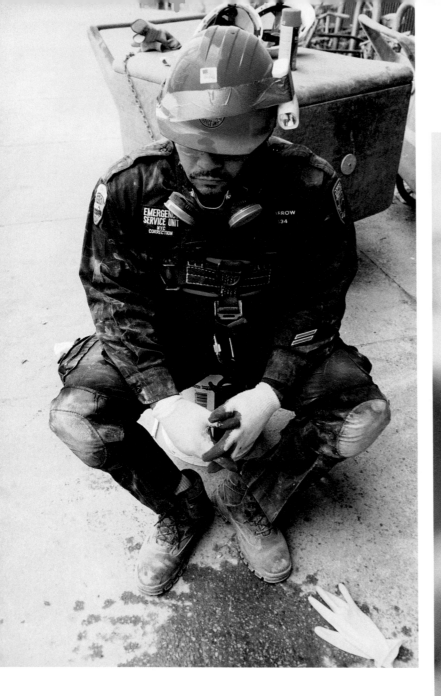

An emergency services officer.

A cop.

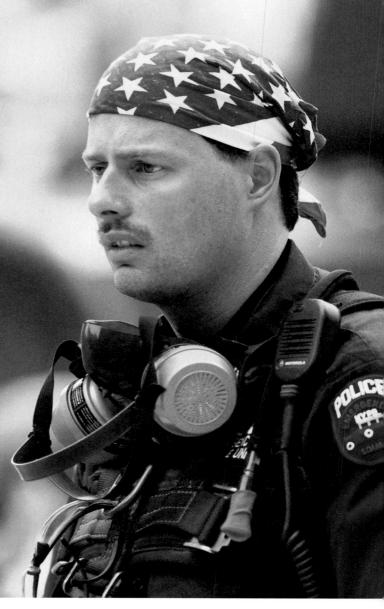

OPPOSITE: Police officers on duty at Ground Zero.

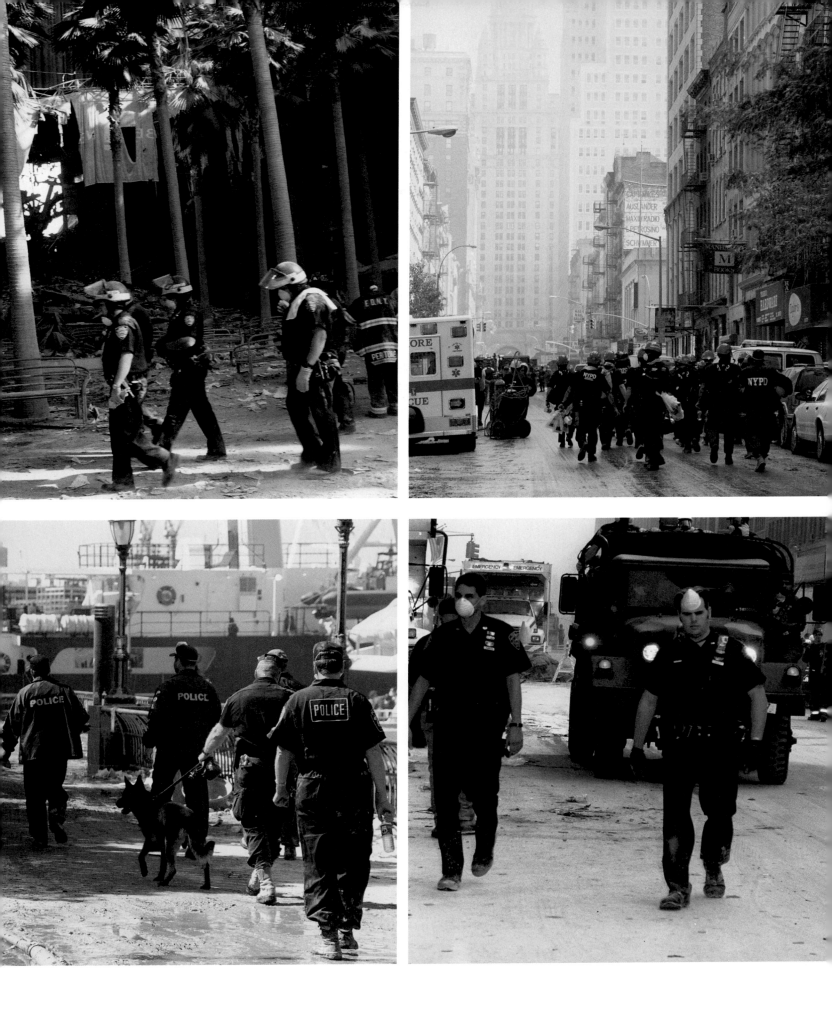

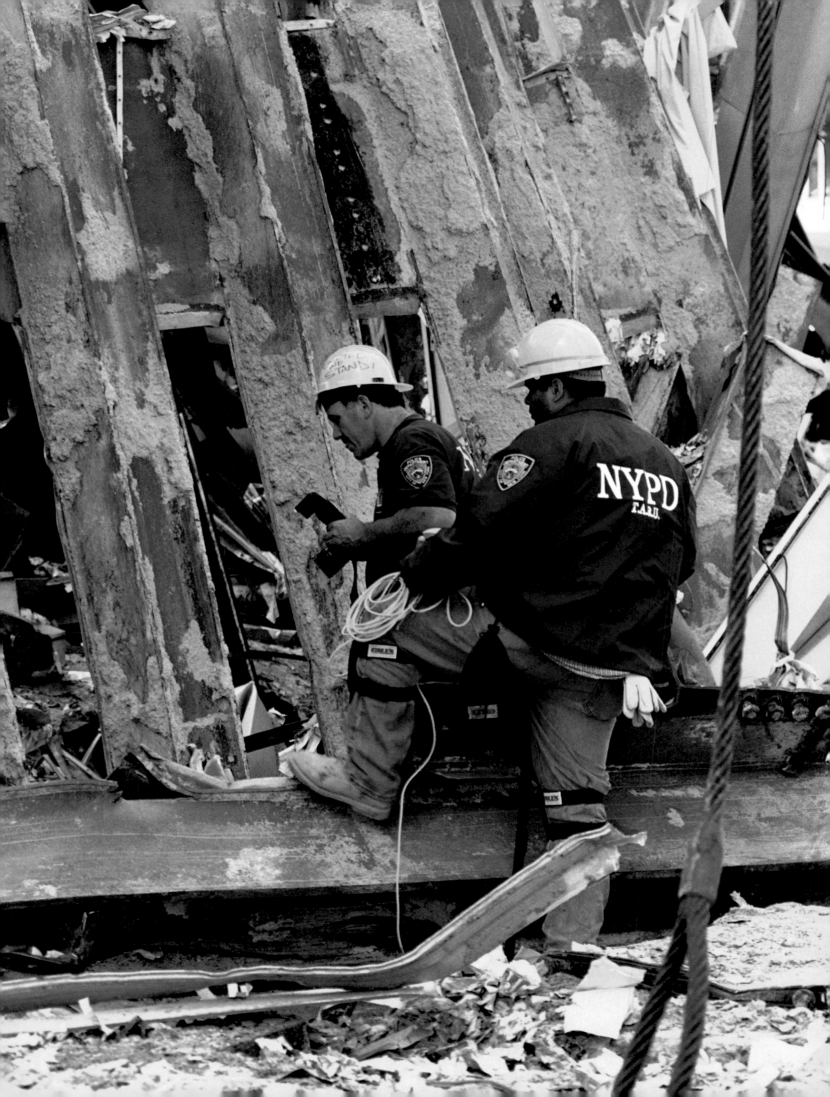

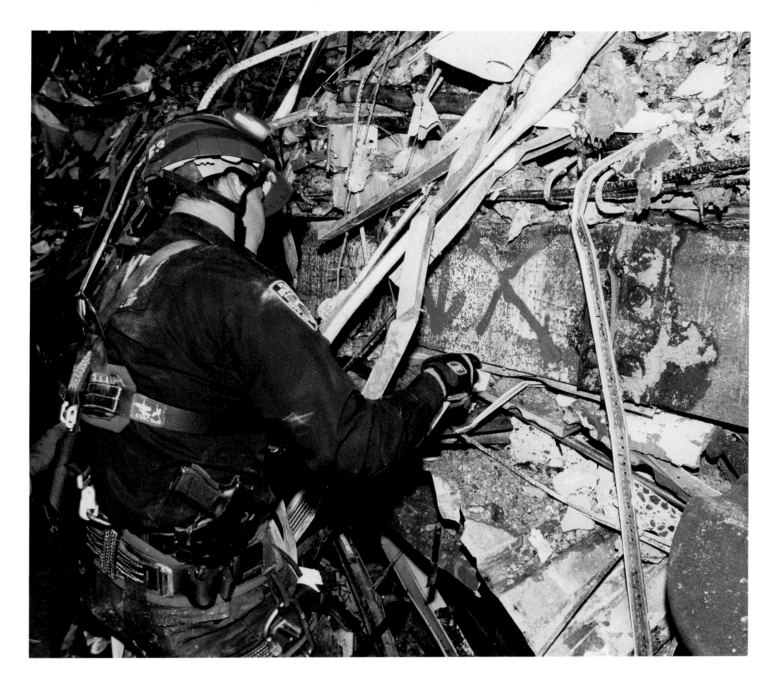

As sad as this mark was, it would, we hoped, lead to some closure for the victim's loved ones.

OPPOSITE: Detectives Dave Fitzpatrick and Sanjiv Panchal
checking a small opening to the concourse level.

OVERLEAF: Amid the madness of the carnage, there
was a sense of pride to be here, trying to make it better.

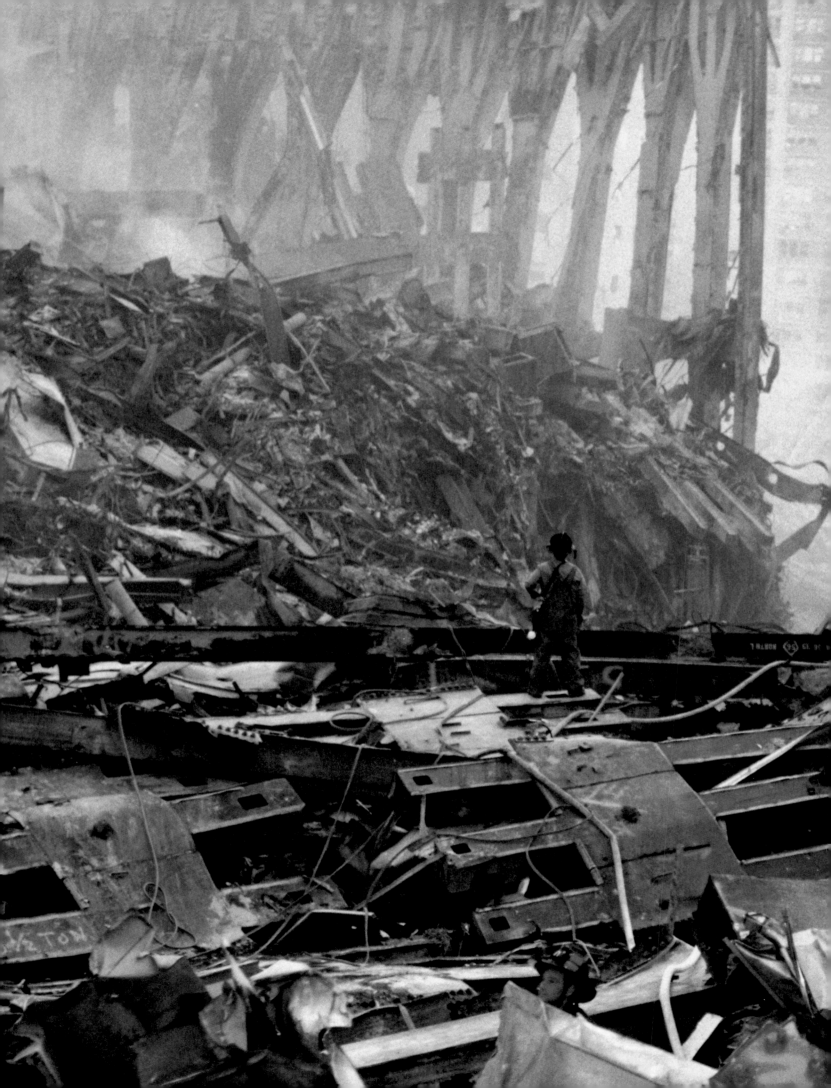

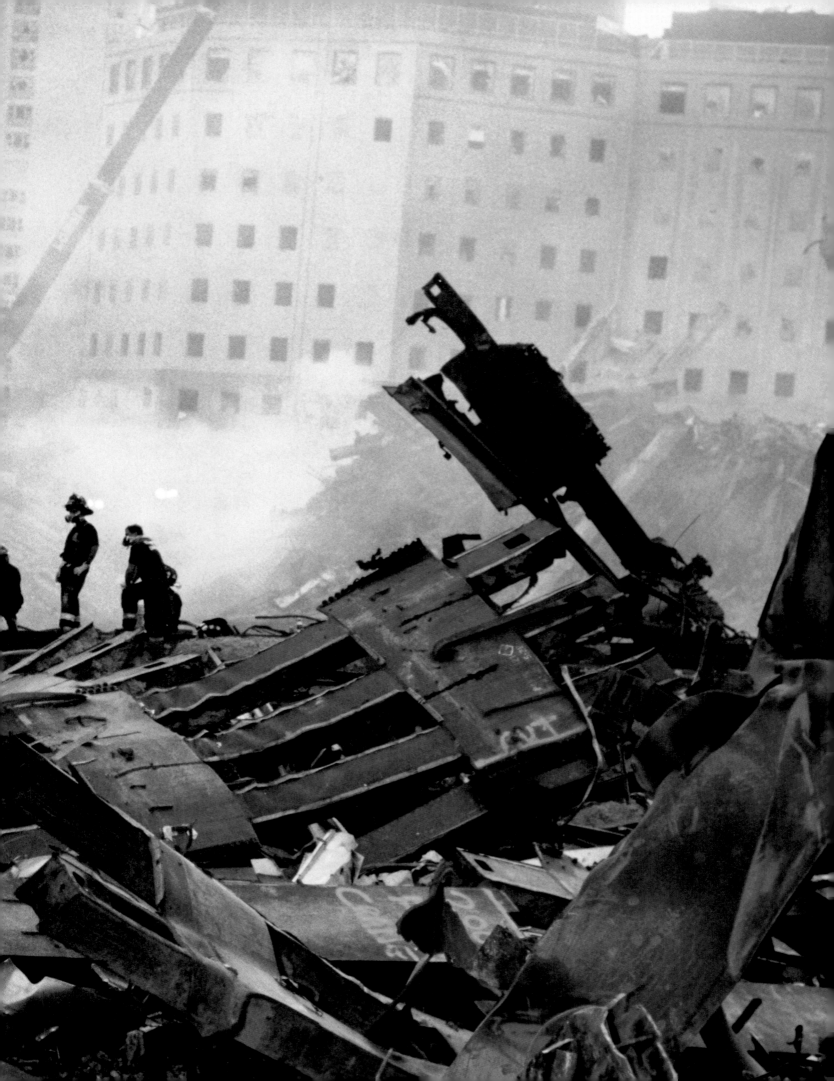

Over time the whole area was marked for clearance, danger spots, the bodies of victims. Multiple operations were carried on at once. While heavy equipment grappled with steel beams, firefighters, cops, and others sifted through the dust and rubble.

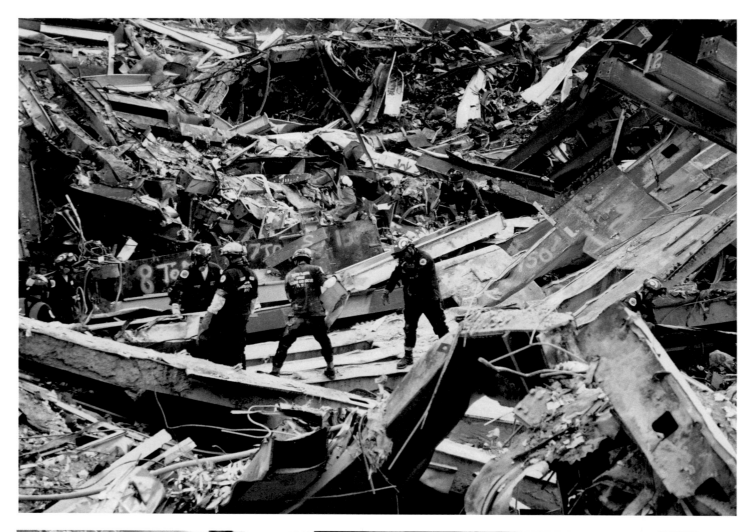

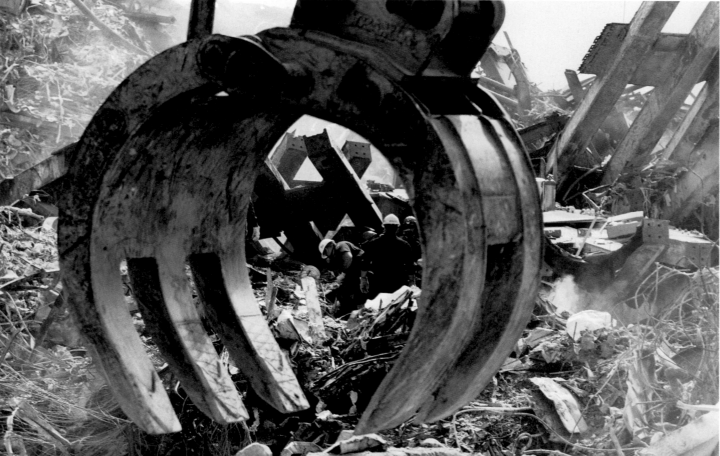

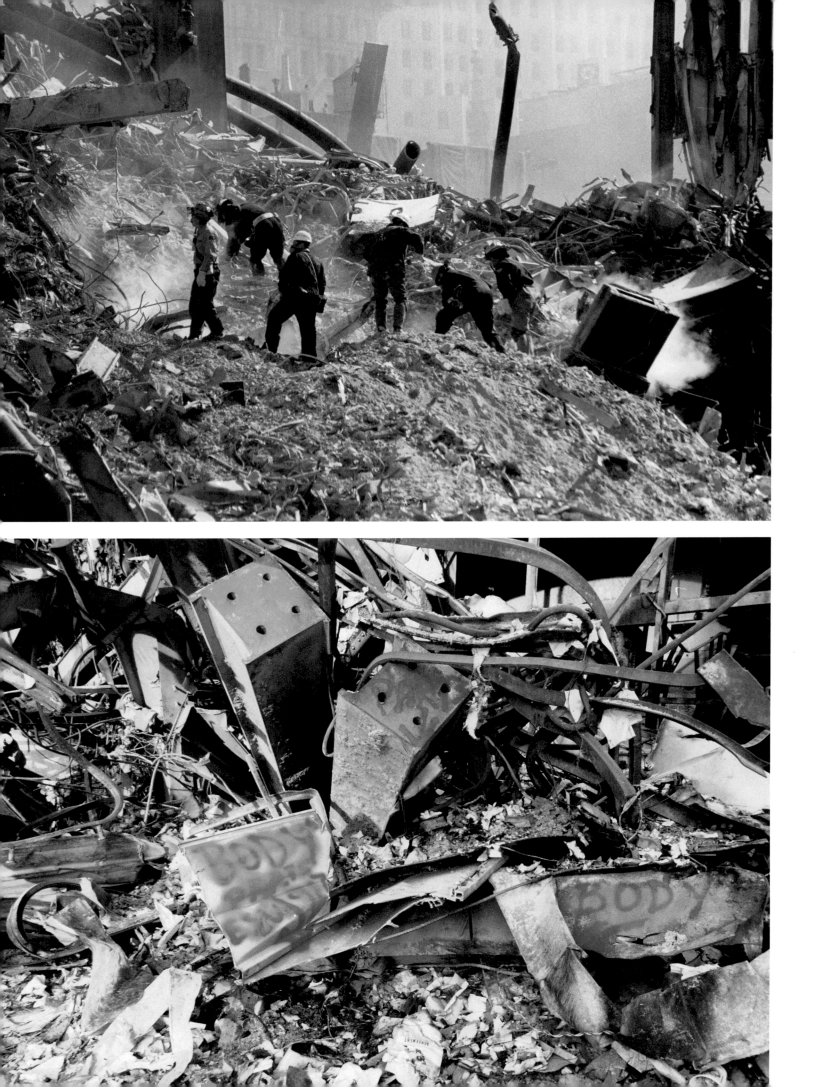

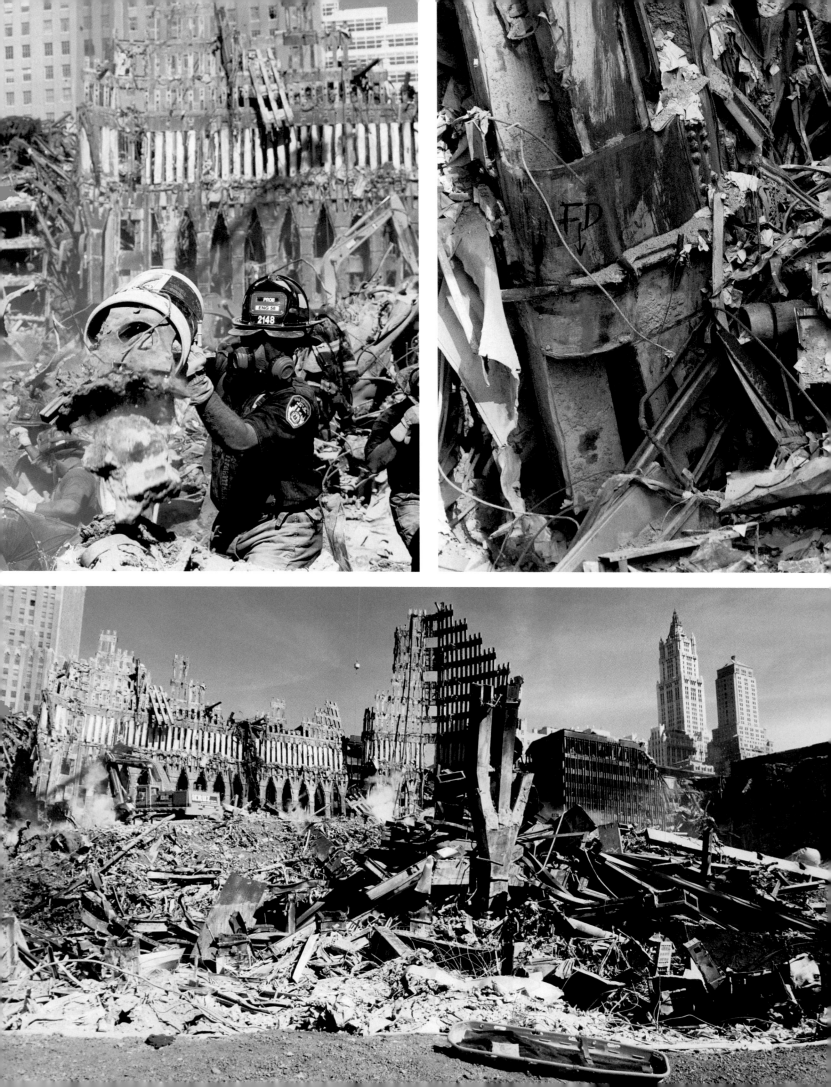

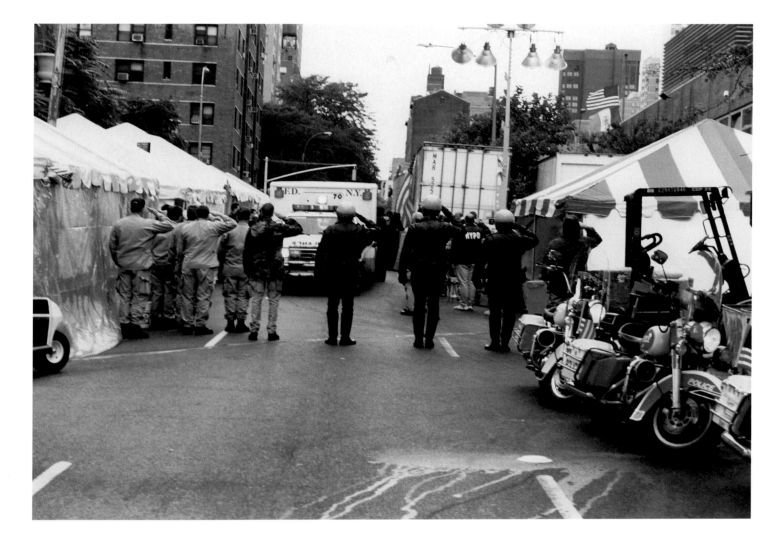

An ambulance carrying a body arrives at the morgue, where it is received in honor.

IN ADDITION TO THE UNIFORMED SERVICES, A HOST OF VOLUNTEERS WORKED ON THE EDGES OF GROUND ZERO.
A MAKESHIFT CITY SPRANG UP ON THE MARGINS OF GROUND ZERO, PROVIDING FOR THE NEEDS OF THE RESCUE WORKERS.

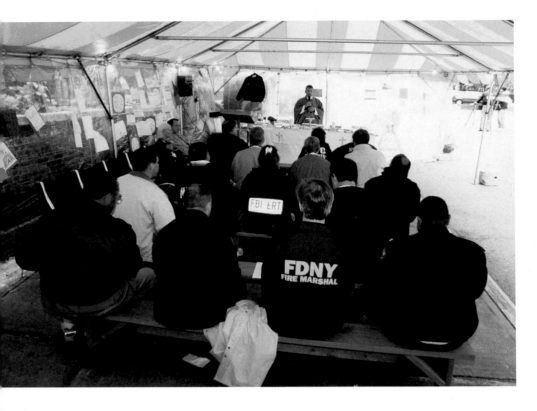

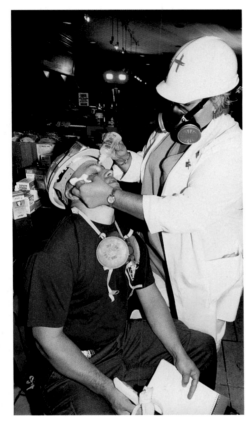

ABOVE AND OPPOSITE:
A first aid station set up in a deli.
It was directly across the street from
the World Trade Center.

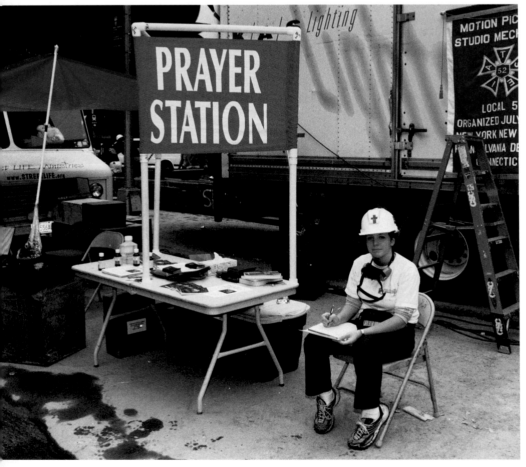

A prayer station.

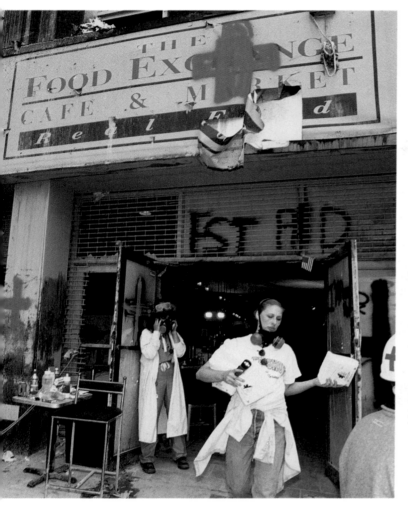

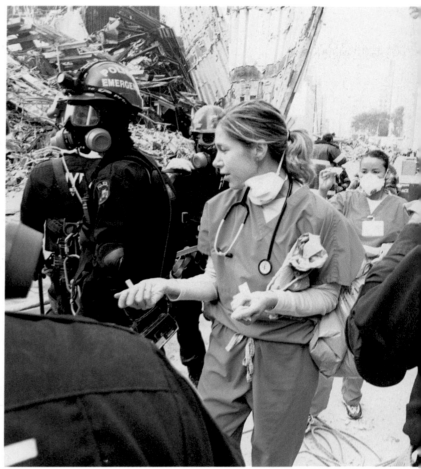

A couple of nurses passing out saline solution to the workers.

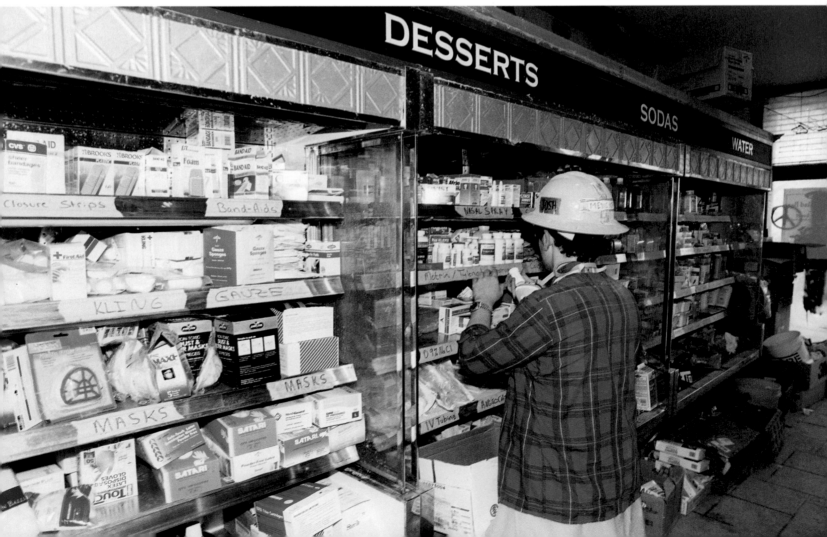

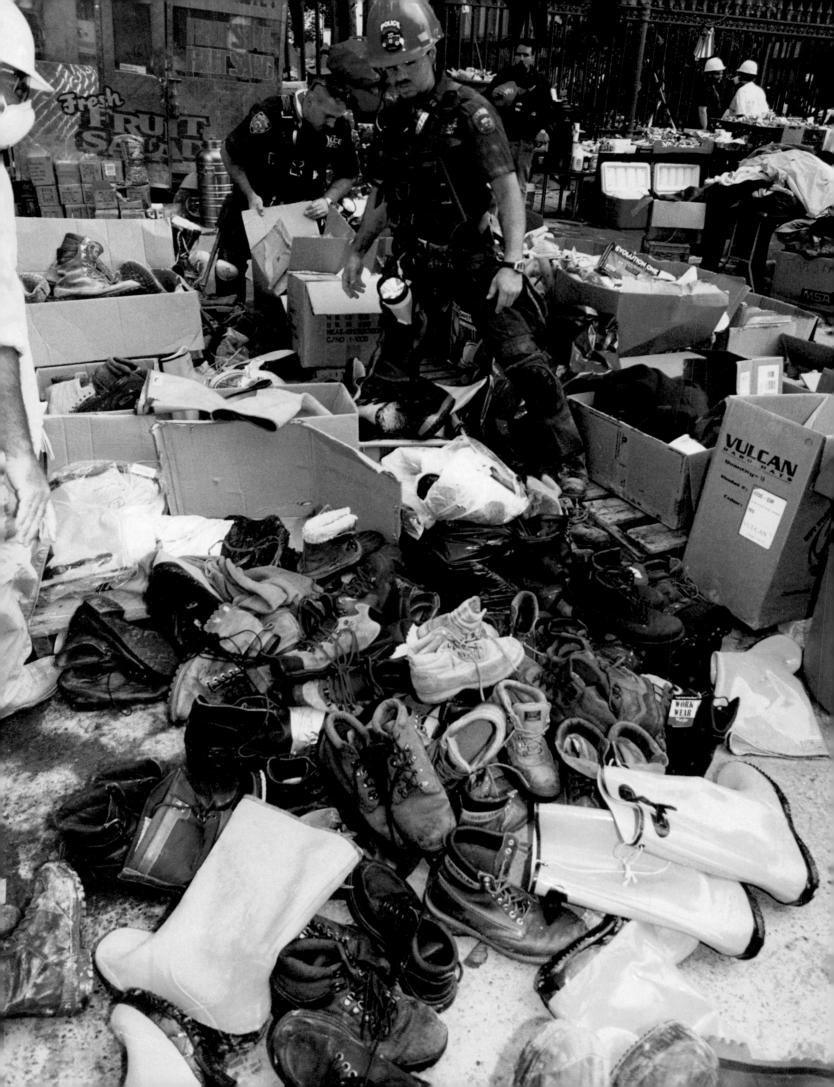

Donations of supplies flowed in and were made available at various street corners. It felt great to see all the stuff. It made us feel like the rest of the country was behind us.

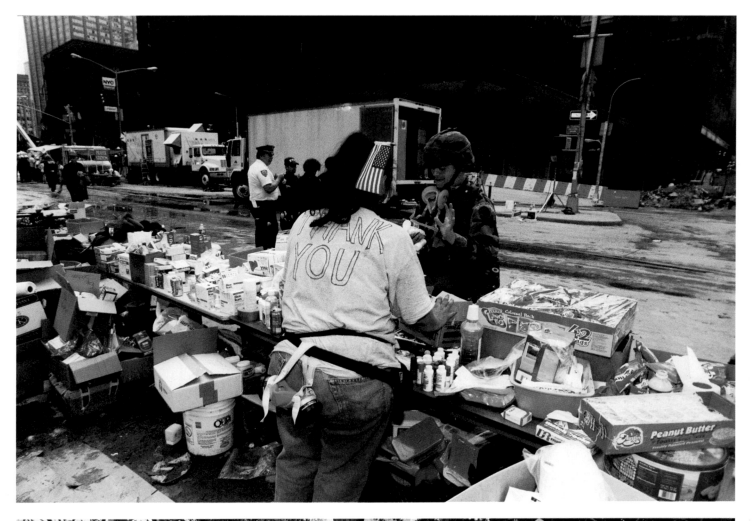

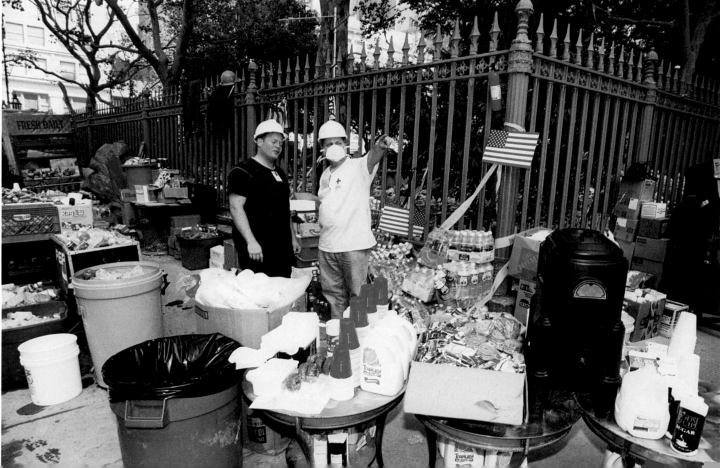

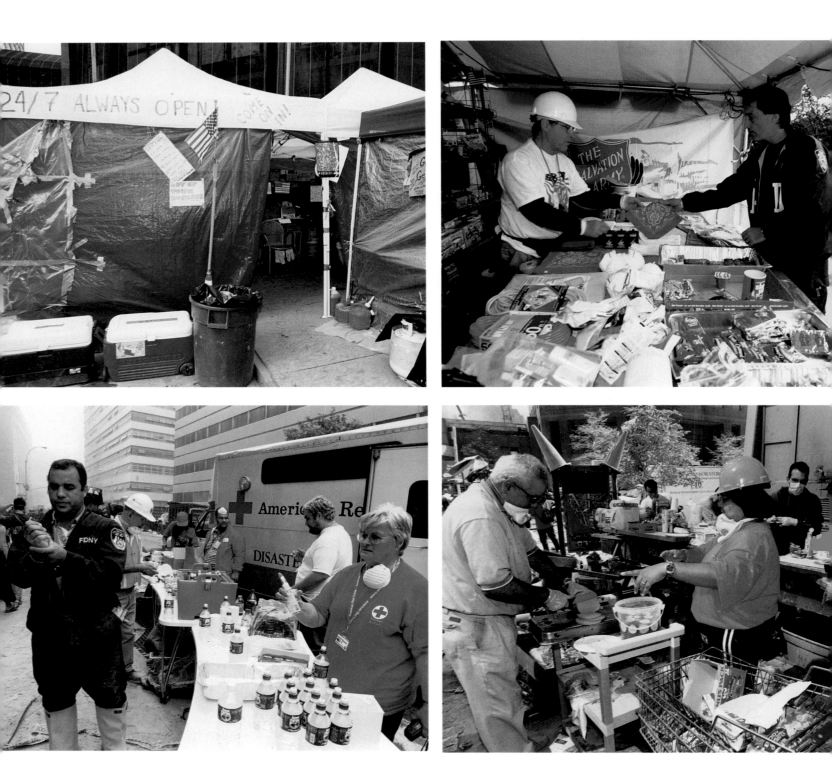

The efforts of the volunteer workers made working a sixteen-hour shift a lot easier.

OPPOSITE: A makeshift sign with a wry and rueful reminder of what followed the attacks on New York and Washington.

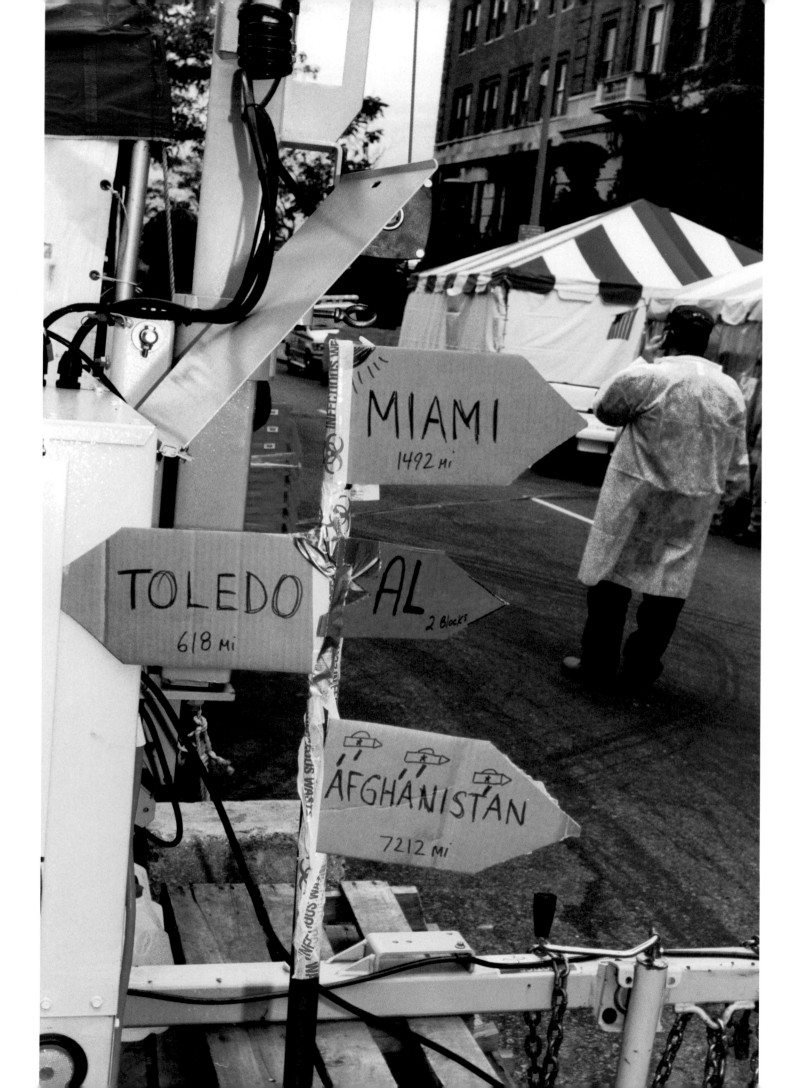

PATRIOTIC FEELING RAN HIGH THROUGHOUT THE COUNTRY.

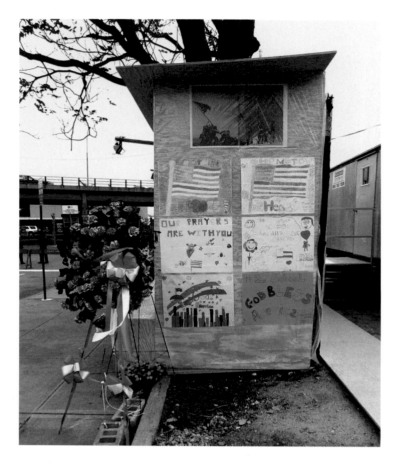

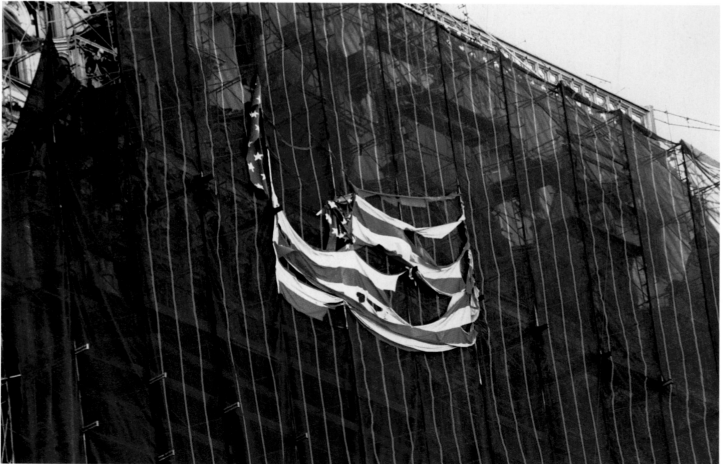

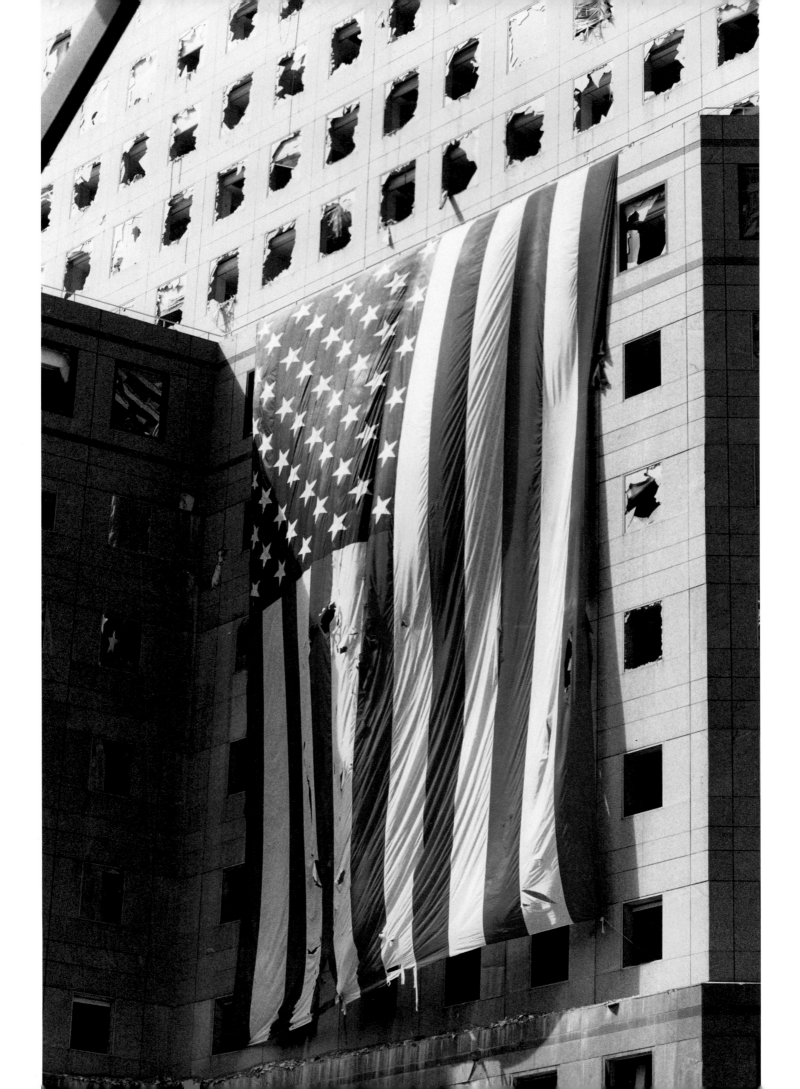

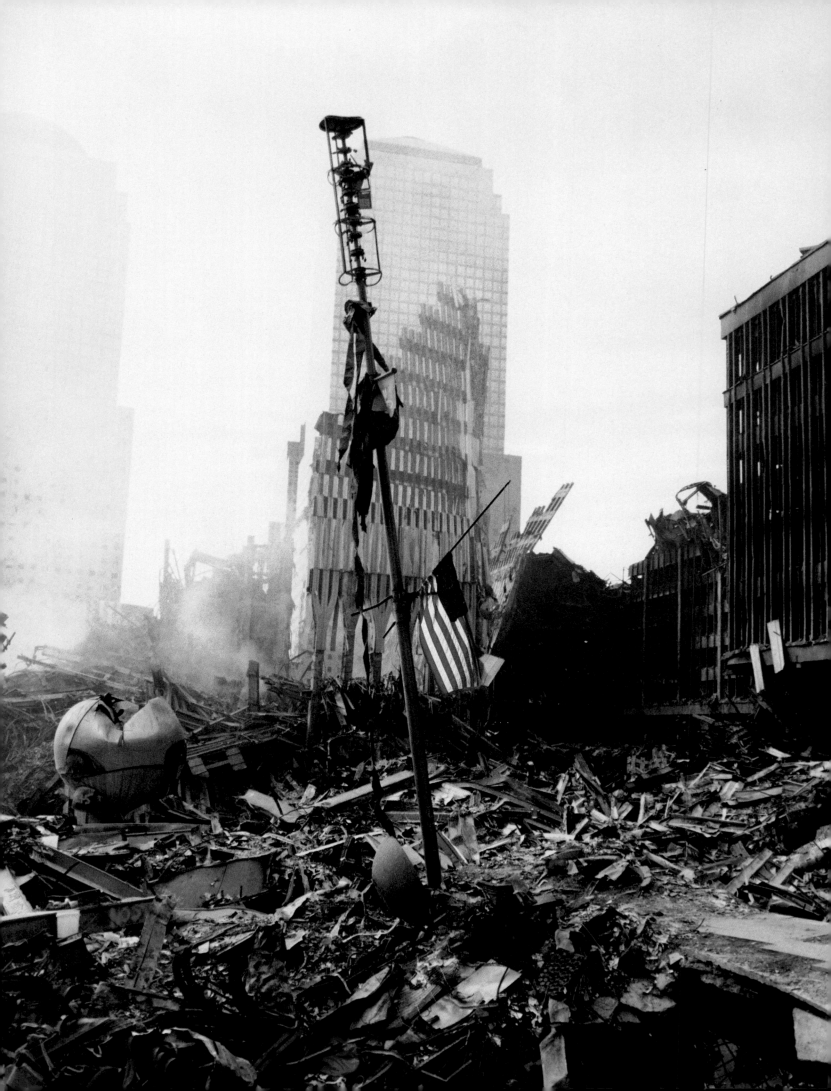

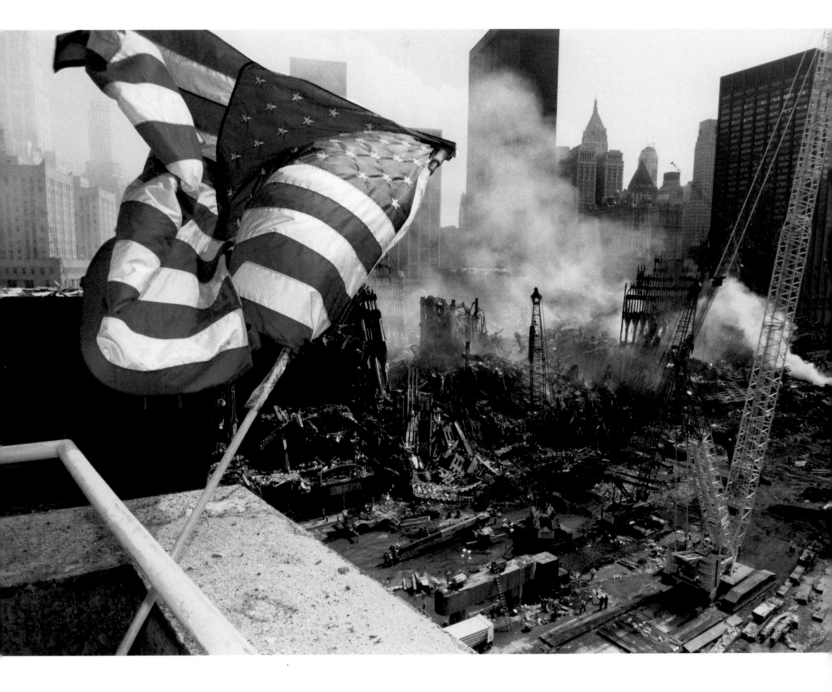

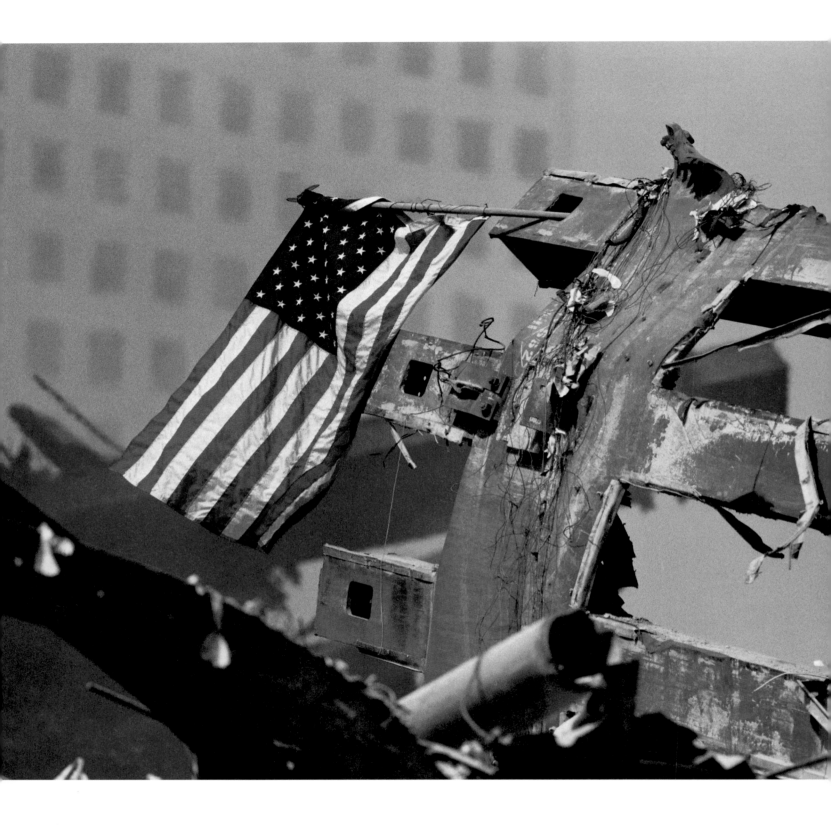

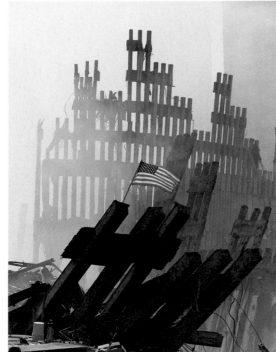

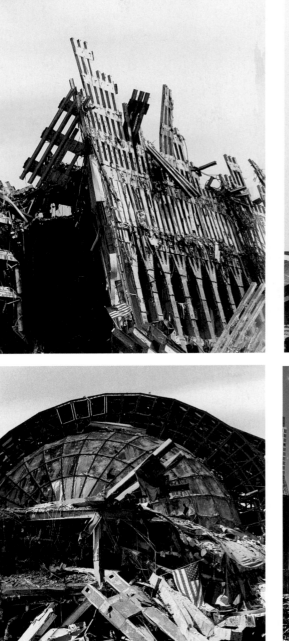

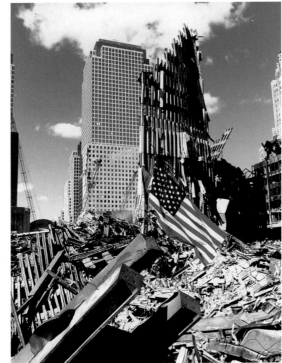

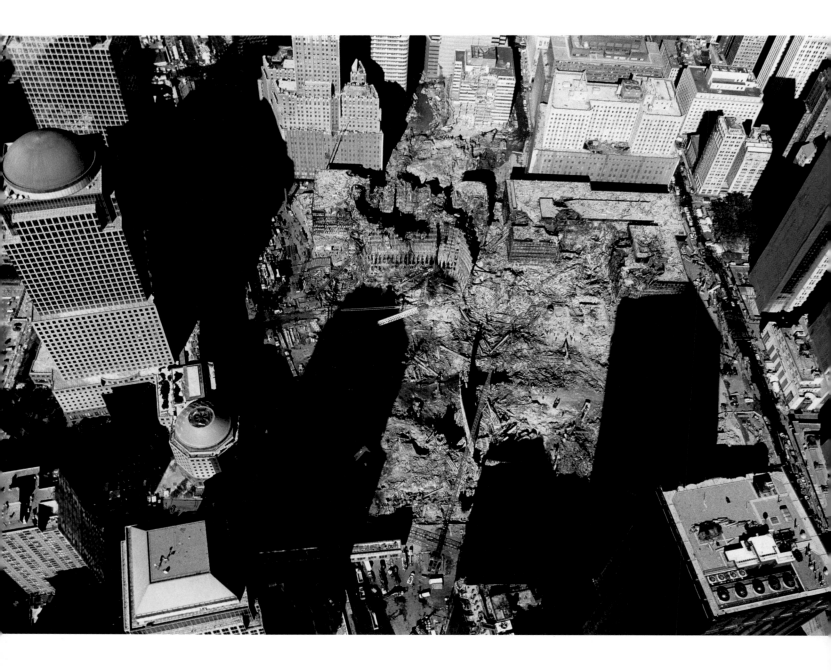

ABOVE HALLOWED GROUND

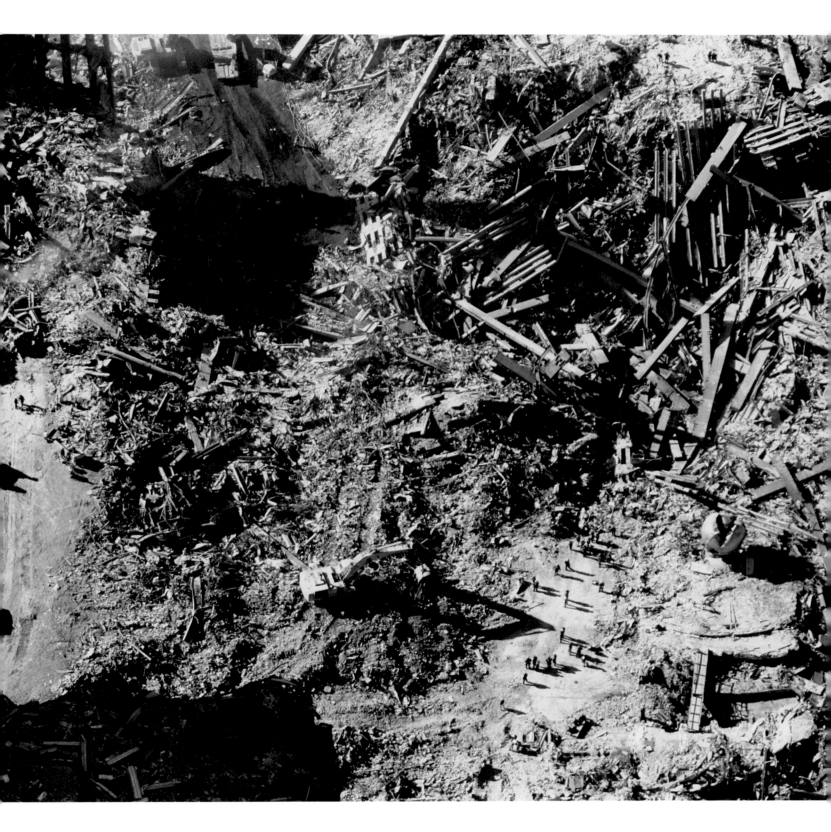

Ground Zero, October 9.

OVERLEAF: Flying back to Floyd Bennett Field one evening, the skyline of lower Manhattan. It would never be the same.

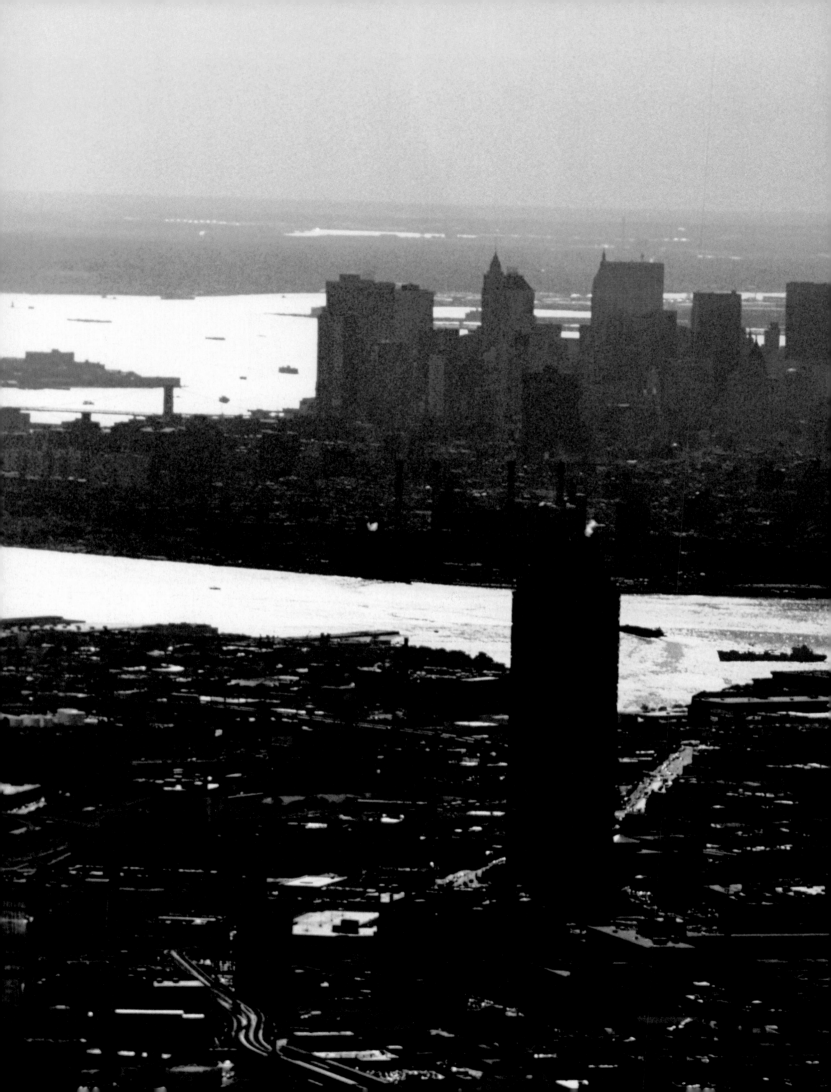

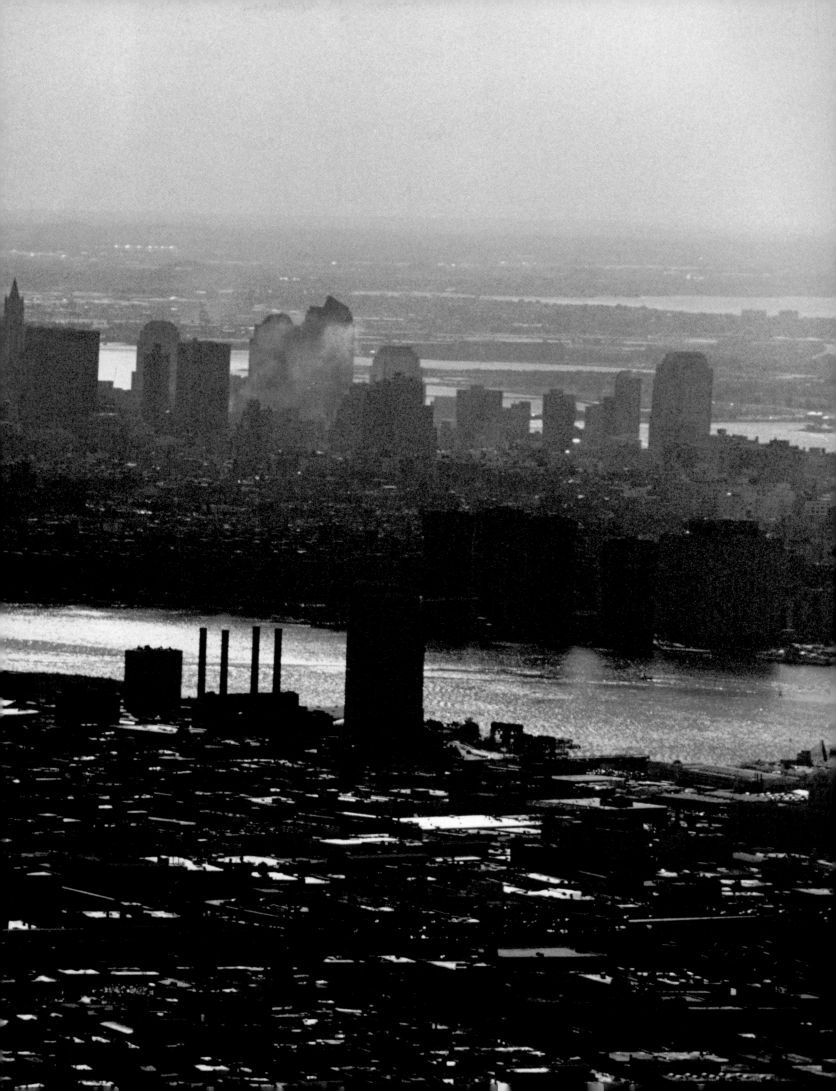

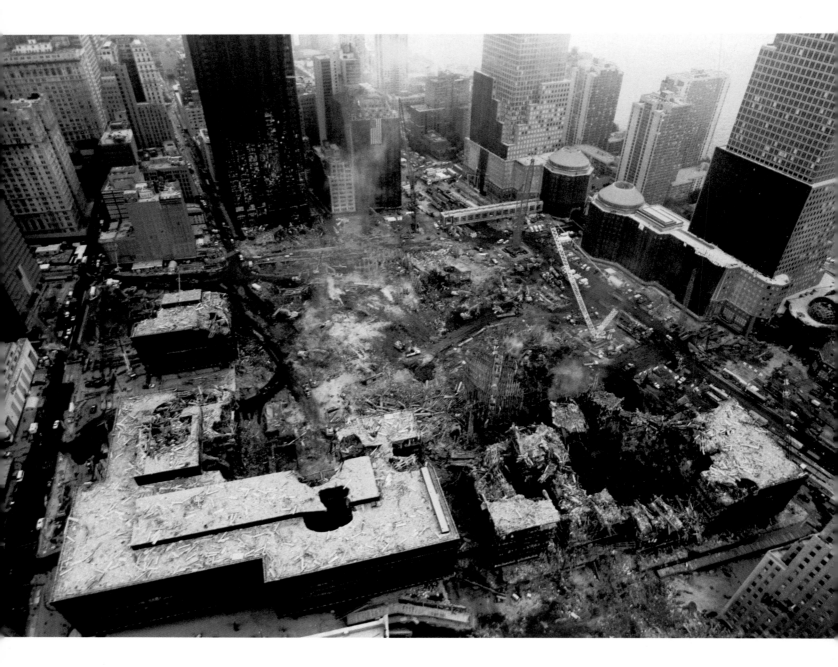

Ground Zero, October 23.

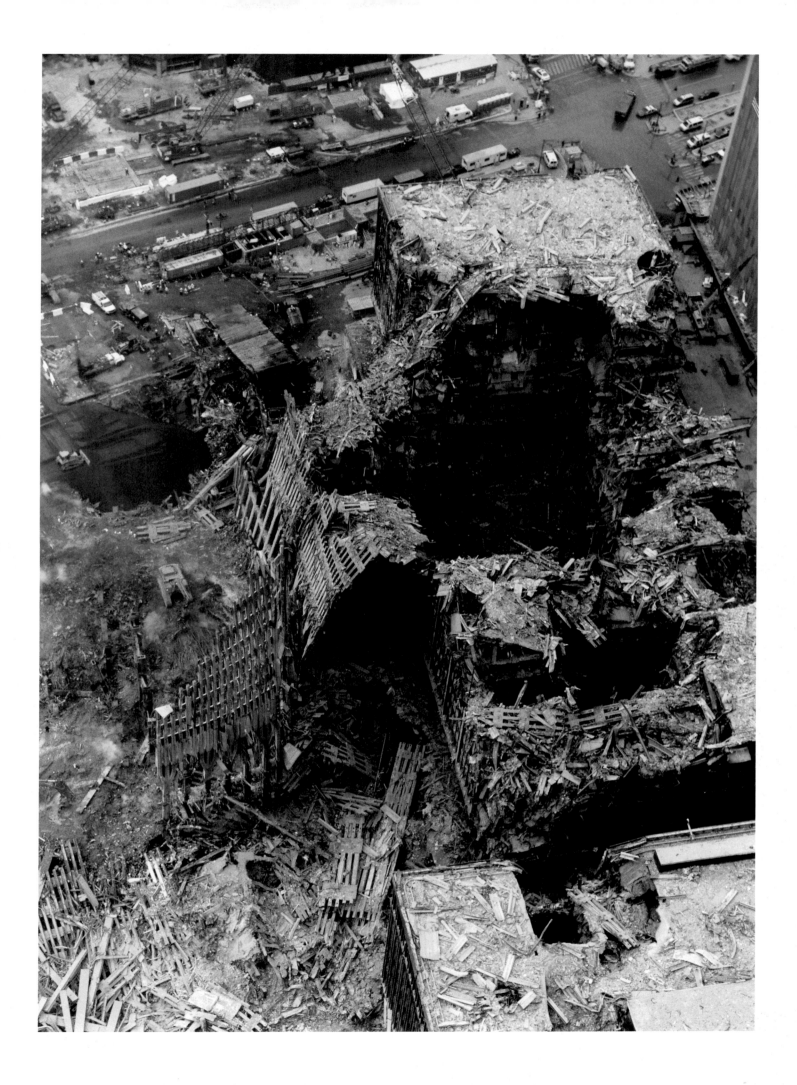

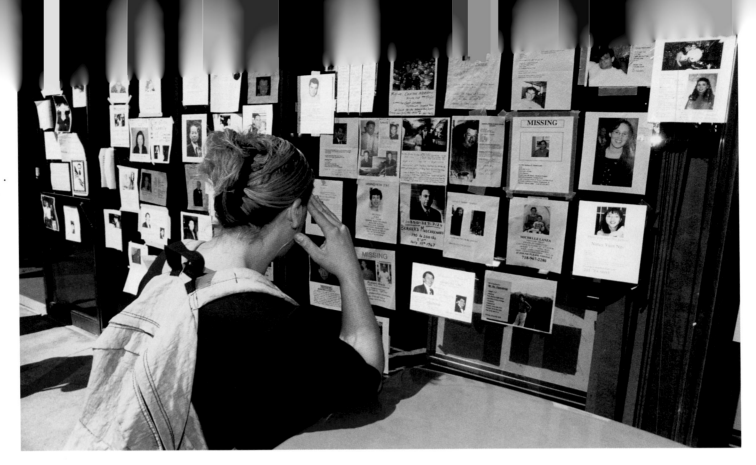

These memorials were common all over the city.

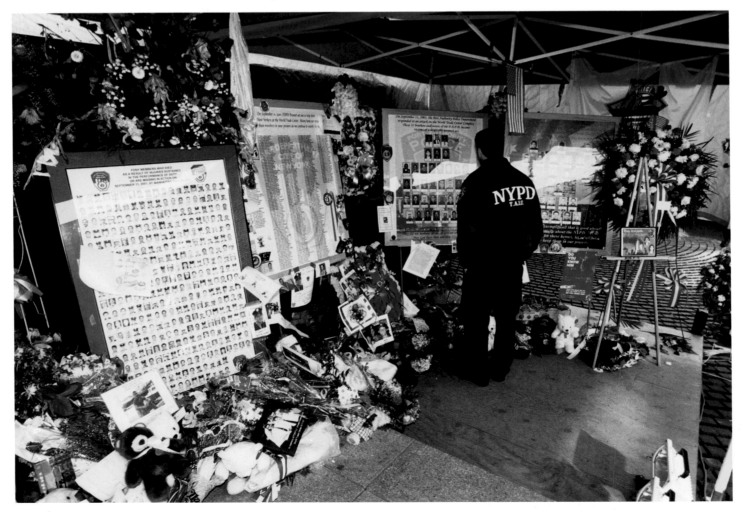

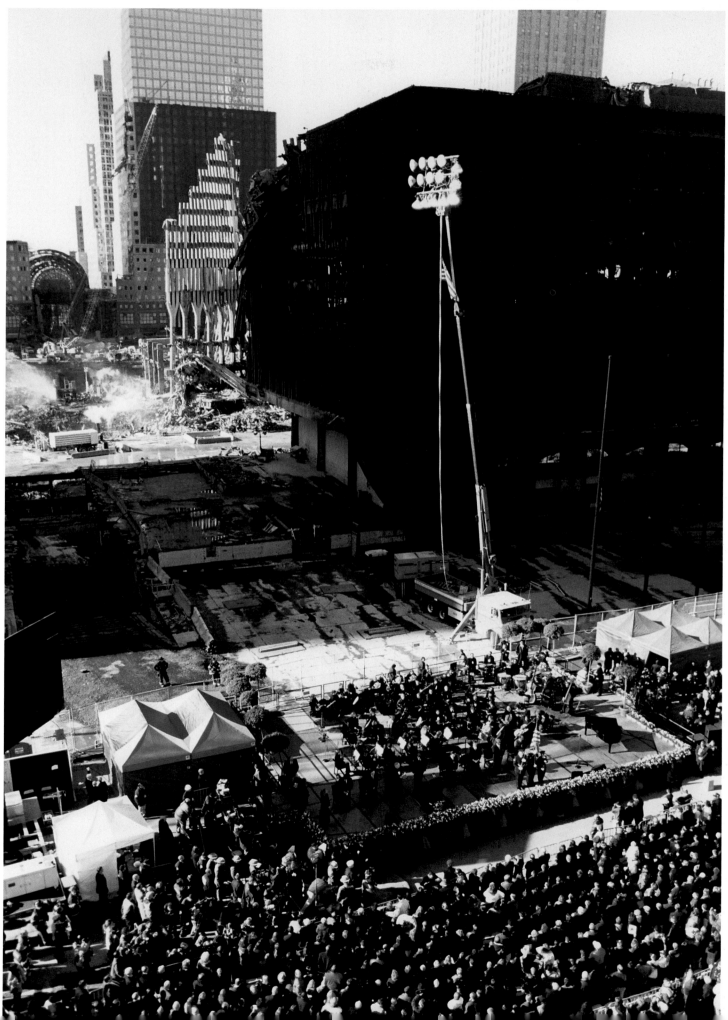

REMEMBERING THOSE WE LOST. A MEMORIAL SERVICE FOR THE VICTIMS' FAMILIES ON OCTOBER 28.

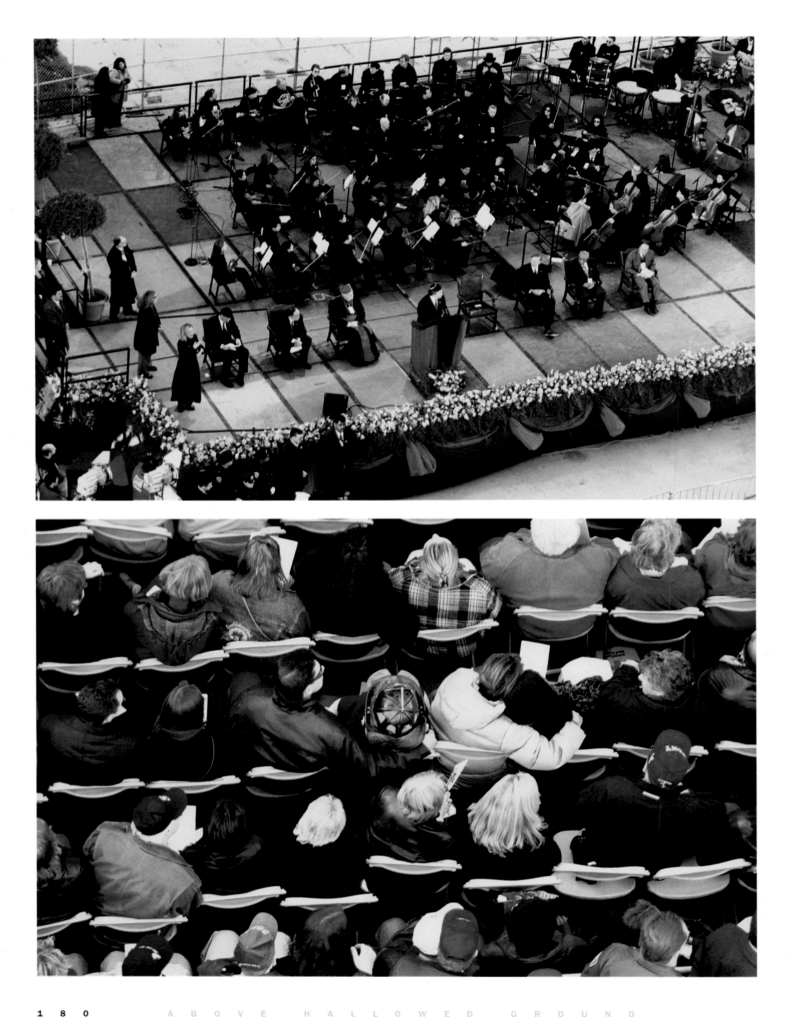

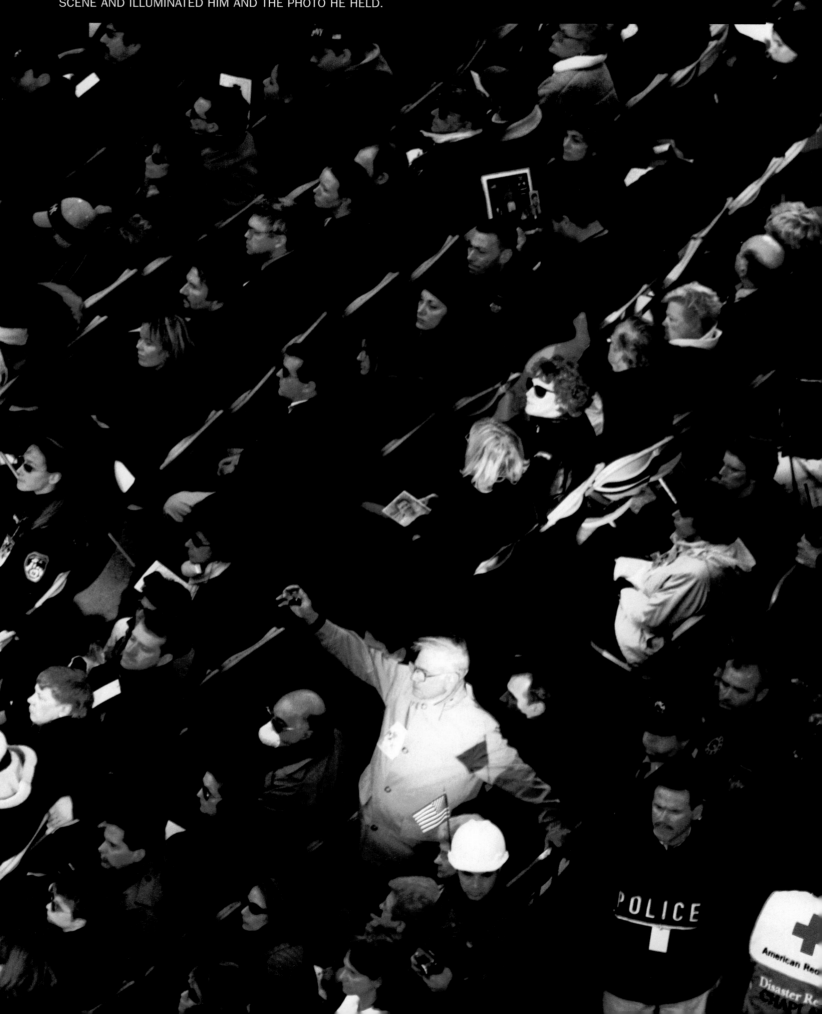

DURING THE SERVICE, A FATHER HELD UP A PHOTO OF HIS SON JUST AS A RAY OF SUNLIGHT GLANCED ACROSS THE SCENE AND ILLUMINATED HIM AND THE PHOTO HE HELD.

A tribute to the twin towers at the Macy's Thanksgiving Day Parade, November 22.

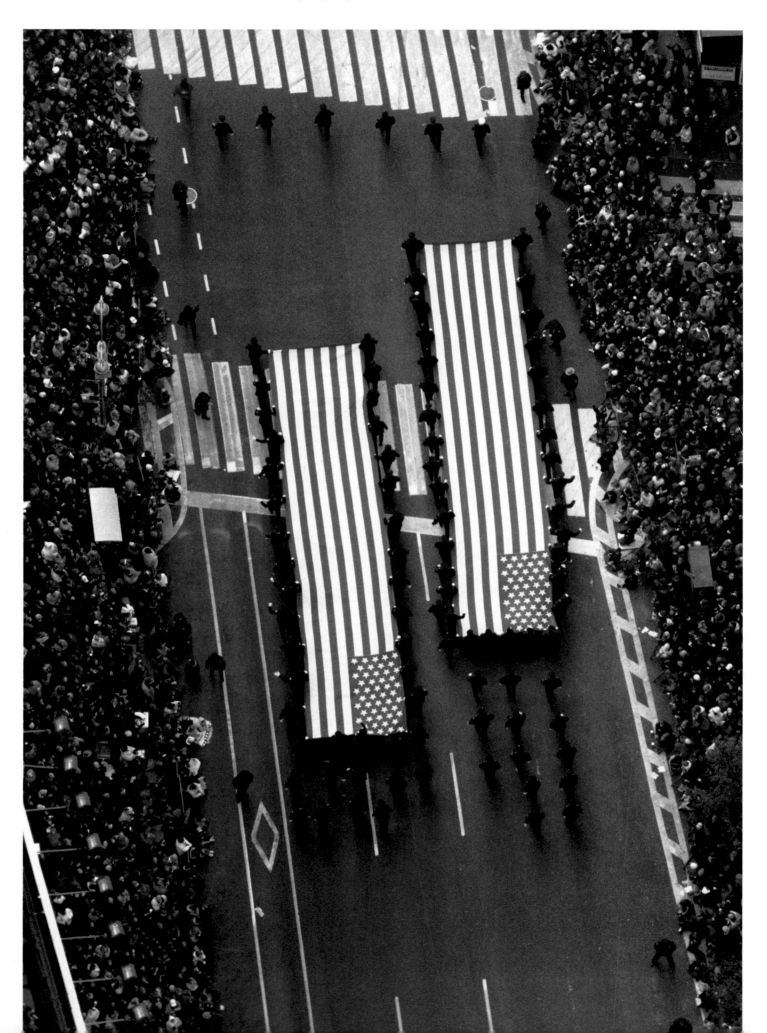

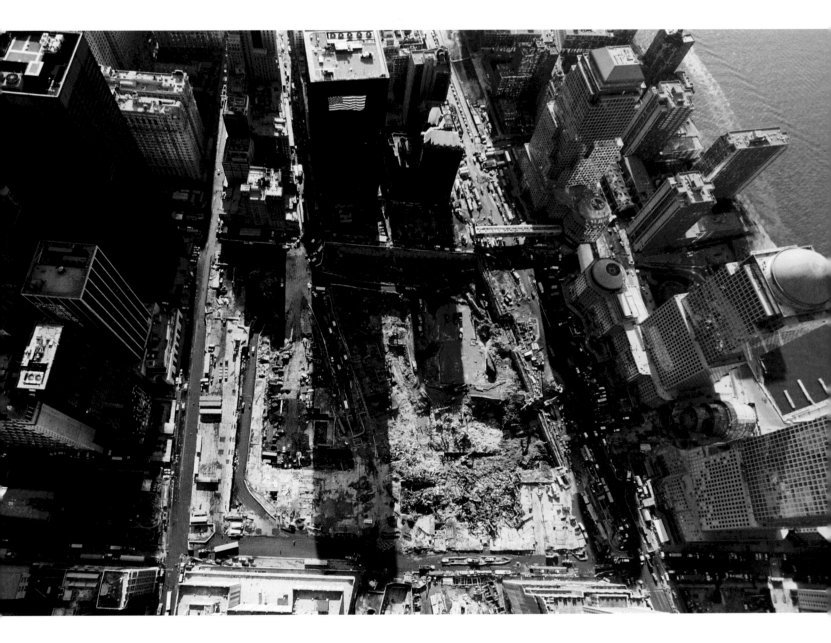

Ground Zero, from above and street level, January 15, 2002.

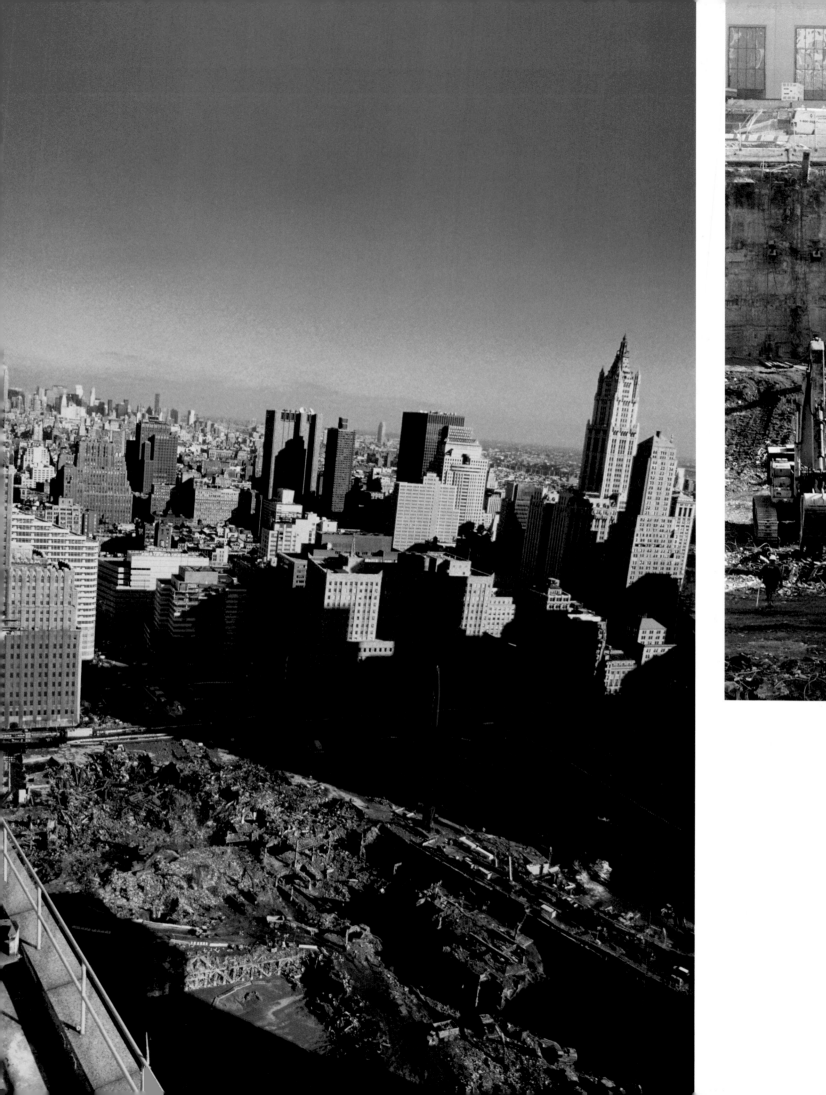

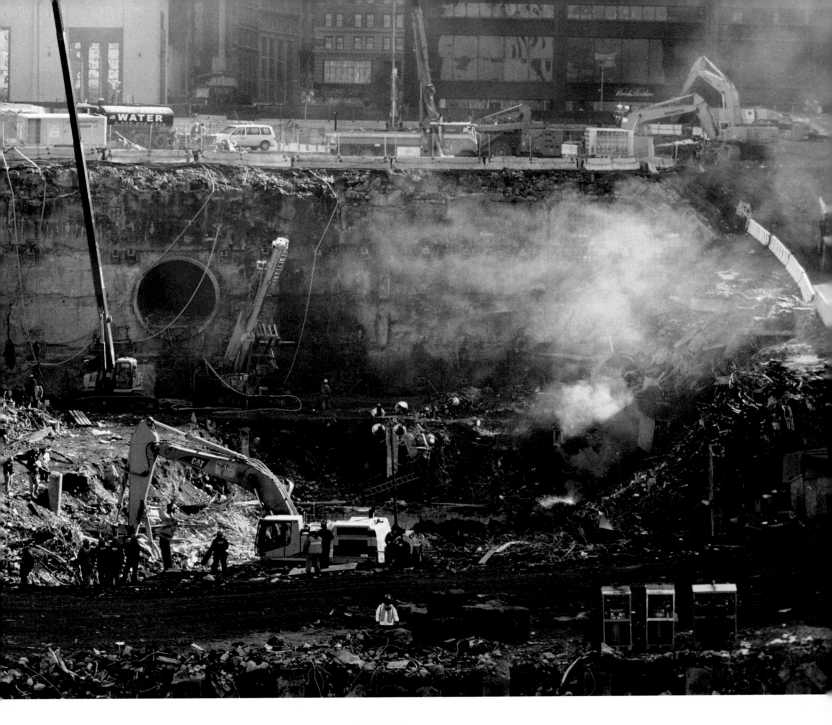

The "pile" at Ground Zero had become a pit, January 15, 2002.

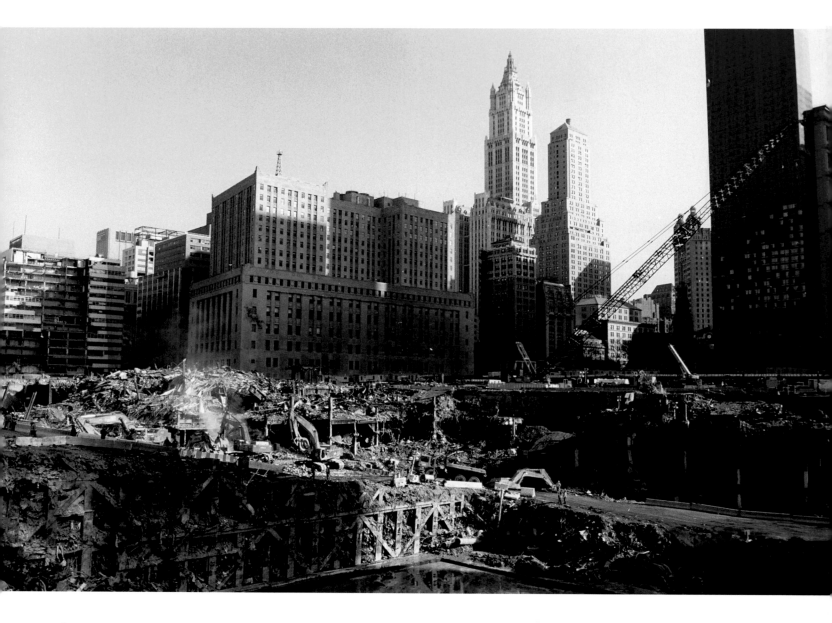

Ground Zero, January 15, 2002.

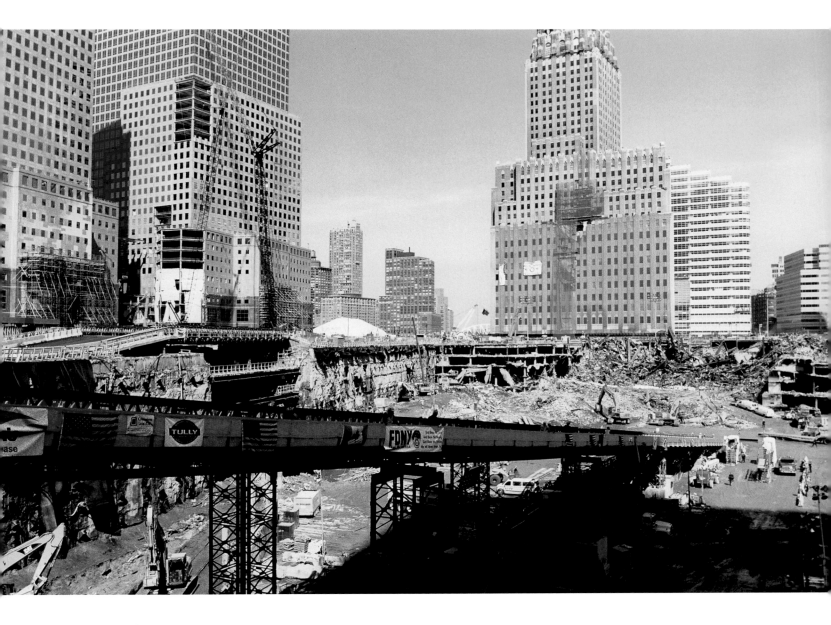

Ground Zero, March 2002.

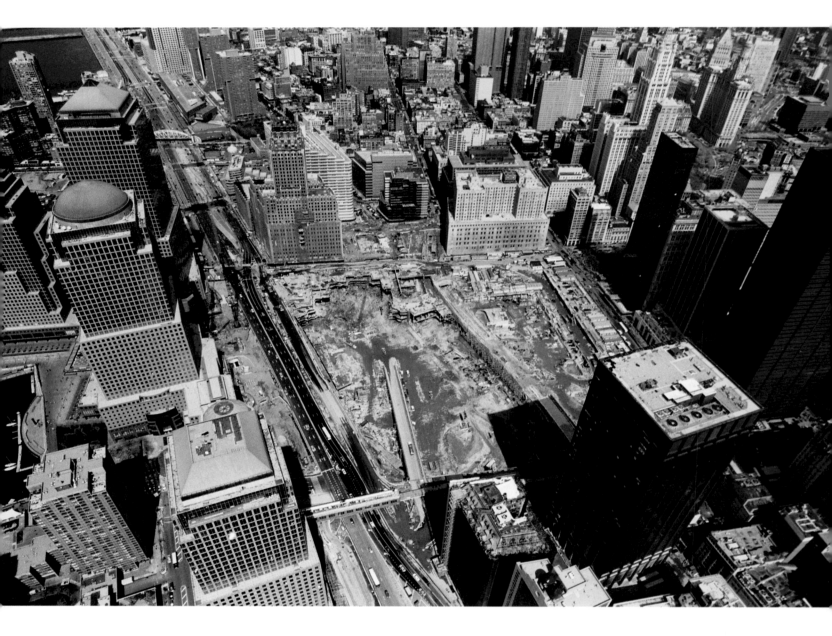

Ground Zero, April 14, 2002.

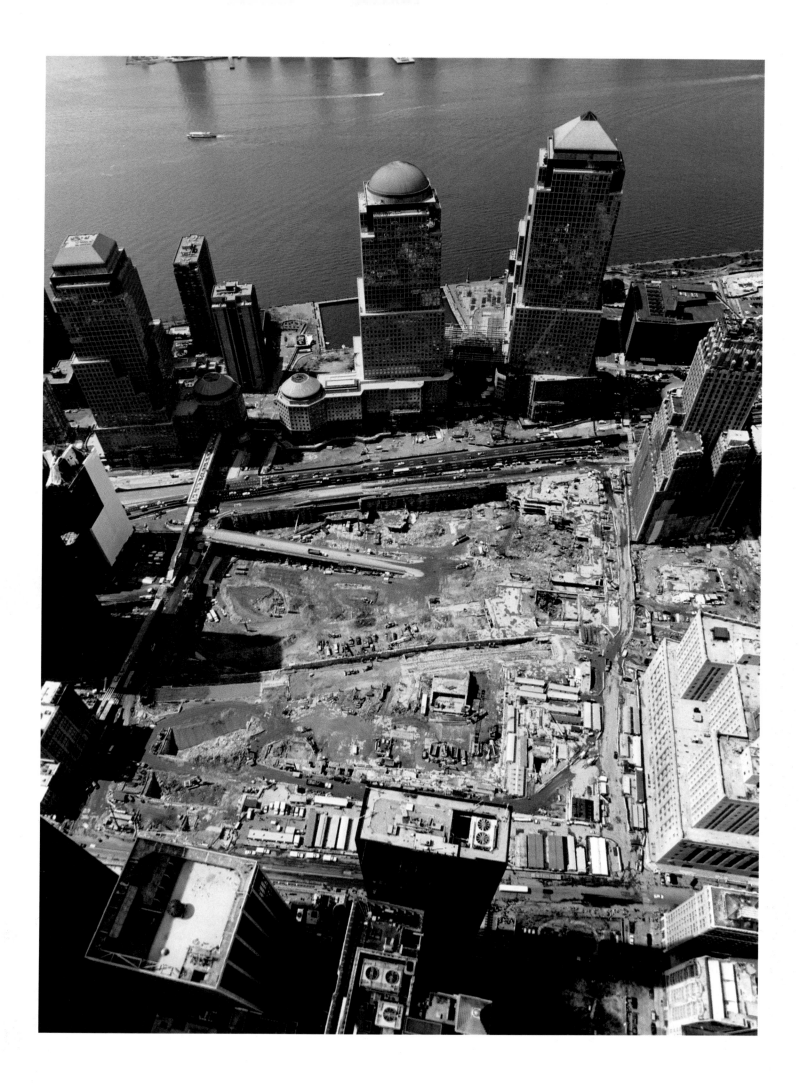

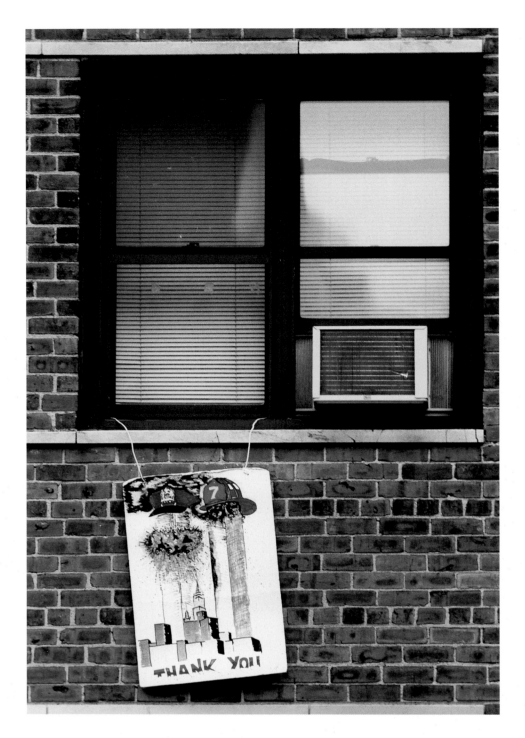

A private tribute to the police and firefighters.

OPPOSITE: This is the last steel beam that will be pulled out of Ground Zero. On it is marked the death toll of the PAPD, NYPD, and FDNY.

OVERLEAF: Twin beams of light were lit in memory of all those lost at the World Trade Center from mid-March to mid-April 2002.

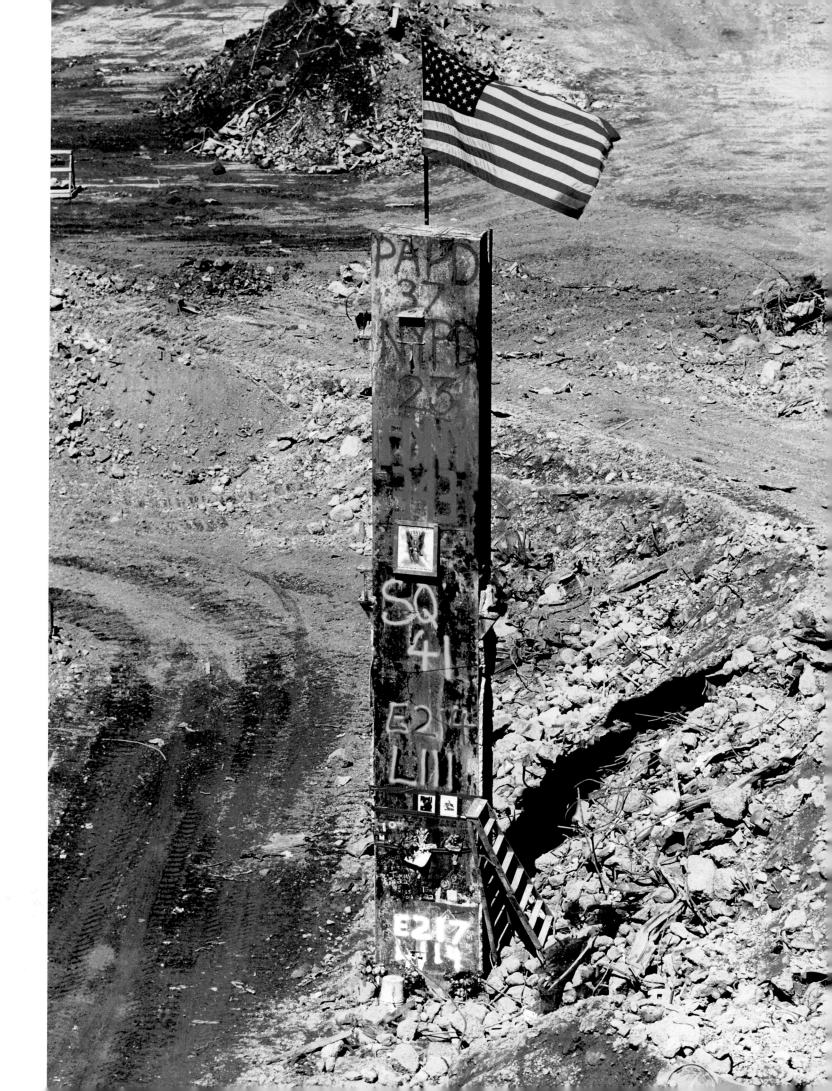

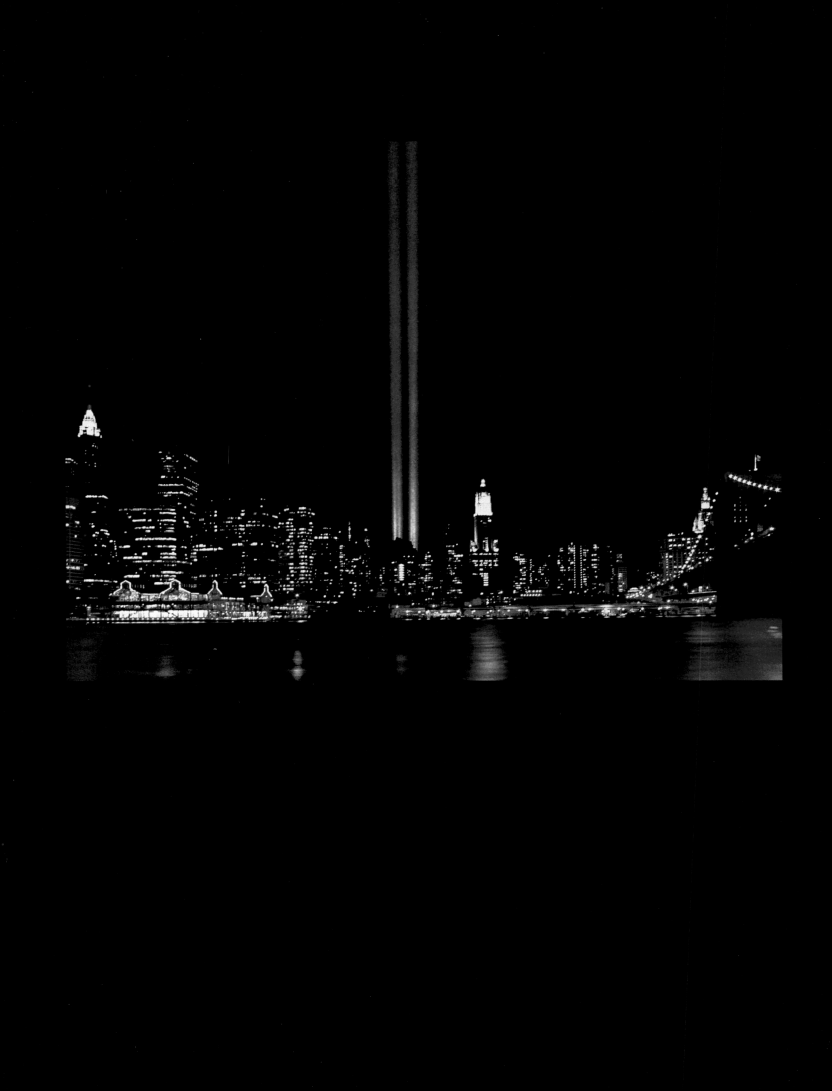